Living in Greece
Vivre en Grèce

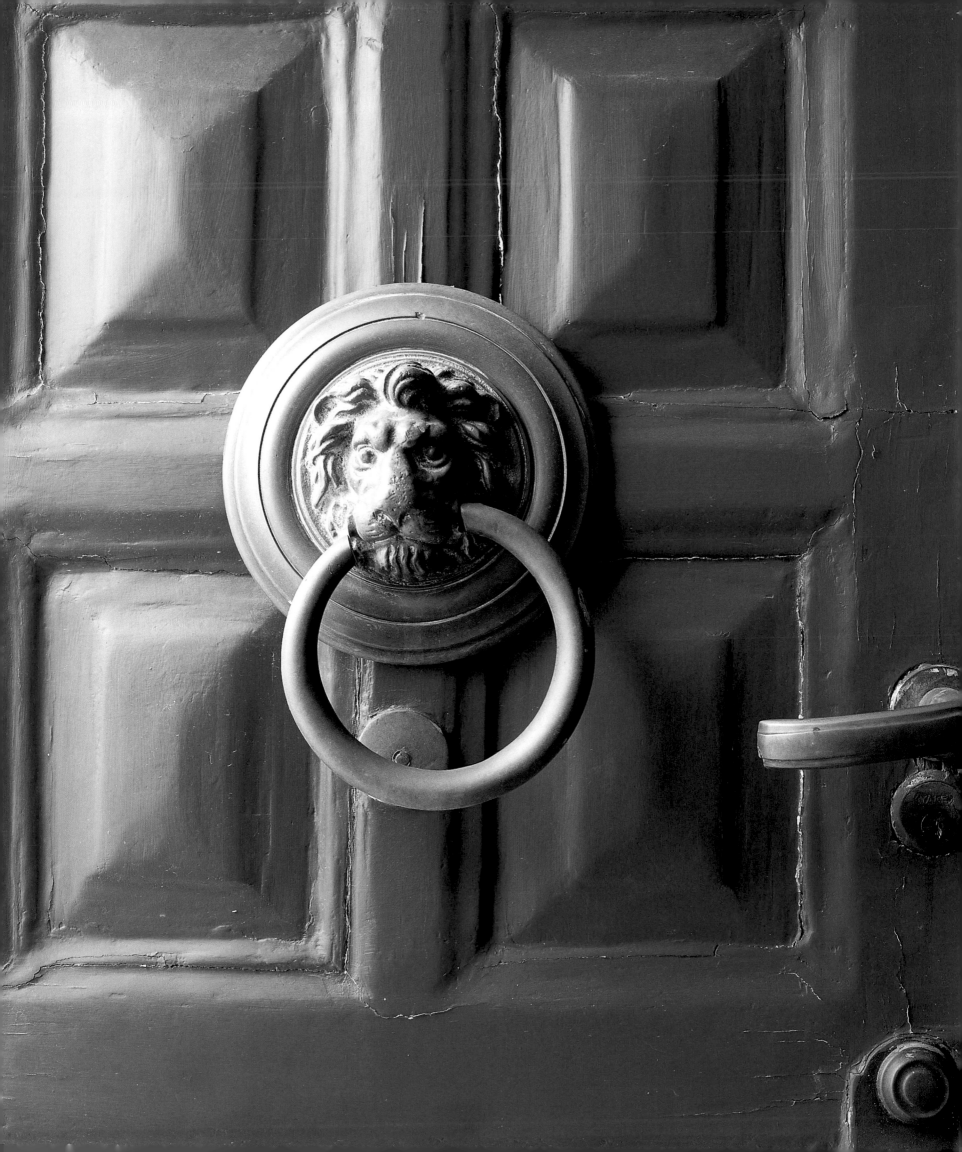

Living in Greece
Vivre en Grèce

Barbara & René Stoeltie

EDITED BY · HERAUSGEGEBEN VON · SOUS LA DIRECTION DE

Angelika Taschen

KÖLN LONDON MADRID NEW YORK PARIS TOKYO

CONTENTS
INHALT
SOMMAIRE

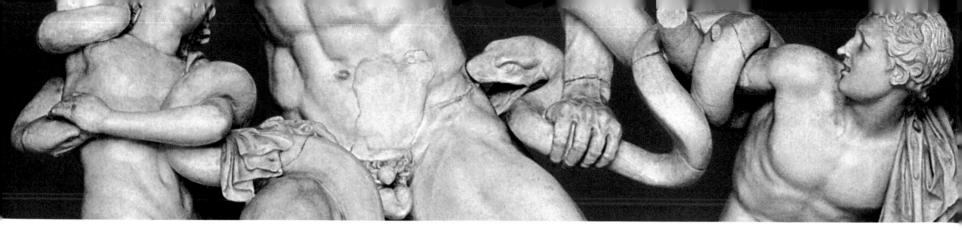

DREAM HOUSES
IN THE *Aegean*

Lakoon (2nd century BC) · Laokoon (2. Jh. v. Chr.) · Laocoon (2ᵉ siècle avant J.-C.), detail, Musei Vaticani, Rome.

Have you ever dreamed of a small white house in Greece? A place on one of the islands of the Dodecanese or the Cyclades, hidden in the streets of some hilltop "chora", or near the quayside where fishermen's boats ride on the glassy water?

"I may not hope to touch the sky," wrote Sappho, the ancient Greek poetess. Are we as modest when we dream of Greece? This indeed is the cradle of eternal beauty, where the light is sometimes so dazzling that it hurts the eyes – a land of blue shutters, red geraniums and vivid purple bougainvilleas. Hydra, Patmos, Aegina, Serifos … the very names of the islands conjure up poetic images. You hear them and are immediately reminded of a village clinging to the flank of a rock, or a church topped with a bright blue dome, so close to a precipice that it seems about to topple into the waves, or the ruin of a temple dedicated to some Olympian god, rearing its columns against the blazing sky.

They say you can't imagine the light in Greece without actually seeing it, and Henry Moore said: "in Greece objects seem illuminated by a light that flows from within." And this perhaps explains how the old Greek gods live on as lovely statuary; and how everything in Greece, however banal, has the potential for transcendent beauty. In this parched land the mythical Perseus slew the Gorgon, Hercules strove with the Lion of Nemea, Poseidon took Amphitrite for his wife and Athena burst fully-armed from the skull of Zeus. Not for nothing is Hellas the birthplace of some of humanity's greatest figures: Socrates, Alexander the Great, Pericles, Plato, Sophocles, Aristotle, Homer and Sappho.

But Greece is also a place of the present, of ordinary men and women. Most striking of all are the ageless faces etched deep by wind and sun, and the ubiquitous dress of mourning black. The Greeks offer you hospitality with a touching spontaneity; they're always ready to share a loaf and some cheese, an almond cake perhaps, a glass

TRAUMHÄUSER IN DER *Ägäis*

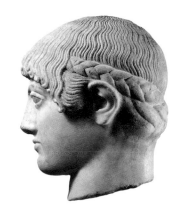

Haben Sie schon einmal von einem kleinen weißen Haus in Griechenland geträumt? Einem Wohnsitz auf den Dodekanes-Inseln oder den Kykladen, versteckt in den Straßen einer auf der Hügelspitze gelegenen »chora« oder unten in der Bucht, wo die Fischerboote auf dem glasklaren Wasser schaukeln?

»Ich darf wohl nicht hoffen, den Himmel zu berühren«, schrieb die antike Dichterin Sappho. Sind wir genauso bescheiden, wenn wir von Griechenland träumen? Denn hier, in diesem Land mit blauen Fensterläden, roten Geranien und kräftig violetten Bougainvillea, steht die Wiege ewiger Schönheit und das Licht ist manchmal so hell, dass es in den Augen schmerzt. Hydra, Patmos, Ägina, Seriphos: Schon die Namen der Inseln beschwören poetische Bilder. Wer sie hört, denkt sofort an ein Dorf, das sich an einen Felsen schmiegt, an eine mit einer strahlendblauen Kuppel überdachte Kirche, die so nahe am Abgrund steht, dass sie jeden Augenblick in die Wellen zu stürzen scheint, oder an die Ruine eines Tempels, der einem der Götter des Olymp geweiht war.

Um sich das Licht in Griechenland vorstellen zu können, so heißt es, müsse man es selbst gesehen haben. Der Bildhauer Henry Moore sagte: »In Griechenland strahlen die Dinge, als käme ihr Licht von innen«. Daraus erklärt sich vielleicht, weshalb dort die antiken Götter in so anmutigen Statuen fortleben und noch die gewöhnlichsten Dinge von so überwältigender Schönheit sein können. In diesem kargen Land tötete der legendäre Perseus die Medusa, Herakles erwürgte den Nemeischen

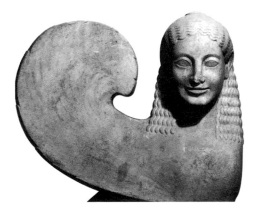

MAISONS DE RÊVE DES ILES DE LA MER *Égée*

N'avez vous jamais rêvé d'une petite maison toute blanche en Grèce? Une petite maison sur une des îles du Dodécanèse ou des Cyclades, cachée au cœur d'un dédale de rues dans une de ces «chora» perchées au sommet d'une colline? Une petite maison près d'un port paisible où les bateaux des pêcheurs tanguent doucement sur la mer limpide?

«Je n'espère pas toucher le ciel …», écrivait Sappho, la poétesse antique. Sommes-nous aussi modestes et aussi humbles quand nous rêvons de la Grèce? Dans ce berceau de la beauté éternelle, du ciel azur et de la mer turquoise qui fait parfois mal aux yeux; là où les volets bleus, les géraniums rouges et le pourpre violent des bougainvillées ne cessent de nous ravir, des noms comme Hydra, Patmos, Egine et Sérifos évoquent des images poétiques: un petit village collé au flanc d'un rocher; une église blanche coiffée d'un dôme bleu vif et si près d'un précipice qu'elle semble prête à se jeter dans les vagues; la ruine d'un temple dédié à un dieu de l'Olympe et qui dresse ses colonnes rongées par les siècles sur un fond de ciel éclatant.

On dit que l'on ne peut imaginer la lumière en Grèce sans en avoir fait l'expérience, et Henry Moore prétendait: «En Grèce les objets semblent illuminés par une lumière qui vient de l'intérieur.» Et voilà ce qui explique la splendeur de tous ces dieux antiques transformés en statues sensuelles et la magie d'un quotidien où chaque chose, même la plus banale devient un objet de beauté. C'est ici, faut-il s'en étonner, que sont

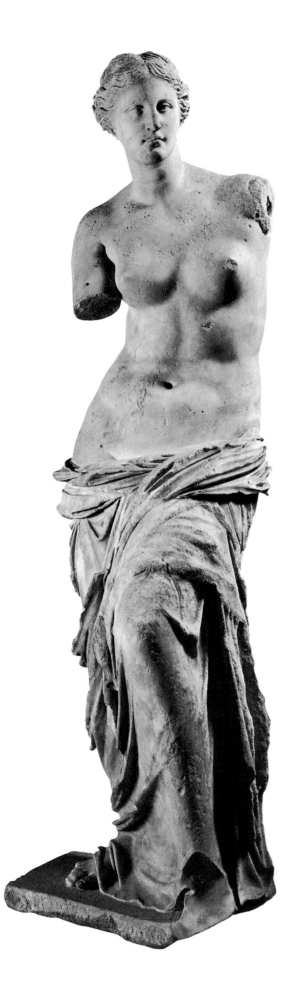

of ouzo or a cup of wine with the traveller, from whom they seem to expect nothing in return. And there are so many other good things.

Your journey is about to begin, the boat awaits you – but when you arrive on the quay, you find yourself lingering in the small harbour "taverna", where there's a terrace, straw-bottomed chairs painted blue, and checked napkins. The "mezédes", the olive bread, the "taramosaláta" and the grilled fish look too delicious to pass up ...

But they'll have to wait till you come back through. For the moment, it's time to embark!

Löwen, Poseidon nahm Amphitrite zur Frau und Athene entsprang in voller Rüstung dem Haupt des Zeus. Nicht umsonst wurden in Hellas einige der größten Gestalten der Menschheitsgeschichte geboren: Sokrates, Alexander der Große, Perikles, Platon, Sophokles, Aristoteles, Homer und Sappho.

Natürlich gibt es aber auch ein Griechenland von heute, mit ganz gewöhnlichen Sterblichen. Sofort ins Auge fallen die vielen Menschen mit alterslosen, von Wind und Sonne gegerbten Gesichtern und der typischen schwarzen Kleidung. Die Griechen sind sehr gastfreundlich; mit großer Selbstverständlichkeit teilen sie mit dem Reisenden etwas Brot und Käse, ein Glas Ouzo oder Wein, ohne dafür eine Gegengabe zu erwarten.

Die Reise kann beginnen, das Boot liegt schon am Kai. Kaum im Hafen angekommen, findet man sich jedoch vor einer kleinen »taverna« wieder, auf deren Terrasse blau gestrichene Stühle mit Strohbezug und Tische mit karierten Decken zum Bleiben einladen. Die »mezédes«, das Olivenbrot, die »taramosaláta« und der gegrillte Fisch wirken zu köstlich, um sie sich entgehen zu lassen.

Aber sie werden bis zum nächsten Mal warten müssen. Denn jetzt ist es Zeit, an Bord zu gehen!

nés Alexandre le Grand, Socrate, Périclès, Platon, Diogène, Démosthène, Aristote, la belle Hélène, Homère et Sappho. Et c'est sur cette terre aride que Persée tua la Gorgone, qu'Hercule abattit le lion de Némée, que Poséidon épousa Amphitrite et qu'Athéna naquit de la tête de Zeus.

Mais la Grèce, c'est aussi ces femmes et ces hommes sans âge, dont la peau ressemble à une terre desséchée aux multiples crevasses et qui s'habillent invariablement en deuil. Ils vous offrent l'hospitalité avec une spontanéité touchante, partageant volontiers leur pain, un morceau de fromage, une sucrerie parfumée à l'amande, un verre d'ouzo ou une bouteille de vin avec le voyageur dont ils ne semblent rien attendre en retour.

Notre voyage peut commencer, le bateau nous attend. Mais sur le quai, à l'arrivée, vous trouverez une petite «taverna» sans prétention, avec une terrasse, des chaises paillées peintes en bleu et des nappes à carreaux. Les «mezédes», le pain aux olives, la «taramosaláta» et les poissons grillés que vous dégusterez là vous laisseront un souvenir inoubliable.

Venez … il est temps de s'embarquer pour la Grèce …!

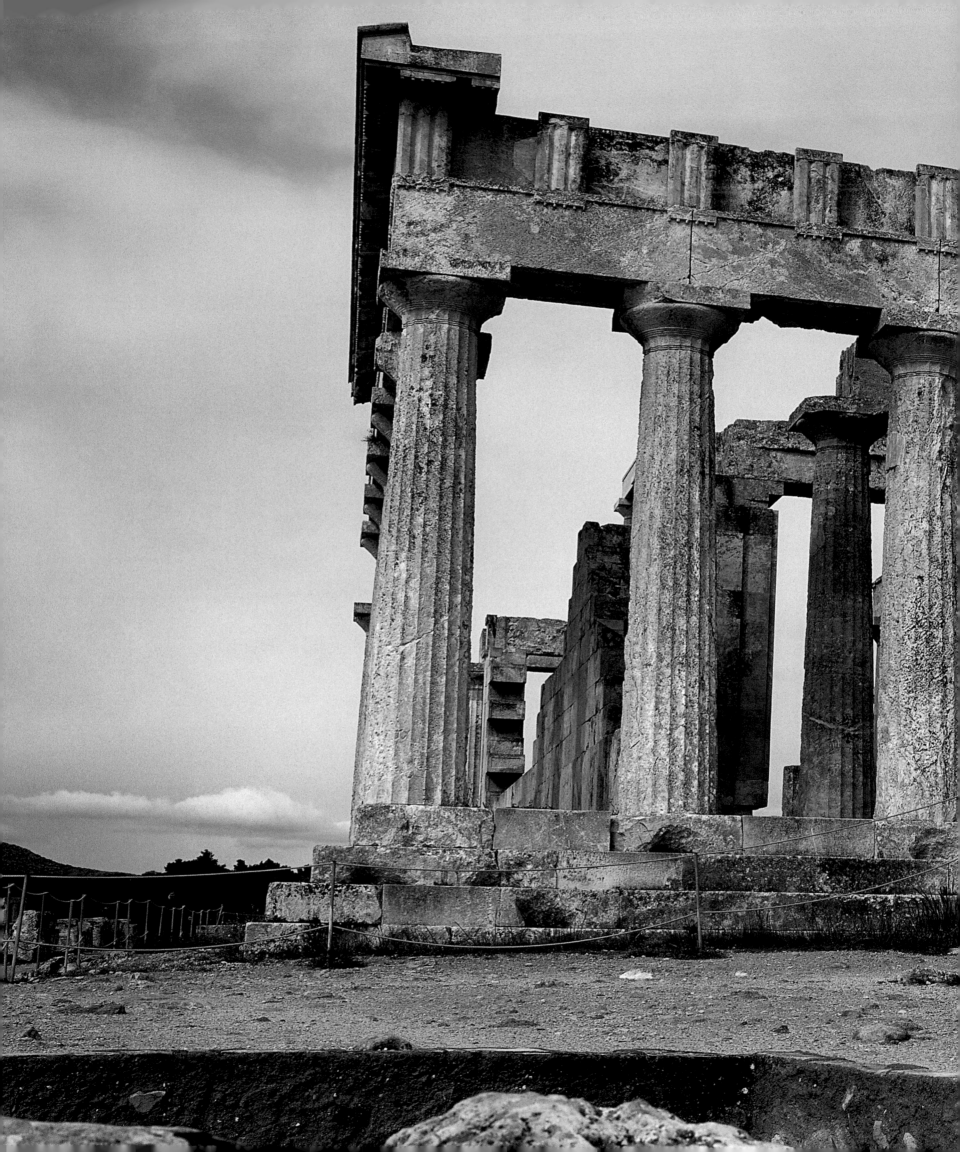

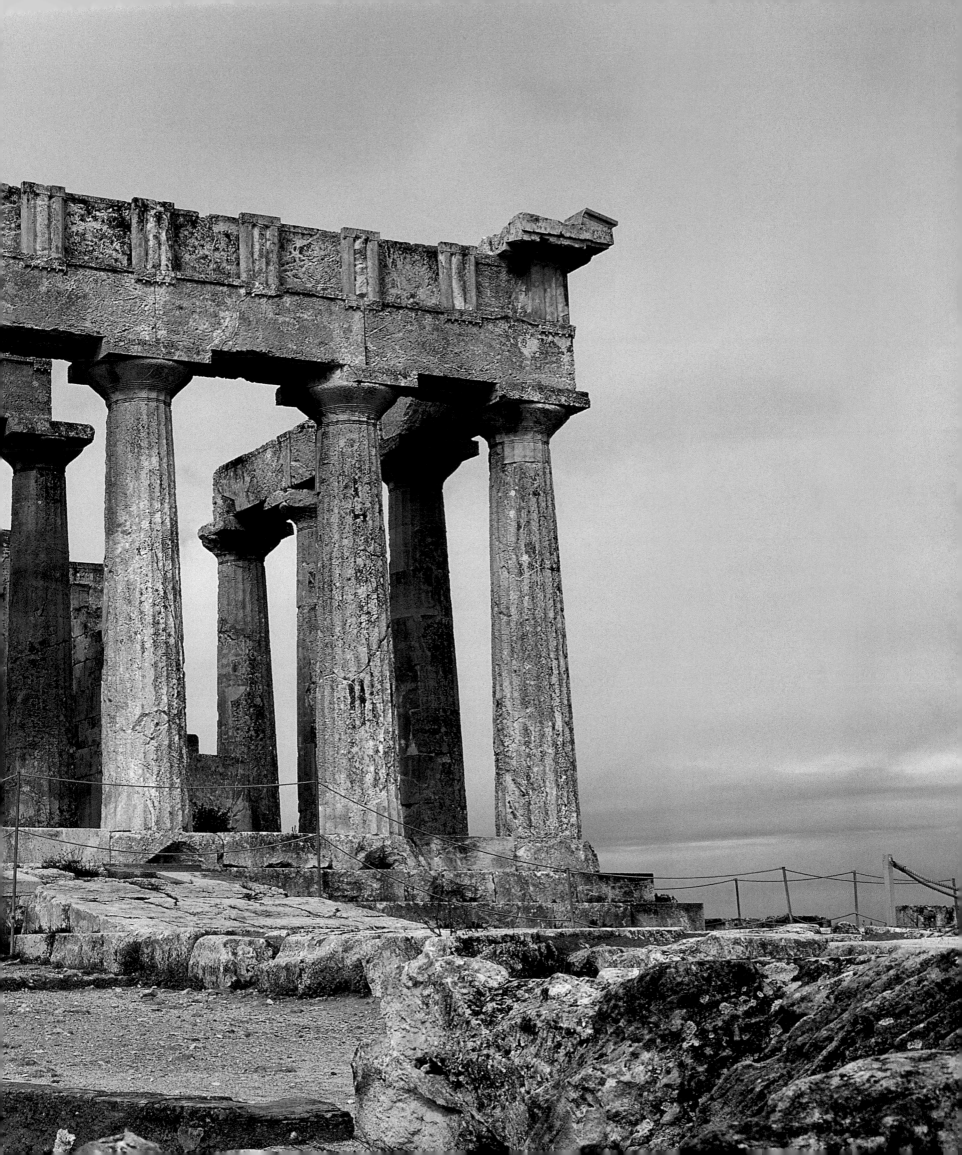

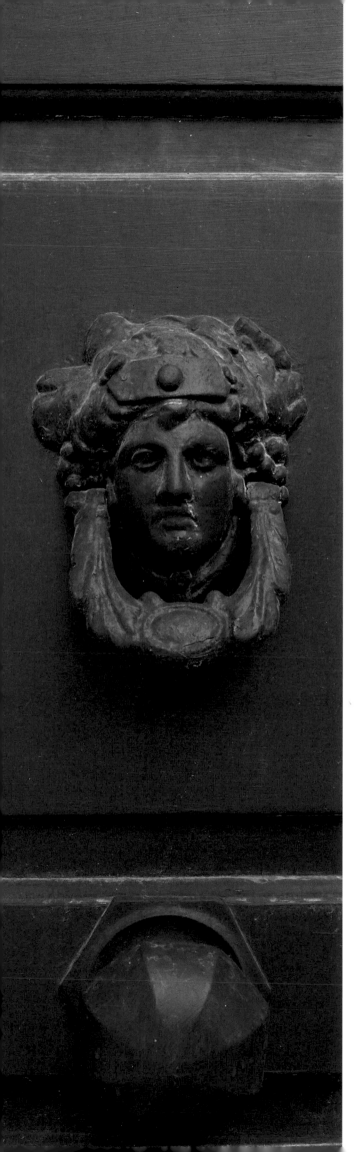

C LETHAM
Jean-Claude Chalmet
Aegina

This villa seems to belong more to Hollywood, California, than to the serenely beautiful island of Aegina, barely an hour by boat from the port of Piraeus. Jean-Claude Chalmet, a businessman and aesthete and a great lover of Hellas and her islands, has been living in Greece for ten years. He saved "Cletham" – an anagram of his own name, Chalmet – in the nick of time. Notwithstanding its sheer grandeur, stunning situation and uninterrupted view across the bay of Agia Marina, when he arrived the building had lost most of its original freshness. Today Chalmet says little of his labours, or of the trouble he took to resurrect the spectacular blue swimming pool which – like a balcony over the sea – stretches away to a terraced garden planted with olive trees, pines, palm trees and flowers. Nor will he even discuss the former state of the terraces themselves, which serve today as an open air salon. He'd rather his guests just settled back in the soft sofas to sip their champagne, before taking an *al fresco* meal with the stars glimmering in the night sky overhead.

PREVIOUS PAGES: *The temple of Aphaia – built circa 490 BC, Aegina.*
LEFT AND ABOVE: *The blue is everywhere: skies, door and knocker.*

VORHERGEHENDE DOPPELSEITE: *Der Aphaia-Tempel, erbaut um 490 v. Chr., Ägina.*
LINKS UND OBEN: *Blau ist die vorherrschende Farbe: im Himmel und auf der Tür mit dem klassischen Klopfer.*

DOUBLE PAGE PRECEDENTE: *Le temple d'Aphaia construit vers 490 avant J.-C., Egine.*
A GAUCHE ET CIDESSUS: *Le bleu domine: dans le ciel et sur la porte avec son heurtoir aux formes classiques.*

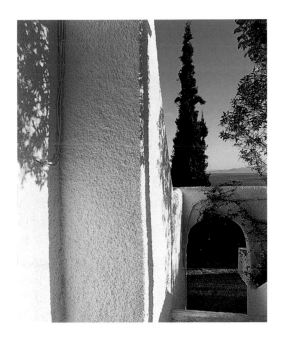

Als eine Art kalifornischer Traum gehört diese Villa eigentlich eher nach Hollywood, als auf die eine knappe Bootsstunde von Piräus entfernte Insel Ägina. Der Ästhet und Geschäftsmann Jean-Claude Chalmet, ein großer Liebhaber von Hellas und seiner Inseln, lebt seit einem Jahrzehnt in Griechenland. Er hat »Cletham« – ein Anagramm von Chalmet – rechtzeitig gerettet. Atemberaubend gelegen, mit einer unverbaubaren Aussicht über die Bucht von Agia Marina und einer unverkennbar herrschaftlichen Anmutung, hatte das Gebäude seinen einstigen Glanz eingebüßt. Diskret schweigt der Eigentümer heute über die Sisyphosarbeit, die etwa mit der Wiederherrichtung des spektakulären blauen Schwimmbeckens verbunden war. Wie ein Balkon erhebt es sich über dem Meer und wird prachtvoll eingerahmt von einem Terrassengarten mit Olivenbäumen, Pinien, Palmen und unzähligen bunten Blumen. Kein Wort will er mehr hören vom früheren Zustand dieser Terrassen, die jetzt mit gemütlichen Kanapees ausgestattet sind und als »Salon im Freien« dienen. Dort entspannt man sich bei einem Glas Champagner und genießt eine Mahlzeit unter dem Sternenhimmel.

A vrai dire, la villa évoque plus le luxe hollywoodien et le rêve californien que la beauté sereine de l'île d'Egine, située à une petite heure de bateau du Pirée. Jean-Claude Chalmet, homme d'affaires et esthète, grand amateur d'Hellas et de ses îles et installé en Grèce depuis une dizaine d'années, sauva «Cletham» – anagramme de Chalmet – au bon moment. Car en dépit du site époustouflant, de la vue imprenable sur la baie d'Agia Marina et de son allure indéniablement grandiose, le bâtiment avait perdu sa fraîcheur d'antan. Aujourd'hui le propriétaire reste muet sur son travail de Sisyphe et sur la résurrection de la spectaculaire piscine bleue qui – tel un balcon sur la mer – s'élance vers un jardin à terrasse planté d'oliviers, de pins, de palmiers et d'une myriade de fleurs multicolores. Et il ne veut plus entendre parler de l'ancien état de ces terrasses qui lui offrent aujourd'hui un véritable «salon à ciel ouvert» équipé de canapés douillets et où l'on déguste avec bonheur un verre de champagne ou un repas à la fraîche sous un ciel étoilé.

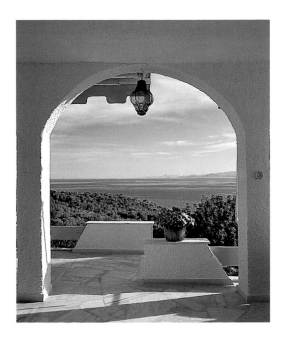

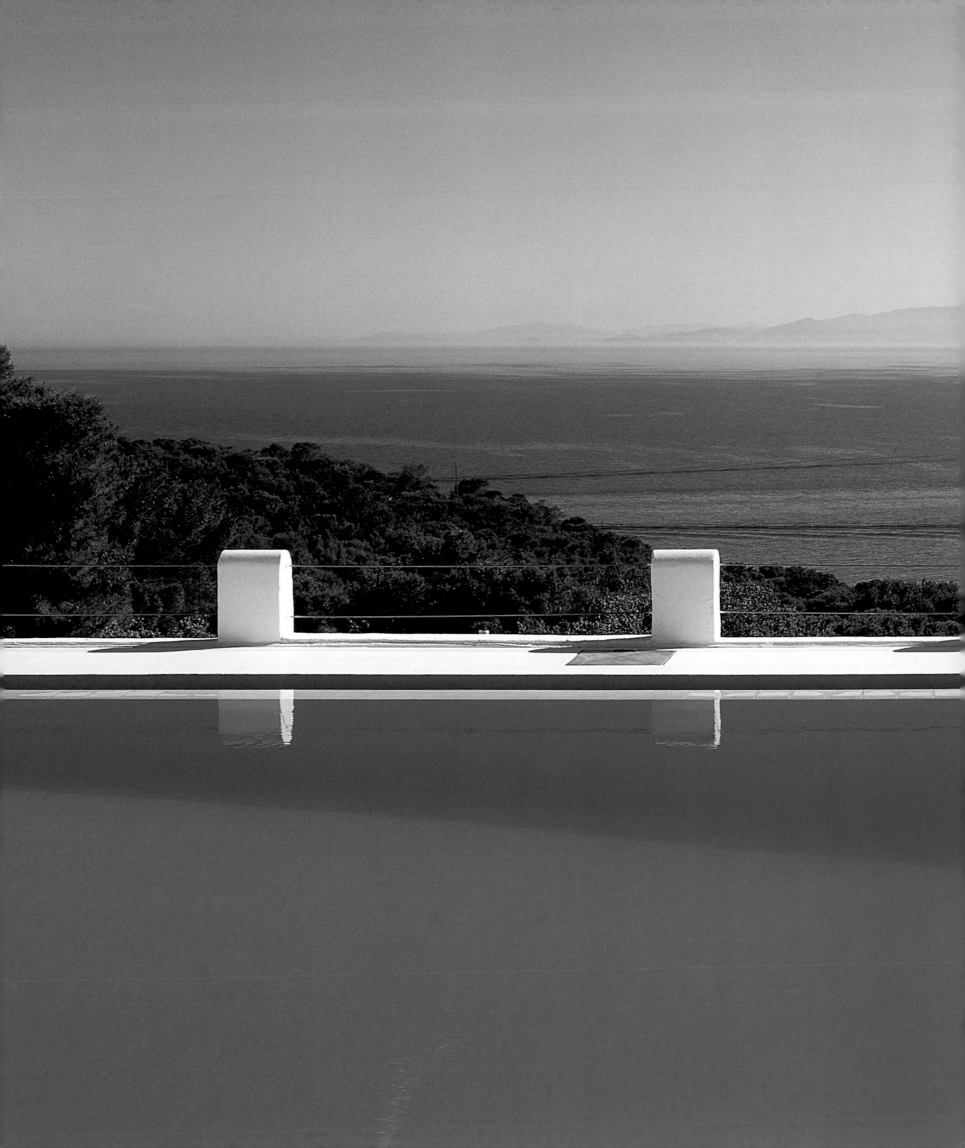

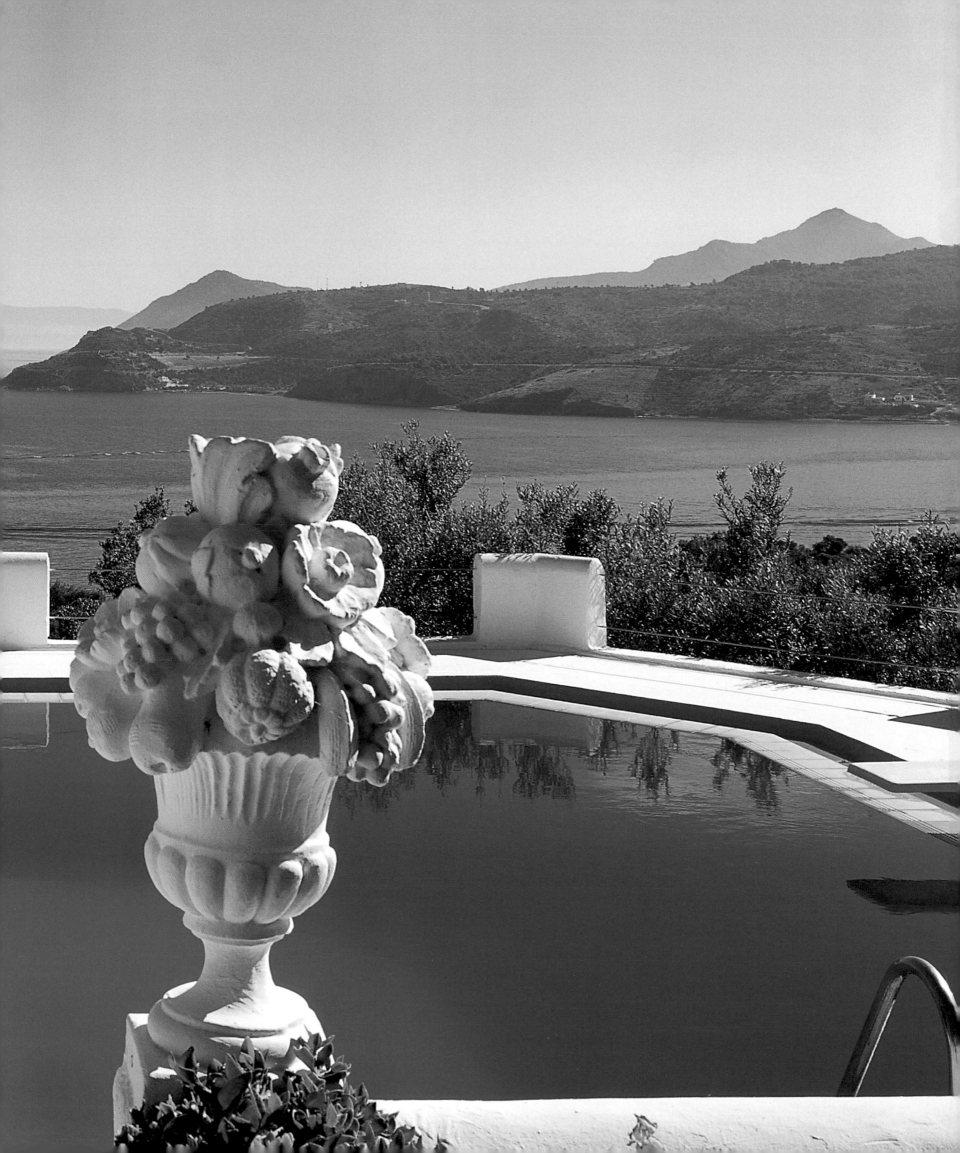

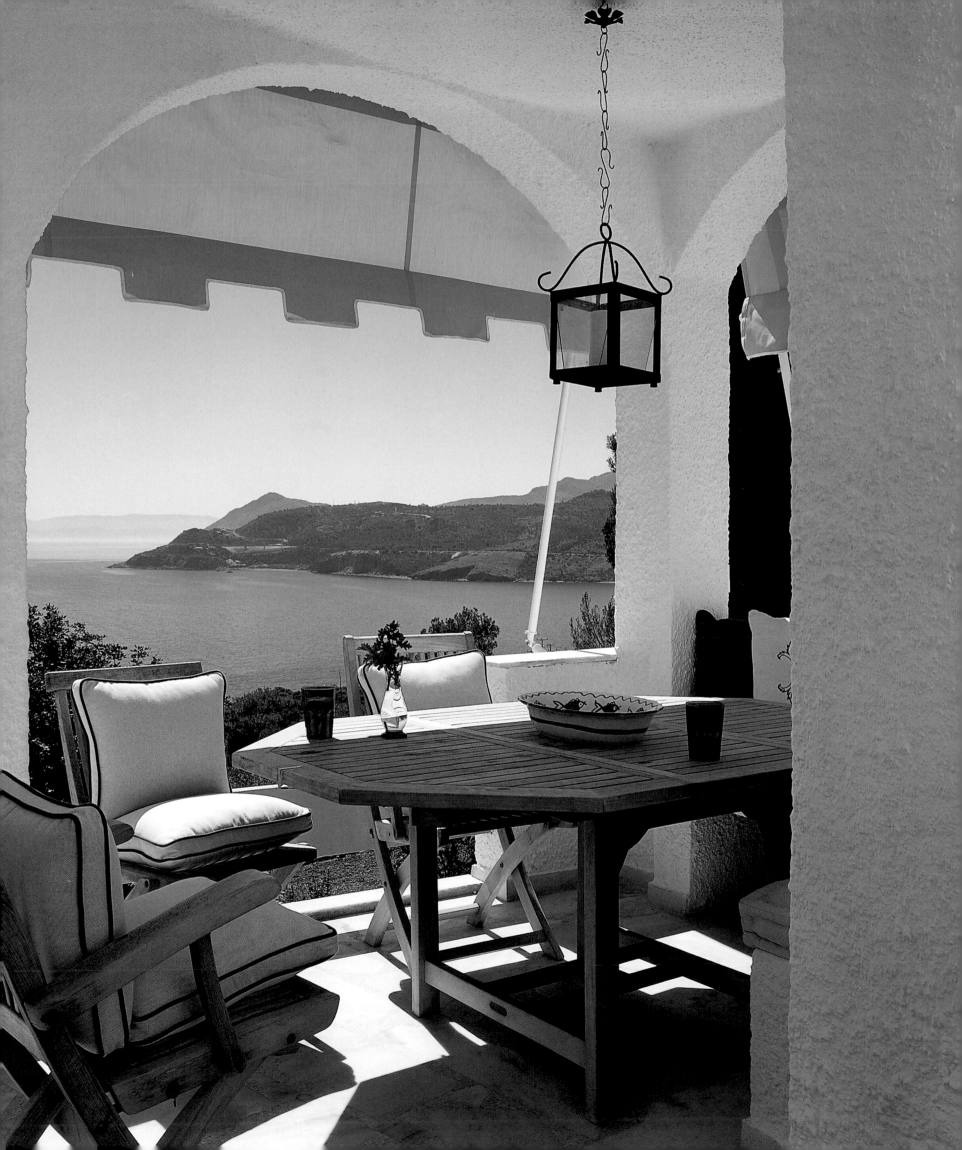

PREVIOUS PAGES:
*the glorious view of
Agia Marina bay from
the blue California-style
pool.*
FACING PAGE AND
ABOVE: *Jean-Claude
Chalmet's tranquil ter-
race, with its elegant
dining area and rattan
chairs and couch.*
RIGHT: *a blue and
white quilt on the wall
between the dining
room and the kitchen.*

VORHERGEHENDE
DOPPELSEITE: *Vom
kalifornischblau gestri-
chenen Schwimmbecken
hat man eine unver-
baubare Aussicht auf
die Bucht von Agia
Marina.*
LINKE SEITE UND
OBEN: *Die Terrasse
lädt zum Ausspannen
ein. Jean-Claude Chal-
met hat hier eine ele-
gante Essecke eingerich-
tet sowie Korbsessel und
-kanapees aufgestellt.*
RECHTS: *Ein blau-
weißer Quilt trennt
Essraum und Küche.*

DOUBLE PAGE
PRECEDENTE: *de la
piscine peinte en bleu
californien, une vue
imprenable sur la baie
d'Agia Marina.*
PAGE DE GAUCHE ET
CI-DESSUS: *La terras-
se invite à la détente.
Jean-Claude Chalmet y
a installé un coin-repas
élégant et des fauteuils
et des canapés en rotin.*
A DROITE: *Un quilt
bleu et blanc sépare la
salle à manger de la
cuisine.*

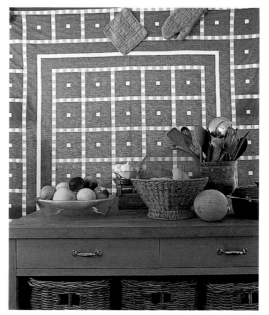

Cool drinks on the terrace, where Jean-Claude's guests often come to bask in the sunshine.

Auf dem erhöhten Teil der Terrasse serviert der Hausherr gern Erfrischungsgetränke; die Gäste können hier ein Sonnenbad genießen.

Le maître de maison aime servir des boissons rafraîchissantes sur le podium de la terrasse. Ici les invités peuvent profiter au maximum d'un soleil éclatant.

THE PINK HOUSE
Henri-Paul Coulon and Theodora Chorafas
Aegina

The photographer Henri-Paul Colon and the ceramist
Theodora Chorafas live in a ravishing house, hidden at the end
of a winding road. The vegetation all around them is like a vir-
gin forest, forming a natural barrier between their own poetic
world and an all-too-present reality. Henri-Paul, Theodora and
their daughter Nefeli have a deep affection for their "Pink
House", with its beautiful flower-canopied terrace, its vaguely
Provençal atmosphere, its French windows giving on to the
garden and the distant sea, and its geranium-filled, flame-
coloured terracotta urns. The house gives them the luxury of
two studios – ideal, because they each have their own branch
of creativity – and the possibility of a third interior perfectly
answering their shared need for sober surroundings. In one
of these stark rooms, curtained with *écru* cotton, the graphic
décor consists of a chair that might have been made by
Shakers, a basket, a tin weathercock and a white canapé. And
the bedroom, with its diaphanous mosquito net, reveals that
this home of artists undeniably has a soul of its own.

*The house owes its pretty
name to the colour of
the rendering on its out-
side walls.*

*Das Haus verdankt sei-
nen hübschen Namen
der Farbe des Mauer-
verputzes.*

*La maison doit son joli
nom de «Maison Rose»
au crépi de ses murs.*

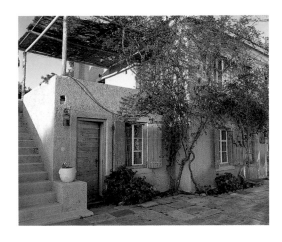

Der Fotograf Henri-Paul Coulon und die Keramikerin Theodora Chorafas wohnen in einem entzückenden Haus, das versteckt am Ende einer verschlungenen Gasse liegt. Die urwaldartigen Pflanzen bilden eine natürliche Schranke zwischen ihrer poetischen Welt und der allzu nahen Realität. Henri-Paul, Theodora und ihre Tochter Nefeli lieben die fast provenzalische Athmosphäre des »Rosa Hauses«: die Terrasse mit der Laube und den großen Terrakotta-Vasen, in denen feuerrote Geranien blühen, und die zum Garten gelegenen Fenstertüren, durch die das Meer in der Ferne zu sehen ist. Besonders schätzen sie auch den Luxus zweier Ateliers, die ihnen den idealen Raum für ihre schöpferischen Tätigkeiten bieten und gleichzeitig ermöglichen, den Wohnbereich so zu gestalten, dass er ihrem Bedürfnis nach klaren Verhältnissen vollkommen entspricht. In diesen sparsam eingerichteten Zimmern, in denen Vorhänge aus naturbelassener Baumwolle das blendende Licht dämpfen, bilden ein Stuhl im Shaker-Stil, ein Korb, eine Wetterfahne aus Blech und ein weißes Sofa eine verblüffend klare Komposition. Das Schlafzimmer mit dem duftenden Moskitonetz über dem Bett deutet an, welch unvergleichlicher Geist diese Künstlerwohnung beherrscht.

Le photographe Henri-Paul Coulon et la céramiste Theodora Chorafas habitent une maison ravissante, cachée au bout d'un chemin sinueux dont la végétation évoque celle de la forêt vierge et qui forme une barrière naturelle entre un monde poétique et la réalité beaucoup trop proche. Henri-Paul, Theodora et leur fille Nefeli adorent la «Maison Rose» avec sa belle terrasse à la tonnelle fleurie, ses faux airs de maison provençale, ses portes-fenêtres donnant sur le jardin et sur la mer au loin et ses grandes jarres en terre cuite où fleurissent des géraniums couleur de feu. Ils l'apprécient également parce qu'elle leur offre le luxe de deux ateliers – le refuge idéal pour leur créativité individuelle – et la possibilité de créer un intérieur répondant parfaitement à leur besoin de sobriété. Dans ces pièces dépouillées où des rideaux en coton écru s'efforcent de tamiser la lumière aveuglante, une chaise aux allures «Shaker», un panier, une girouette en tôle et un canapé blanc forment une composition d'un graphisme surprenant. Et dans la chambre à coucher, un lit voilé d'une moustiquaire révèle que cette demeure d'artistes possède une âme incomparable.

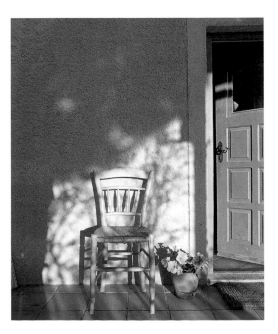

The pink of the façade, the olive green of the door and the pale green of the chair go well with the bouquet of flowers.

Das Rosa der Fassade, das Olivgrün der Tür und das Blassgrün des Stuhls harmonieren mit den Farben des Blumenstraußes.

Le rose de la façade, le vert olive de la porte et le vert pâle de la chaise riment avec le bouquet.

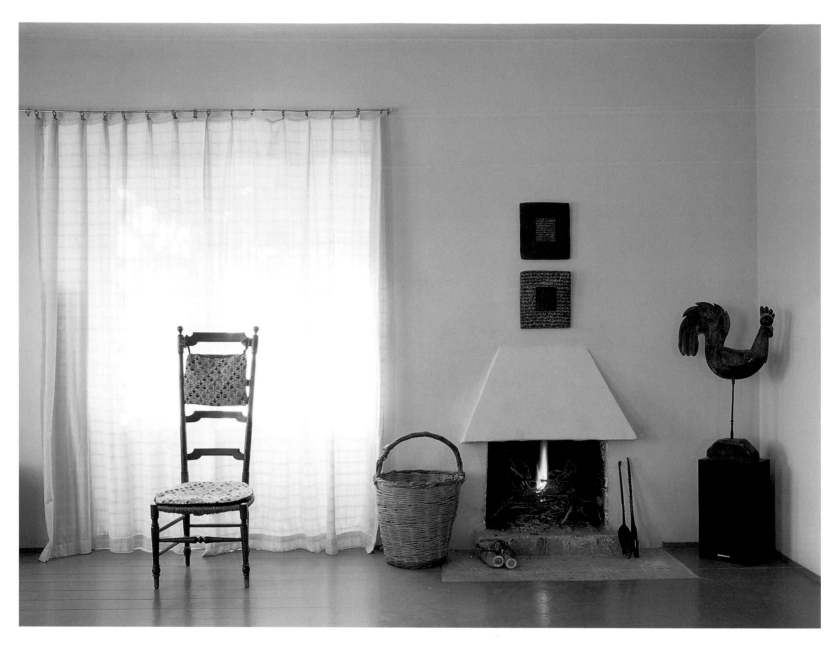

ABOVE AND FACING PAGE: *The warm tones of the walls offset the furniture and objects, whose stark outlines are reminiscent of Shaker furniture. Above the fireplace, the two ceramic plaques were made by Theodora.*
RIGHT: *the kitchen stove, much-used.*

OBEN UND RECHTE SEITE: *Der warme Ton der Wände bringt die Möbel und sonstigen Einrichtungsgegenstände zur Geltung, deren klares Design an die Shaker-Möbel denken lässt. Die beiden Keramikplatten über dem Kamin hat Theodora gestaltet.*
RECHTS: *der viel genutzte Küchenofen.*

CI-DESSUS ET PAGE DE DROITE: *Le ton chaud des murs met en valeur les meubles et les objets dont le sobre dessin fait penser au mouvement Shaker. Au-dessus de la cheminée, les deux plaquettes en céramique sont l'œuvre de Theodora.*
A DROITE: *La maîtresse de maison prépare ici des petits plats pour sa famille et ses amis.*

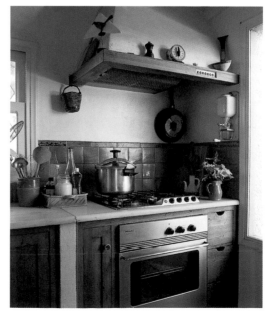

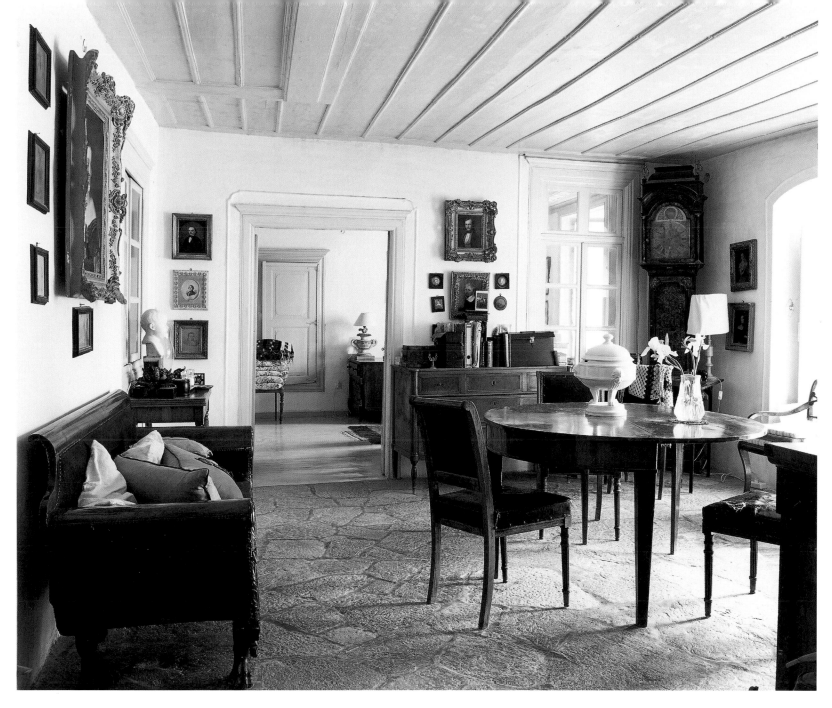

FACING PAGE: *a niche crowded with vases and old terracotta urns.*

ABOVE AND RIGHT: *The small salon on the ground floor contains treasures brought home from the Hennessys' travels. On the 18th century table stands an earthenware terrine from Naples.*

LINKE SEITE: *eine mit alten Vasen und Krügen aus Terrakotta gefüllte Nische.*

OBEN UND RECHTS: *Der kleine Salon im Erdgeschoss beherbergt Schätze aus aller Welt. Auf dem Tisch aus dem 18. Jahrhundert steht eine Fayence-Terrine aus der neapolitanischen Manufaktur.*

PAGE DE GAUCHE: *Une niche abrite des vases et des jarres anciennes en terre cuite.*

CI-DESSUS ET A DROITE: *Le petit salon du rez-de-chaussée regorge des trésors rapportés des quatre coins du monde. Sur la table 18ᵉ, la place d'honneur revient à une terrine en faïence de la manufacture de Naples.*

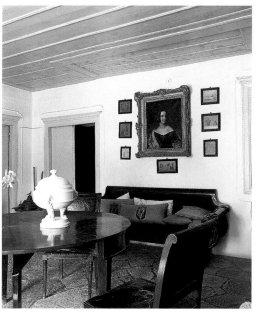

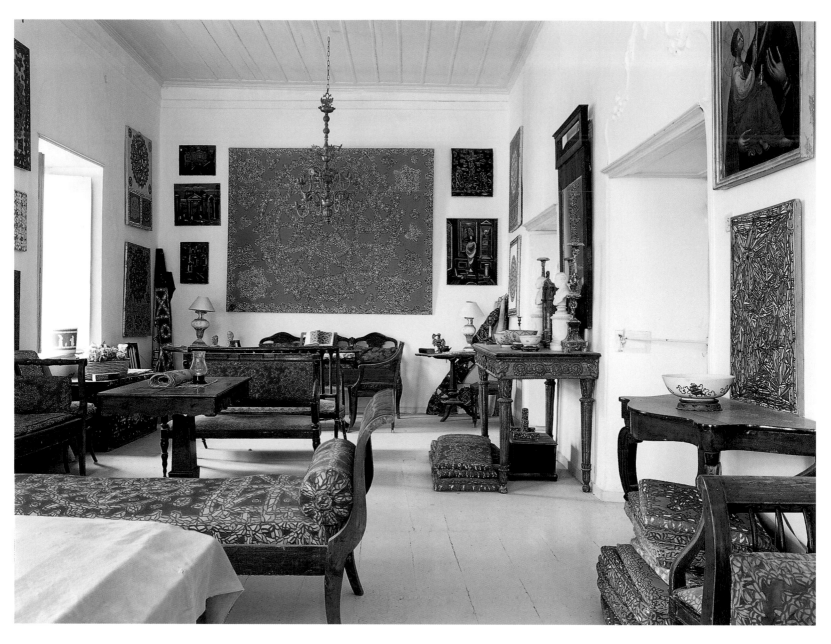

On the walls of the small salon, paintings by Timothy Hennessy and works of art by his friends and colleagues. The furniture is upholstered with fabrics painted by Hennessy himself.

An den Wänden des großen Salons im Obergeschoss hängen Bilder des Hausherrn und Kunstwerke seiner Kollegen und Freunde. Die Möbel sind mit einem von Hennessy eigenhändig bemalten Stoff bezogen.

Sur les murs du grand salon au premier étage, des tableaux du maître de maison et des œuvres d'art de ses collègues et amis. Hennessy n'hésite pas à habiller les meubles d'un tissu peint de sa main.

An icon hanging above the sofa, with a red background that marries perfectly with the painted décor of the cushions.

Über das Kanapee hat Hennessy eine Ikone gehängt, deren roter Hintergrund gut zu den mit Ornamenten bemalten Kissen passt.

Au-dessus d'un canapé, Hennessy a accroché une icône dont le fond rouge se marie à la perfection au décor peint des coussins.

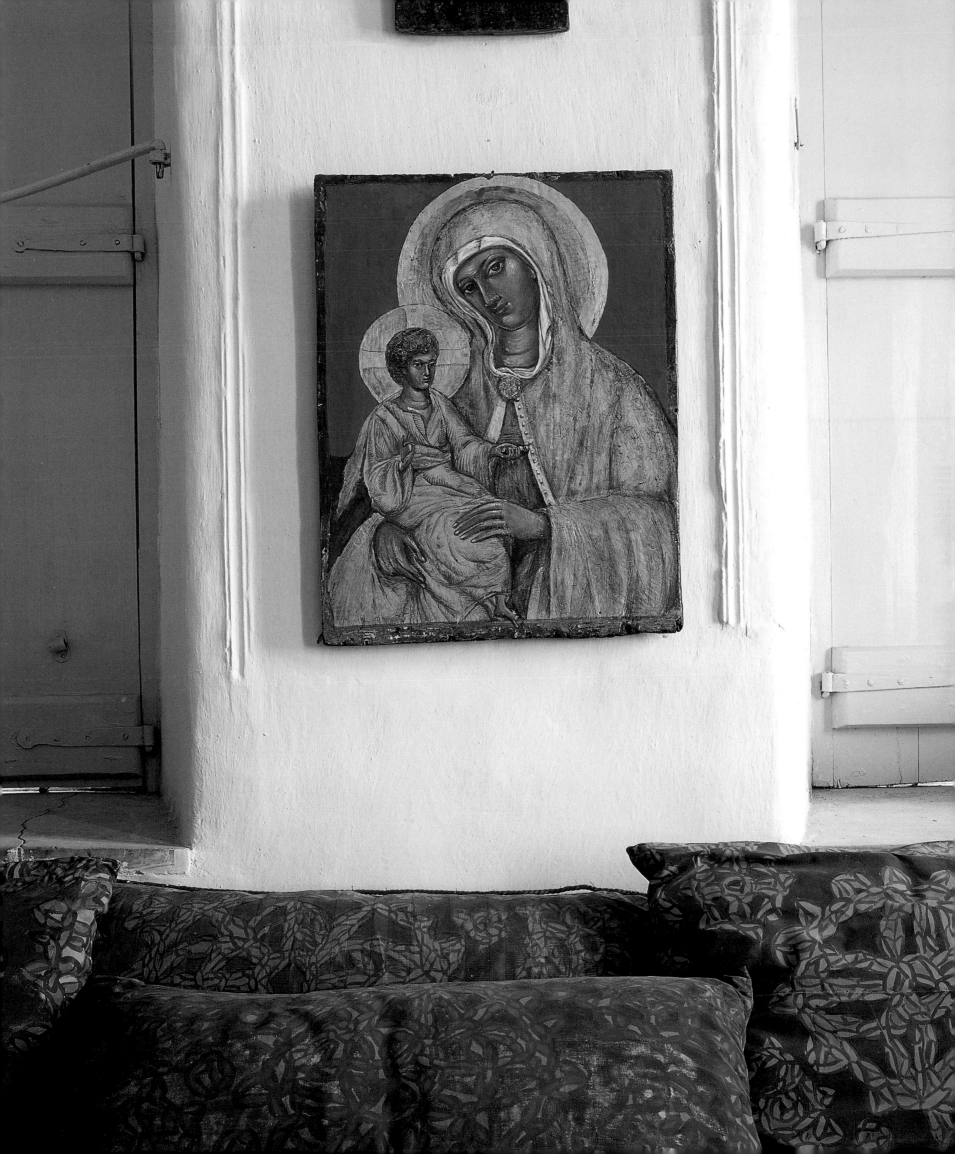

THE PAOURIS PALACE

Maria Matzini

Hydra

Even if you know nothing of its splendid past, the fine white façade and graceful loggia of the Paouris Palace overlooking the port of Hydra is not a sight you will easily forget. Built after the 1821 revolution by Lazaros Kondouriotis for his sister, the palace was purchased on the eve of the Second World War by Katherina Paouris, a woman of legendary brilliance and beauty, who went on to restore it to its former glory. With its antique treasures, opalines, Venetian mirrors, china, paintings and icons, the house that Mrs Paouris decorated in such luxurious good taste reflects an era that is already long gone. Nevertheless, her innate romanticism didn't prevent this remarkable woman – who liked acid tones just as well as she liked Baroque and contemporary art – from being the intimate friend of some of the greatest artists of her time. She once told her daughter Maria: "You and this house are the two great loves of my life"; and today her presence is as strong as ever in the house that is her greatest memorial.

Blue painted shutters in the dining room.

Die Innenläden im Esszimmer wurden blau angestrichen.

Dans la salle à manger, les volets intérieurs ont été peints en bleu.

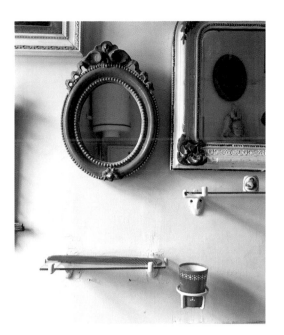

Selbst wenn Sie nichts von seiner glanzvollen Vergangenheit wissen, werden Sie den majestätischen Paouris-Palast, der den Hafen von Hydra dominiert, schon allein wegen seiner schönen weißen Fassade mit der großen Loggia nicht so schnell vergessen. Lazaros Kondouriotis hat den Palast nach der Revolution von 1821 für seine Schwester erbauen lassen. Kurz vor dem Zweiten Weltkrieg erwarb ihn die legendär schöne und kluge Katherina Paouris und verhalf dem imposanten Bau-Ensemble wieder zu seiner früheren Pracht und Herrlichkeit. Mit unverkennbar luxuriösem Geschmack eingerichtet, spiegelt das Gebäude mit den Antiquitäten, venezianischen Spiegeln, Opalinen, Porzellanen, Gemälden und Ikonen eine Epoche wider, deren romantische Anmutung schon lange der Vergangenheit angehört. Diese großartige Frau, die sehr kräftige Farbtöne ebenso liebte wie den Barock und die zeitgenössische Kunst, war eng mit den größten Künstlern ihrer Zeit befreundet. Zu ihrer Tochter Maria sagte sie: »Du und mein Haus, ihr seid die beiden großen Lieben meines Lebens!« Heute ist sie lebendiger denn je und der Paouris-Palast hält ihr Gedenken in Ehren.

Il domine le port de Hydra et, même si on ignore son passé prestigieux, le majestueux Palais Paouris reste gravé dans la mémoire de tous ceux qui ont contemplé sa belle façade blanche ornée d'une grande loggia. Edifié après la révolution de 1821 par Lazaros Kondouriotis pour sa sœur, le palais fut acheté à la veille de la Seconde Guerre mondiale par Katherina Paouris, une femme d'une beauté et d'une intelligence légendaires, qui sut restituer à cet ensemble architectural imposant, sa gloire et sa beauté d'antan. Avec ses antiquités, ses miroirs vénitiens, ses opalines, ses porcelaines, ses tableaux et ses icônes, la demeure que Madame Paouris sut meubler avec un goût évident pour le faste, reflète une époque qui nous semble déjà lointaine. Une époque teintée de romantisme, ce qui n'empêcha pas cette femme formidable, qui aimait autant les tons acidulés que le baroque et l'art contemporain, d'être l'amie intime des plus grands artistes. Celle qui disait à sa fille Maria: «J'ai vécu deux grandes histoires d'amour dans ma vie: ma maison et toi!» demeure plus vivante que jamais, et le palais Paouris continue d'honorer sa mémoire.

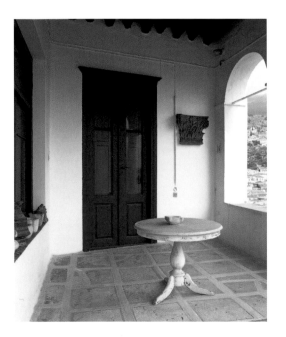

The dining room is classically decorated with early 19th century furniture. The period English china offsets the oval table and the pure white walls.

Das Esszimmer ist mit klassischem Mobiliar vom Beginn des 19. Jahrhunderts ausgestattet. Ein englisches Fayence-Tafelservice aus derselben Epoche schmückt den ovalen Tisch und betont die makellos weißen Wände.

La salle à manger accueille un mobilier classique du début du 19e siècle. Un service en faïence anglais de la même époque fait ressortir la table ovale et les murs d'un blanc immaculé.

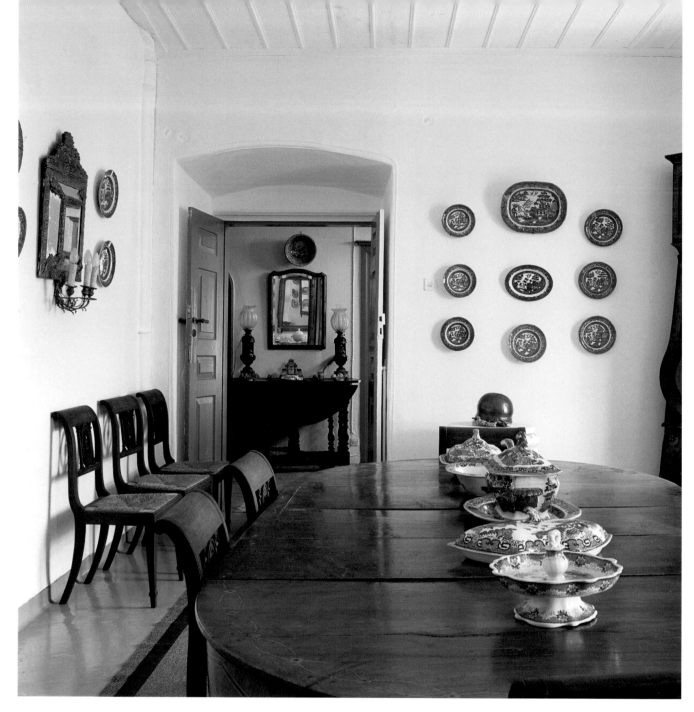

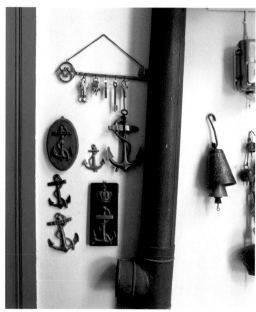

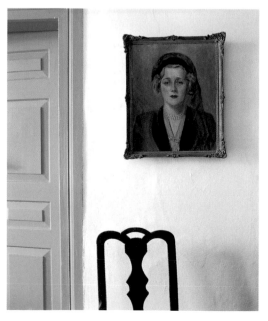

LEFT: *The corridor contains a large number of decorative objects: anchors of various types, sheep bells and cow bells. The portrait of Katherina Paouris dates from the 1930s.*
FACING PAGE: *Icons hanging on the pale blue wall of one of the bedrooms.*

LINKS: *Im Flur hängt eine Reihe dekorativer Objekte: Anker aller Art, Schlüssel und Glöckchen. Das Portait von Katherina Paouris stammt aus den 1930er Jahren.*

RECHTE SEITE: *Von der hellblauen Wand eines Schlafzimmers heben sich Ikonen ab.*

A GAUCHE: *Le couloir contient un grand nombre d'objets décoratifs: des ancres de toutes sortes, des clés, des clochettes et des grelots. Le portrait de Madame Katherina Paouris date des années 1930.*

PAGE DE DROITE: *Des icônes se détachent sur le mur bleu pâle d'une chambre à coucher.*

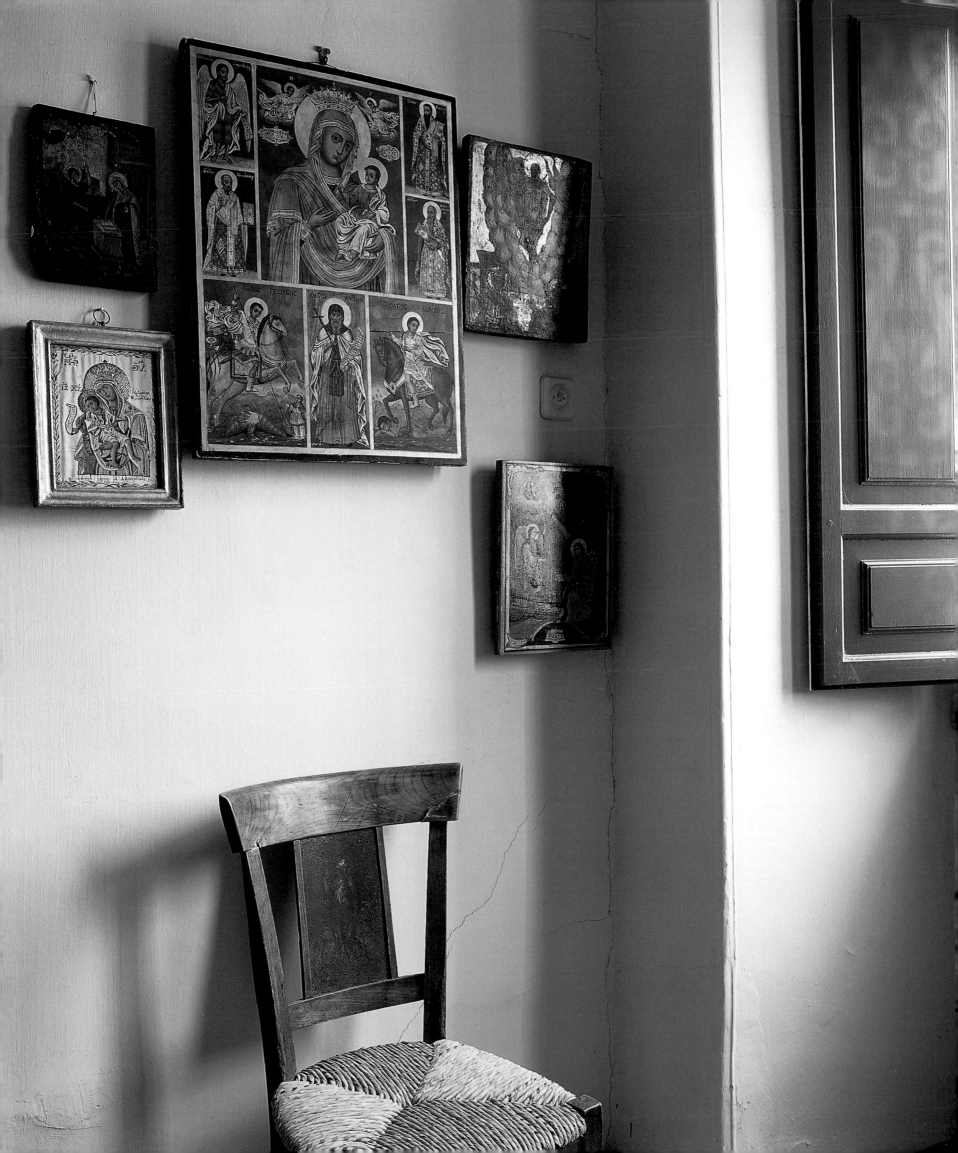

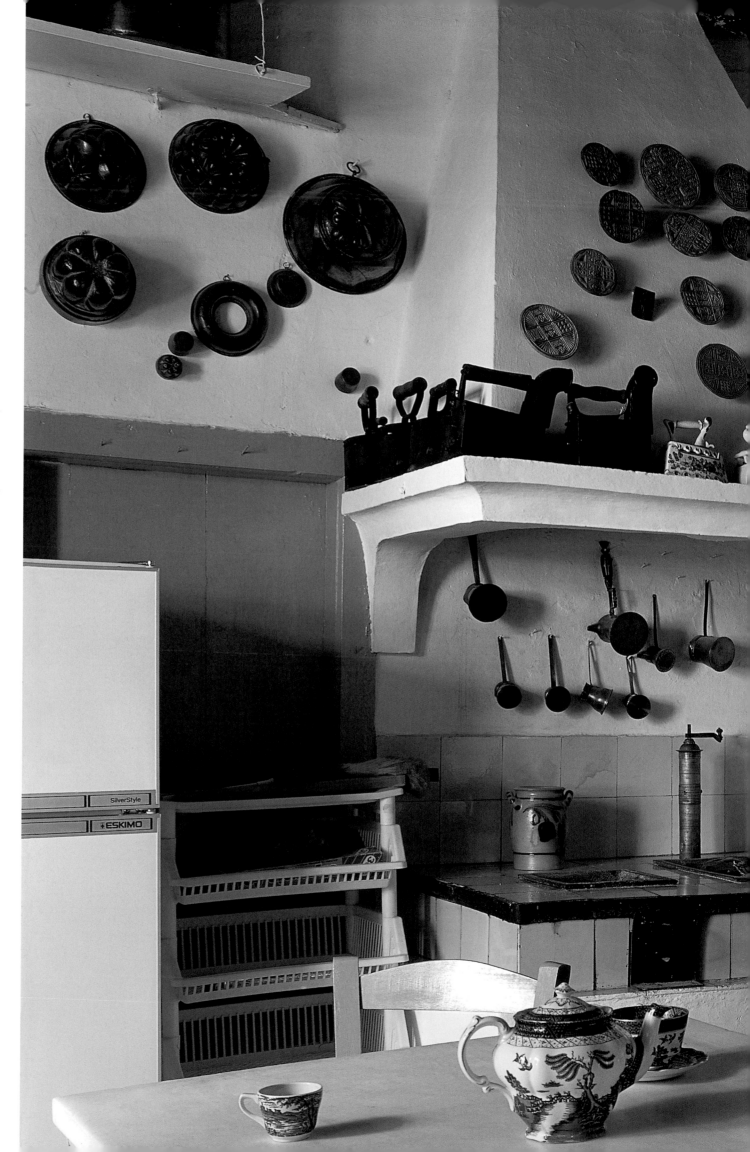

The spacious kitchen, with its collection of saucepans, cake tins and copper coffee pots. The English stove dates from the early 20th century.

Die geräumige Küche mit ihrer Sammlung von Kasserollen, Kuchenformen und kupfernen Kaffeekannen sowie einem englischen Herd vom Anfang des 20. Jahrhunderts.

La cuisine spacieuse avec sa collection de casseroles, de moules à gâteau et de cafetières en cuivre et son ancienne cuisinière anglaise qui date du début du 20e siècle.

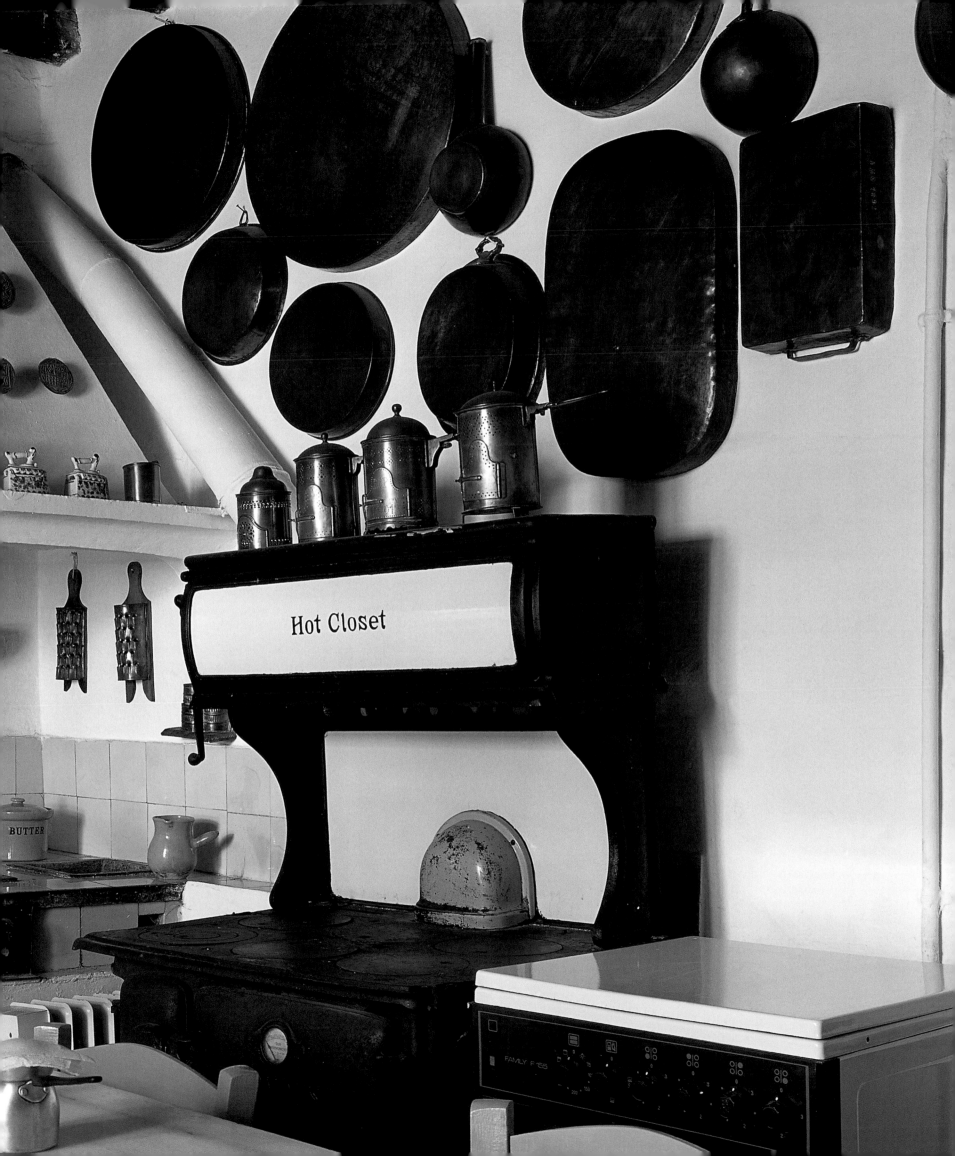

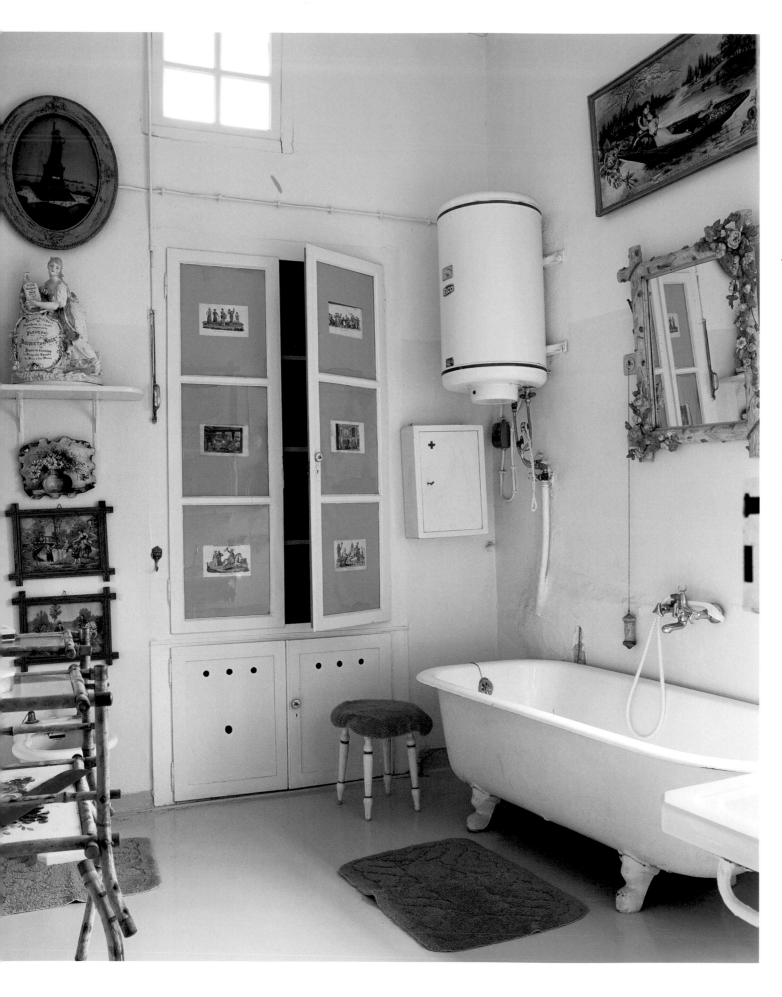

LEFT: *The bathroom, daringly decorated like an intimate salon by Katherina Paouris.*
FACING PAGE: *A collection of elaborately framed mirrors surrounds the washbasin.*

LINKS: *Die verstorbene Hausherrin dekorierte das Badezimmer so, als handele es sich um einen intimen kleinen Salon.*
RECHTE SEITE: *Über dem Waschbecken hängen verschnörkelte Spiegel.*

A GAUCHE: *Dans la salle de bains, feu la maîtresse de maison a eu l'audace de décorer la pièce comme s'il s'agissait d'un petit salon intime.*
PAGE DE DROITE: *Une collection de miroirs tarabiscotés entoure le lavabo.*

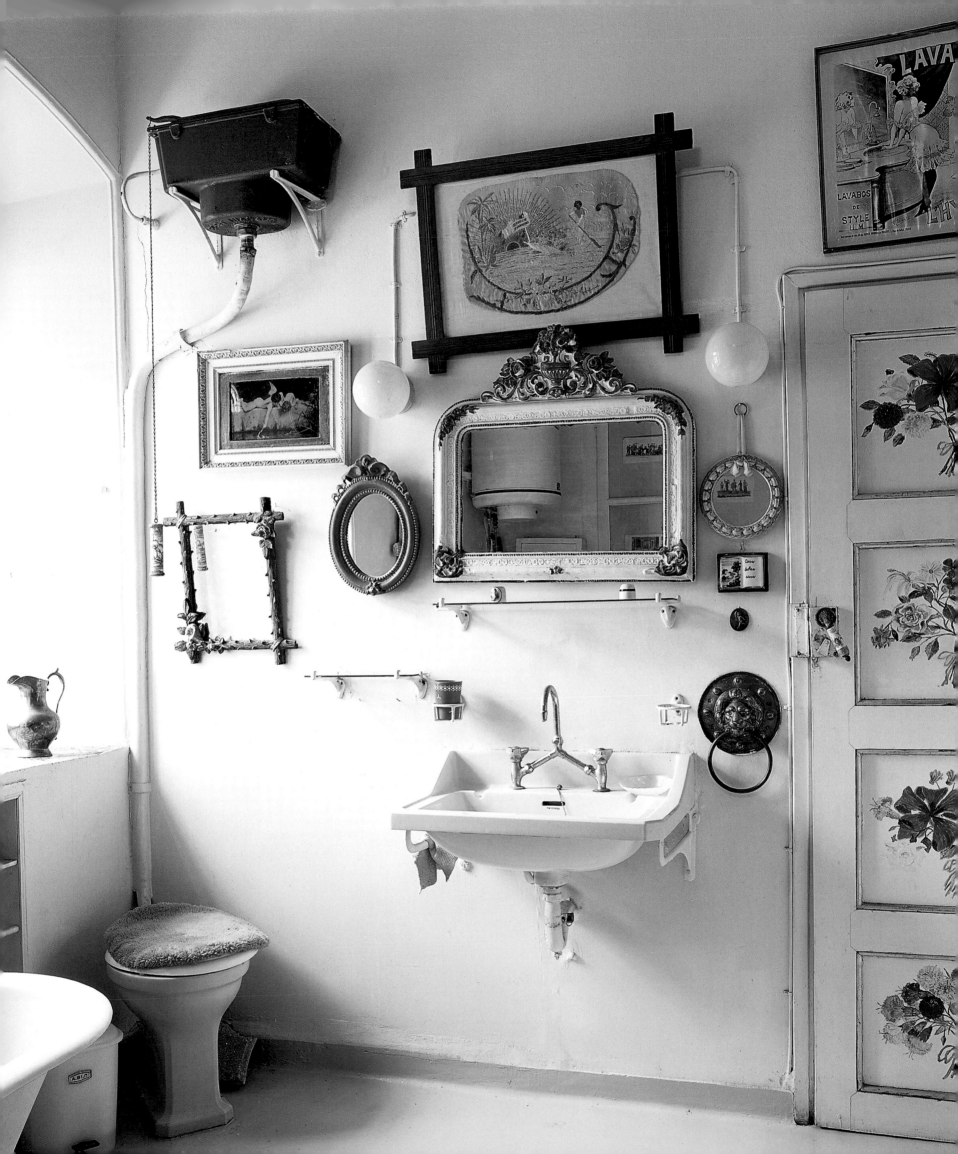

MAXIE LEOUSSIS

Hydra

She bought this little house on the port of Hydra on impulse, because the family of her husband Yannis was one of the leading clans of Hydra and because she herself had wonderful memories of holidays spent on the island. Maxie Leoussis is an extraordinary woman who never stops travelling and visiting her friends in every corner of the world. But even the most dedicated nomad needs a place to hang her hat, where she can escape the watching eyes and incessant demands of daily life. Hidden behind a wall in a small street by the port, her house is squeezed into the back of an ochre-painted courtyard with a fountain, a pergola and a terracotta sphinx jardiniere. There's a kitchen-living room, a small private salon, a large bedroom, two bathrooms and a spacious guest bedroom – all of which are furnished in the taste of a real artist, with that indescribable Bohemian touch that elevates ordinary objects like a fish-shaped cushion, a vase with a human face, a portmanteau painted cobalt blue or a fragment of carved wood, to the rank of genuine art objects.

The tap, with its snail-shaped handle.

Der Wasserhahn läuft in einem schneckenförmigen Handgriff aus.

Le robinet est couronné d'une poignée en forme d'escargot.

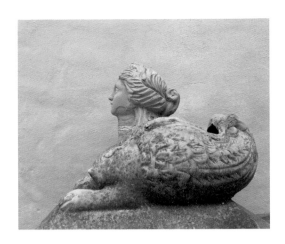

Als sie das kleine Haus im Hafen von Hydra kaufte, folgte sie einem Herzenswunsch, denn die Angehörigen ihres Mannes Yannis gehörten zu den einflussreichen Familien von Hydra und sie selbst hatte unvergessliche Erinnerungen an die Ferien auf dieser bezaubernden Insel. Maxie Leoussis ist eine außergewöhnliche Frau, die unaufhörlich in der Welt herumreist und ihre Freunde besucht. Aber auch die leidenschaftlichste Weltenbummlerin braucht ein Refugium, um sich vom Alltag zu erholen. In einer Hafengasse, am hinteren Ende eines kleinen ockerfarbenen Hofes mit einem Springbrunnen, einer Pergola und einem sphinxförmigen Terrakotta-Blumentopf, verbirgt sich ihr Haus hinter einer Mauer. Es umfasst eine Wohnküche, einen intimen kleinen Salon, ein geräumiges Schlafzimmer, zwei Badezimmer und ein großes Gästezimmer. Der Geschmack, mit dem die Räume eingerichtet sind, verrät die Künstlerin und Nomadin und hat diesen unverkennbaren Hauch von »haute bohème«, der so bescheidene Gegenstände wie ein fischförmiges Kissen, eine Vase mit menschlichem Antlitz, eine schlichte, kobaltblau gestrichene Garderobe oder ein Stück geschnitztes Holz in den Rang eines Kunstwerks erhebt.

Elle acheta la petite maison dans le port d'Hydra sur un coup de cœur, parce que la famille de son mari, Yannis, était – jadis – une des familles importantes d'Hydra et qu'elle-même avait des souvenirs inoubliables de vacances passées sur cette île enchanteresse. Maxie Leoussis est une femme extraordinaire qui ne cesse de voyager et de rendre visite à ses amis aux quatre coins du monde. Mais même le voyageur le plus assidu a besoin d'un refuge où il peut se dérober un moment aux regards et aux exigences de la vie quotidienne. Dissimulée derrière un mur dans une petite ruelle du port, blottie au fond d'une courette couleur ocre agrémentée d'une fontaine, d'une pergola et d'une jardinière-sphynx en terre cuite, la maison de Maxie abrite un séjour-cuisine, un petit salon intime, une grande chambre à coucher, deux salles de bains et une grande chambre d'amis. Le tout meublé avec un goût qui trahit l'artiste et la nomade et manifeste indéniablement ce côté «haute bohème» qui élève des objets modestes, comme un coussin en forme de poisson, un vase à visage humain, un simple portemanteau peint en bleu cobalt et un fragment en bois sculpté, au rang d'objet d'art.

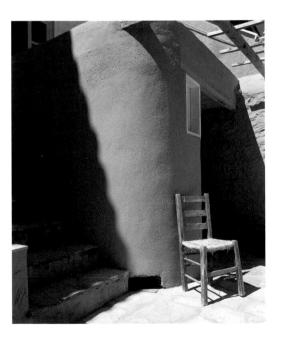

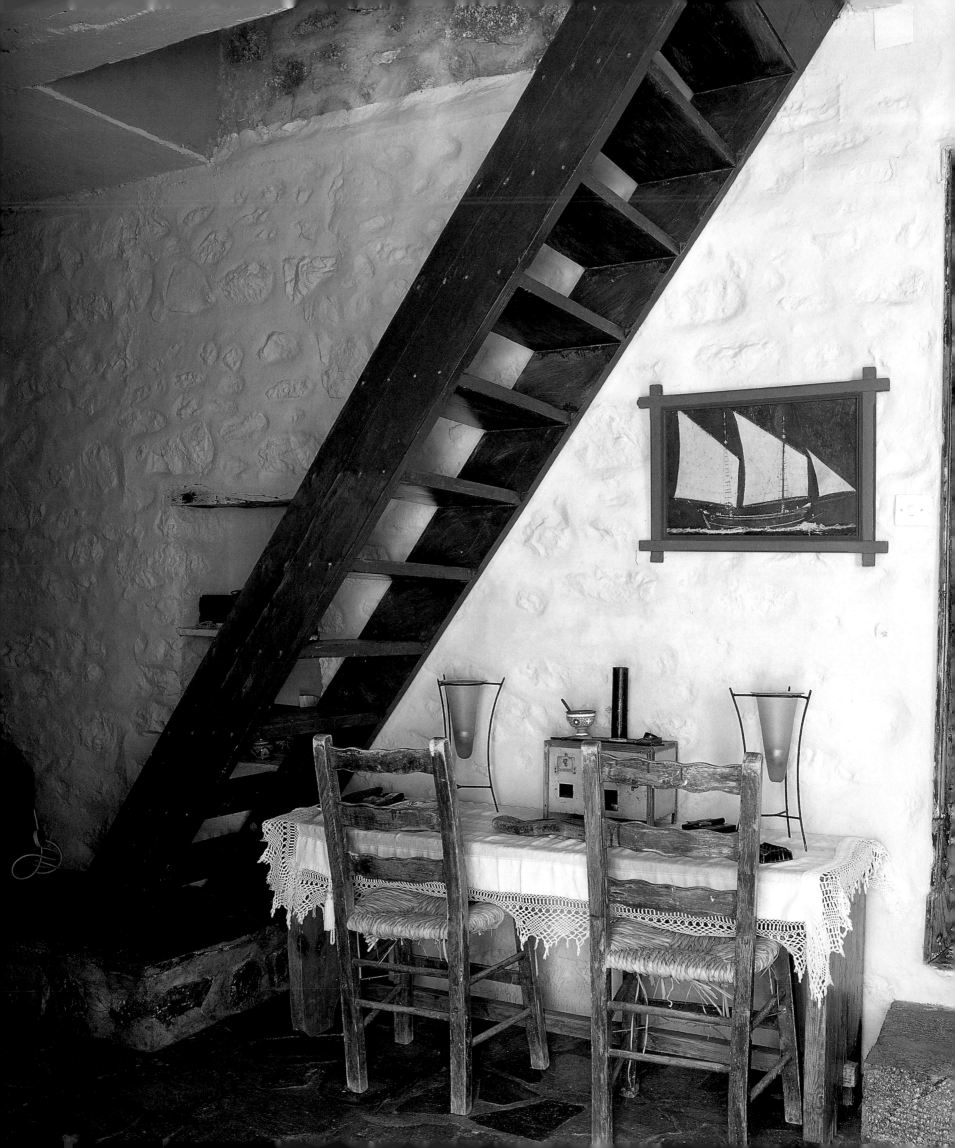

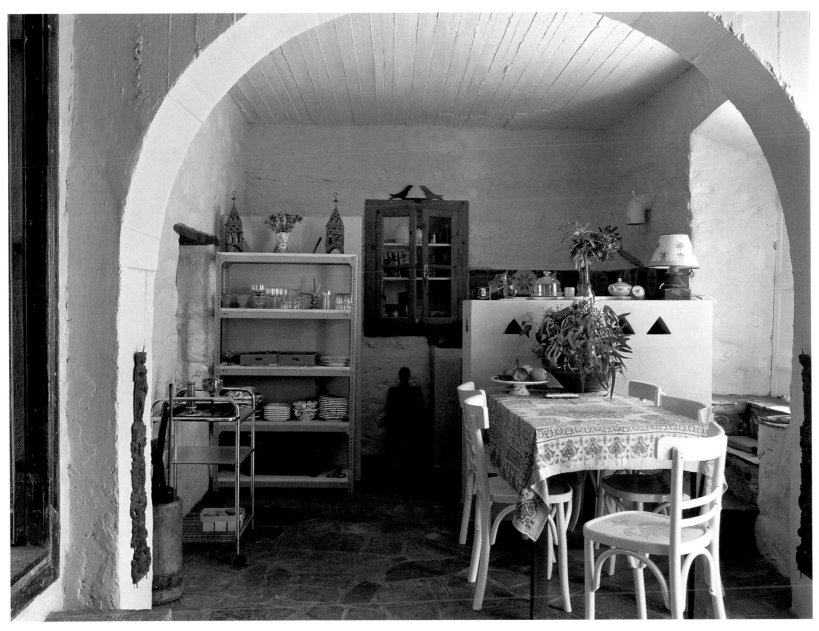

FACING PAGE: *the staircase leading from the kitchen to the first floor bedroom. The rustic furniture here is typical of the island.*
ABOVE: *the kitchen, to the right of the main room. Maxie has furnished it with a country table, white-painted Thonet chairs and unpretentious cupboards and shelves that mask the cooker and sink.*
RIGHT: *Cool, cosy and spacious, the guest bedroom is painted in a light shade of apricot.*

LINKE SEITE: *Von der Küche aus führt eine Treppe ins Obergeschoss, wo sich das Schlafzimmer der Hausherrin befindet. Das rustikale Mobiliar ist auf der Insel hergestellt worden.*
OBEN: *Im rechten Teil des Wohnraums ist die Küche untergebracht. Maxie hat sie mit einem ländlichen Tisch und weiß lackierten Thonet-Stühlen möbliert. Hinter den Schränken und Regalen verbergen sich Herd und Spüle.*
RECHTS: *das geräumige und freundliche Gästezimmer mit apricotfarbenen Wänden.*

PAGE DE GAUCHE: *Dans la cuisine, un escalier grimpe vers le premier étage où se trouve la chambre à coucher de la maîtresse de maison. Le mobilier rustique est originaire de l'île.*
CI-DESSUS: *La partie droite du séjour abrite la cuisine. Maxie l'a meublée avec une table campagnarde, des chaises Thonet et avec des armoires et des rangements sans prétention qui cachent la cuisinière et l'évier.*
A DROITE: *la chambre d'amis aux murs couleur abricot.*

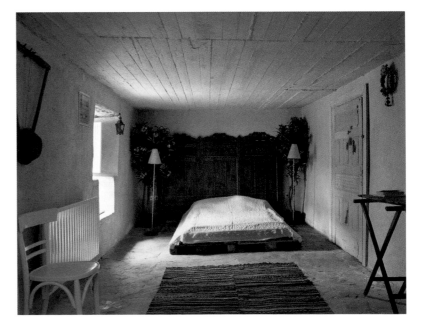

THE HOUSE OF THE SHOOTING STAR

George Petrides

Hydra

The Athenian decorator George Petrides has called his house on Hydra by the symbolic and mysterious name of "The House of the Shooting Star". He only likes places with authentic character, and his own is tangible proof of it. As a decorator, Petrides knows how to gauge the visual effect of a powerful architectural ensemble. And he is aware of the impact of a white villa on top of a hill, the charm of a view across the intense blue of the Mediterranean and the aesthetic charge contained in the sight of broad salons flooded with light, white marble floors and a neoclassical chimneypiece loaded with magnificent antique objects. One day he decided to stop dreaming and actually build his "Star" as close to the sky as possible, and when it was ready he decorated it with period furniture, contemporary artworks and beautiful objects. Those who know the style of this witty bon vivant and artist are full of praise for his taste. And this dreamlike refuge, wherein he has surrounded himself with soft sofas, works of art, four-poster beds, comfortable yet elegant chairs and a magnificent garden, proves that they are quite right.

The walls of the bedroom are decorated with a white ceramic bas-relief made by Niki Kanaginis.

Die Schlafzimmerwände schmückt ein weißes Keramik-Relief von Niki Kanaginis.

Les murs de la chambre à coucher sont ornés d'un bas-relief en céramique blanc signé Niki Kanaginis.

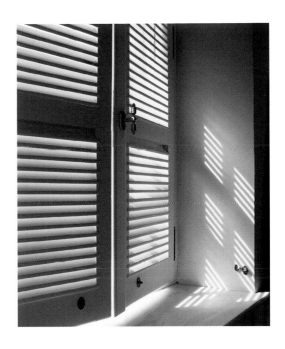

Der Athener Dekorateur George Petrides gab seinem Wohnsitz auf Hydra den schillernden und sinnbildlichen Namen »The House of the Shooting Star«. Ihm gefallen ausschließlich Häuser mit einem authentischen Charakter und das seinige ist dafür der sichtbare Beweis. Als Inneneinrichter kann Petrides die visuelle Wirkung von ausdrucksstarker Innenarchitektur beurteilen. Auch weiß er um die imposante Anmutung einer weißen Villa auf einer Hügelkuppe, um den Charme eines Ausblicks auf das kräftigblaue Mittelmeer und um die Ästhetik weiter, lichtdurchfluteter Räume, weißer Marmorböden und eines klassizistischen Kamins, auf dem wundervolle antike Objekte stehen. Warum also weiterträumen, statt in größtmöglicher Nähe zum Himmel seinen »Stern« zu erbauen und ihn mit historischen Möbeln, zeitgenössischer Kunst und hochwertigen Objekten auszustatten? Jene, die den Stil dieses lebenslustigen Künstlers kennen, loben seinen vollendeten Geschmack. Und dieses traumhafte Refugium, in dem er sich mit gemütlichen Sofas, Kunstwerken, Himmelbetten, ebenso schönen wie komfortablen Sesseln und einem prächtigen Garten umgibt, beweist, dass sie Recht haben.

Il a appelé sa demeure à Hydra «The House of the Shooting Star», un nom intrigant et symbolique. Mais le décorateur athénien George Petrides n'apprécie que les maisons qui ont du caractère, et la sienne en est la preuve tangible. En tant que décorateur, Petrides sait juger l'effet visuel d'un ensemble architectural puissant. Et il connaît l'impact d'une villa blanche au sommet d'une colline, le charme d'une vue sur la Méditerranée au bleu intense et «le coup de poing» esthétique que génère la confrontation avec de vastes salons inondés de lumière, des sols en marbre blanc et une cheminée néoclassique où reposent des objets magnifiques datant de l'Antiquité. Alors pourquoi ne pas cesser de rêver, construire son «étoile» aussi près que possible du ciel et la décorer de meubles d'époque, d'art contemporain et d'objets de qualité. Ceux qui connaissent bien le style de cet artiste bon vivant et spirituel, font l'éloge de son goût parfait. Et ce refuge de rêve où il s'entoure de canapés moelleux, d'œuvres d'art, de lits à baldaquin, de sièges aussi beaux que confortables et d'un jardin somptueux, prouve qu'ils ont raison.

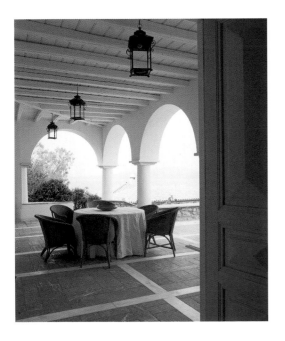

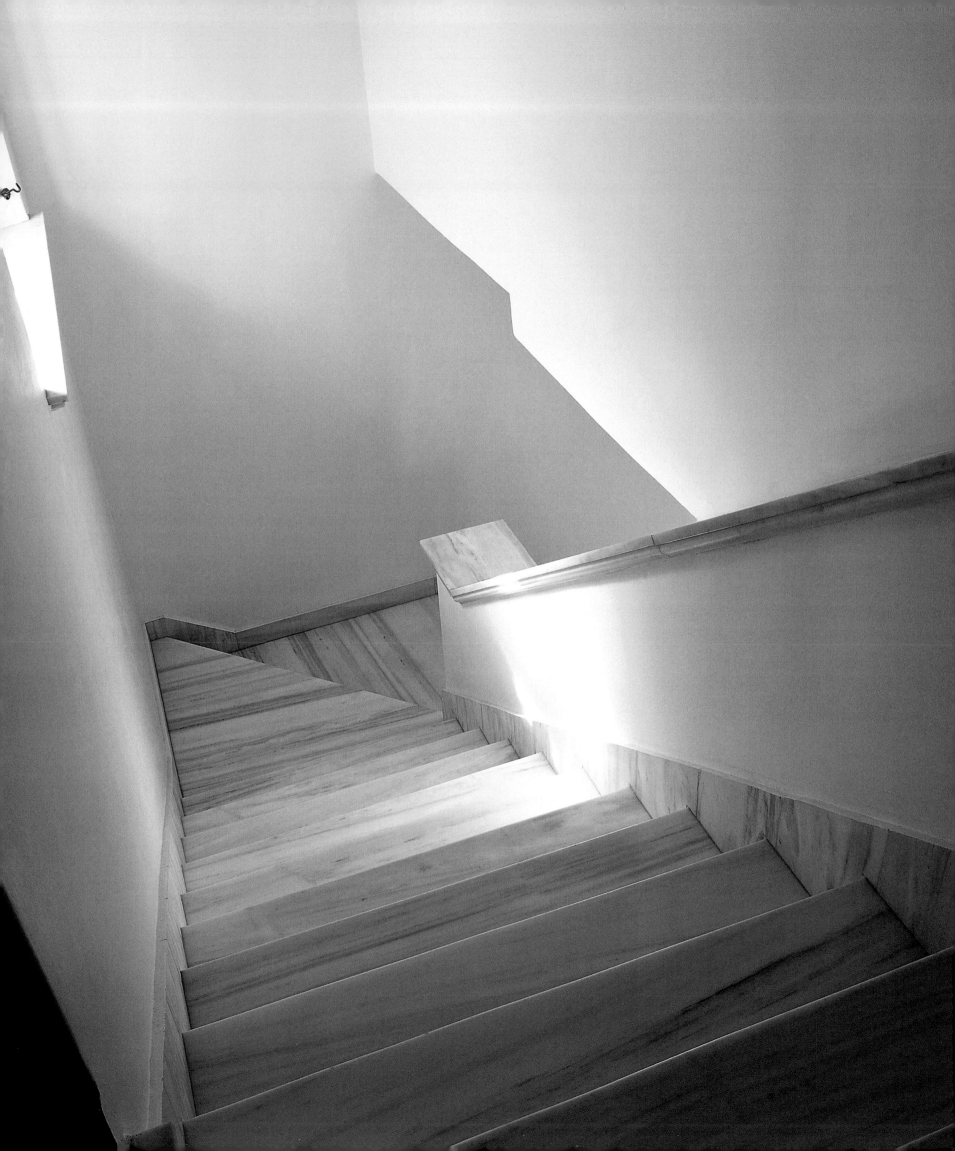

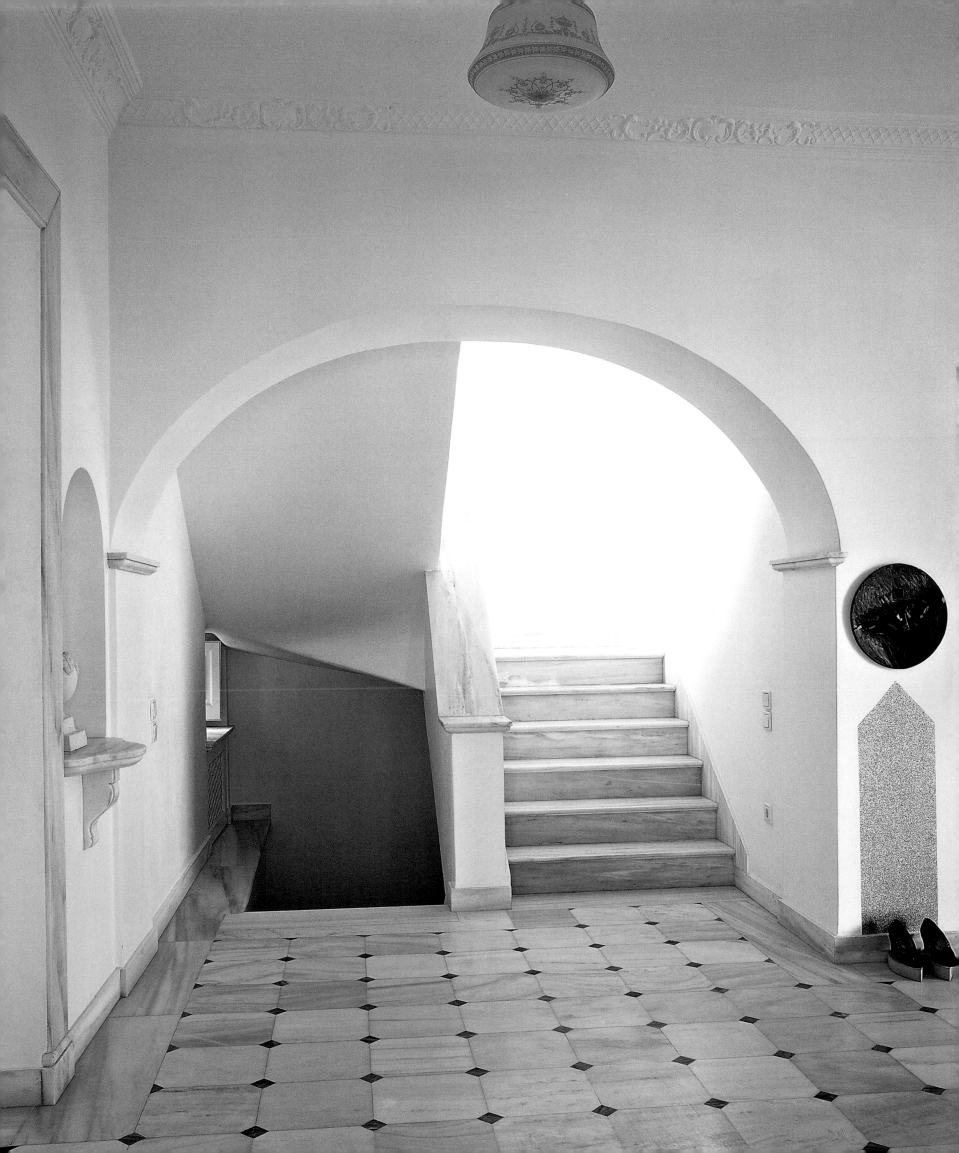

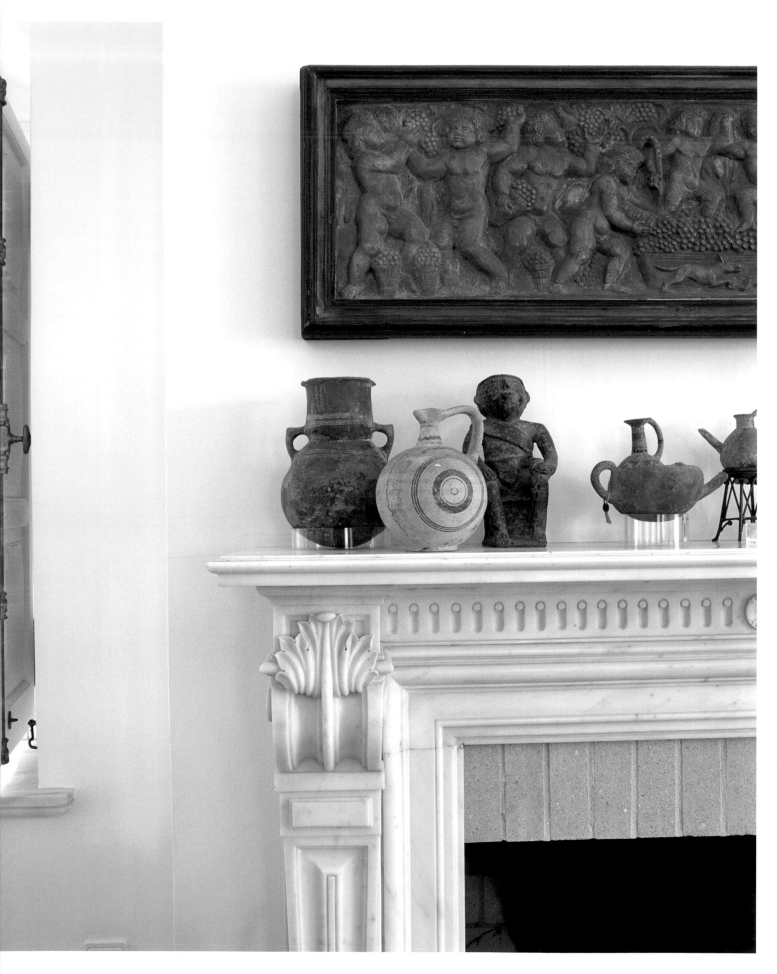

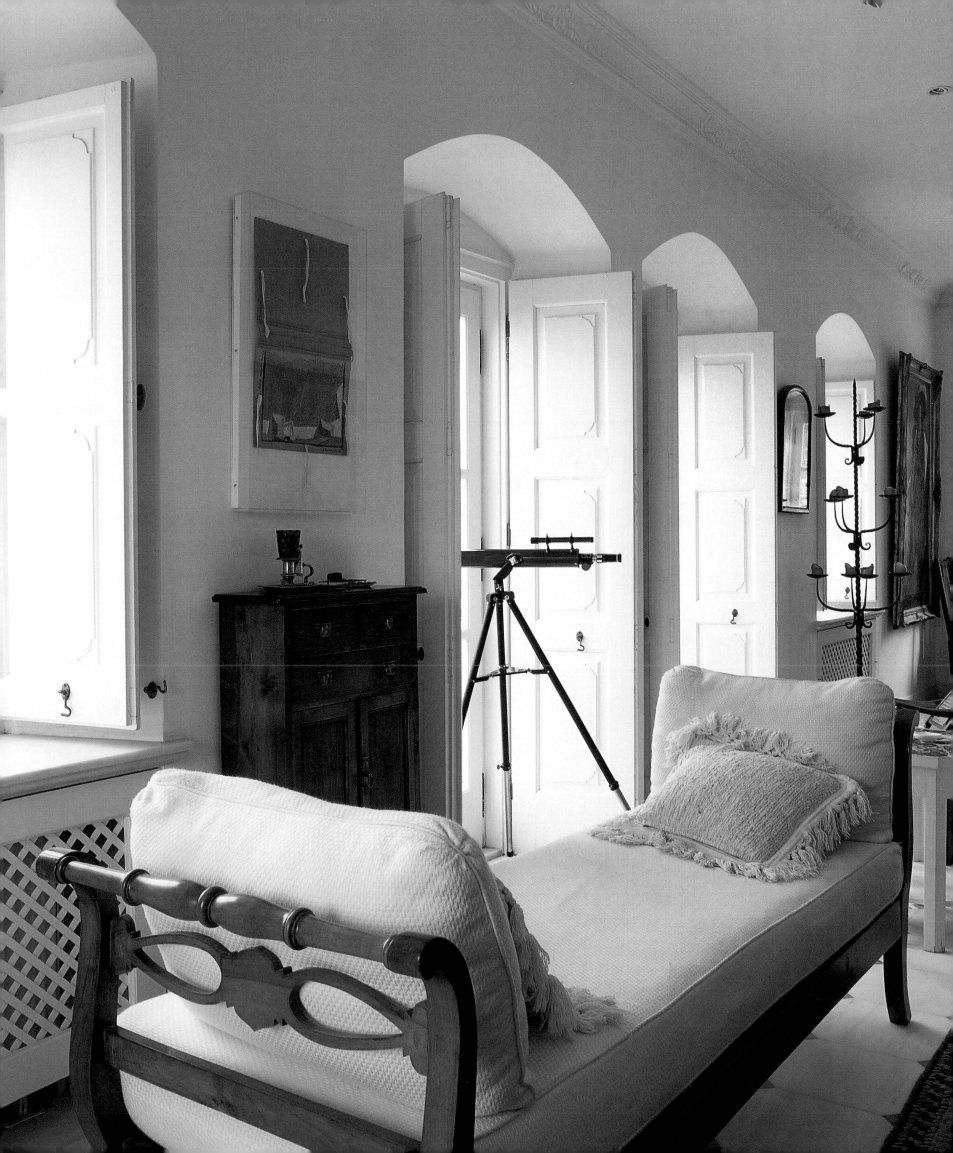

An Architect's Refuge
The Tseghis Family
Hydra

The Athenian architect Vassily Tseghis claims that he bought this house on the island of Hydra for lazy weekends with his wife and his friends. But the moment you cross his threshold in one of the alleys behind the cathedral, you begin to suspect that Vassily, a passionate architect and decorator, has taken intense pleasure in creating the remarkable décor here. With its shady, flower-filled courtyard, the second home of the Tseghis family has an enchanting little kitchen with sunflower-yellow walls, built around a rock that pokes right into the room. There is also a delightful surprise in the form of a modest living room on the first floor, which Vassily has transformed into an elegant salon by installing a Turkish-style sofa upholstered with old fabrics and cushions covered in a spectacular cotton print from Comoglio. A deco ambiance? Not at all. The trained eye of Tseghis has avoided facile effects, opting for tried and true quantities such as a traditional 19th century brass bed, Oriental carpets, Victorian mahogany furniture, and that faint perfume of the past that one only seems to find in houses that are very much out of the ordinary.

LEFT: *a plant's shadow cast against a shutter.*
ABOVE: *In the kitchen, a 19th century opaline goblet stands on the mantel.*

LINKS: *der Schatten einer Pflanze auf dem Fensterladen.*
OBEN: *Auf dem Kaminsims in der Küche steht ein Opalinkelch aus dem 19. Jahrhundert.*

A GAUCHE: *Une plante projette une ombre énigmatique sur le volet.*
CI-DESSUS: *Dans la cuisine, une coupe en opaline 19ᵉ est posée sur la tablette de la cheminée.*

Der Athener Architekt Vassily Tseghis behauptet, er habe dieses Haus auf der Insel Hydra erstanden, um dort mit seiner Frau und seinen Freunden am Wochenende zu faulenzen. Tritt man jedoch über die Schwelle, so ahnt man gleich, dass sich der leidenschaftliche Dekorateur Vassily mit Herzenslust an die Gestaltung einer außergewöhnlichen Inneneinrichtung gemacht hat. Neben dem bescheidenen kleinen Hof, der den Bewohnern heute den Luxus eines bepflanzten und schattigen Platzes bietet, verzaubert vor allem die kleine Küche mit ihren sonnenblumengelben Mauern, die um einen in den Raum ragenden Felsen gezogen wurden. Überrascht ist man auch, wenn man den ehemals bescheidenen Wohnraum im Obergeschoss betritt: Vassily hat ihn in einen eleganten Salon verwandelt, indem er dort ein Sofa im türkischen Stil einbaute. Es ist mit alten Stoffen bezogen und die Kissenbezüge ziert ein wunderbarer Baumwolldruck von Comoglio. Deko-Ambiente? Keineswegs. Mit seinem geübten Auge hat Tseghis alle Effekthaschereien vermieden. Der Besucher entdeckt ein traditionelles Kupferbett aus dem 19. Jahrhundert, Orientteppiche, viktorianische Mahagonimöbel und jenes Fluidum der Vergangenheit, das man nur sehr selten antrifft.

The patio, filled with climbing plants and potted geraniums.

Eine Fülle von Kletterpflanzen und eingetopften Geranien belebt den kleinen Hof.

La courette regorge de plantes grimpantes et de géraniums en pots.

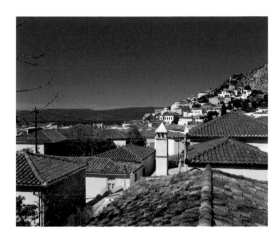

The roofs of the neighbouring houses, seen from the Tseghis's terrace.

Aussicht von der Terrasse der Tseghis auf die Dächer der Nachbarhäuser.

Les toits des maisons voisines, vus de la terrasse des Tseghis.

L'architecte athénien Vassily Tseghis prétend qu'il a acheté cette maison sur l'île d'Hydra pour y passer des week-ends de paresse exquise avec sa femme et ses nombreux amis. Mais en franchissant le seuil de sa demeure située dans une des ruelles derrière la cathédrale, on soupçonne que Vassily, un architecte et décorateur passionné, a pris bien du plaisir à créer un décor exceptionnel. Agrémentée d'une modeste courette qui offre aujourd'hui à ses habitants le luxe indispensable d'un coin fleuri et ombragé, la résidence secondaire des Tseghis séduit par sa petite cuisine aux murs jaune tournesol, construite autour d'un rocher qui pénètre dans la pièce. Et par la surprise agréable d'un modeste séjour à l'étage que Vassily a transformé en salon élégant en y installant un sofa à la turque habillé de tissus anciens et de coussins revêtus d'un magnifique coton imprimé de chez Comoglio. Ambiance Déco? Pas du tout. L'œil averti de Tseghis a su éviter les effets trop faciles. Le visiteur charmé découvre un lit en cuivre 19e traditionnel, des tapis d'Orient, des meubles en acajou victoriens et ce parfum d'antan que l'on ne respire que dans les demeures hors du commun.

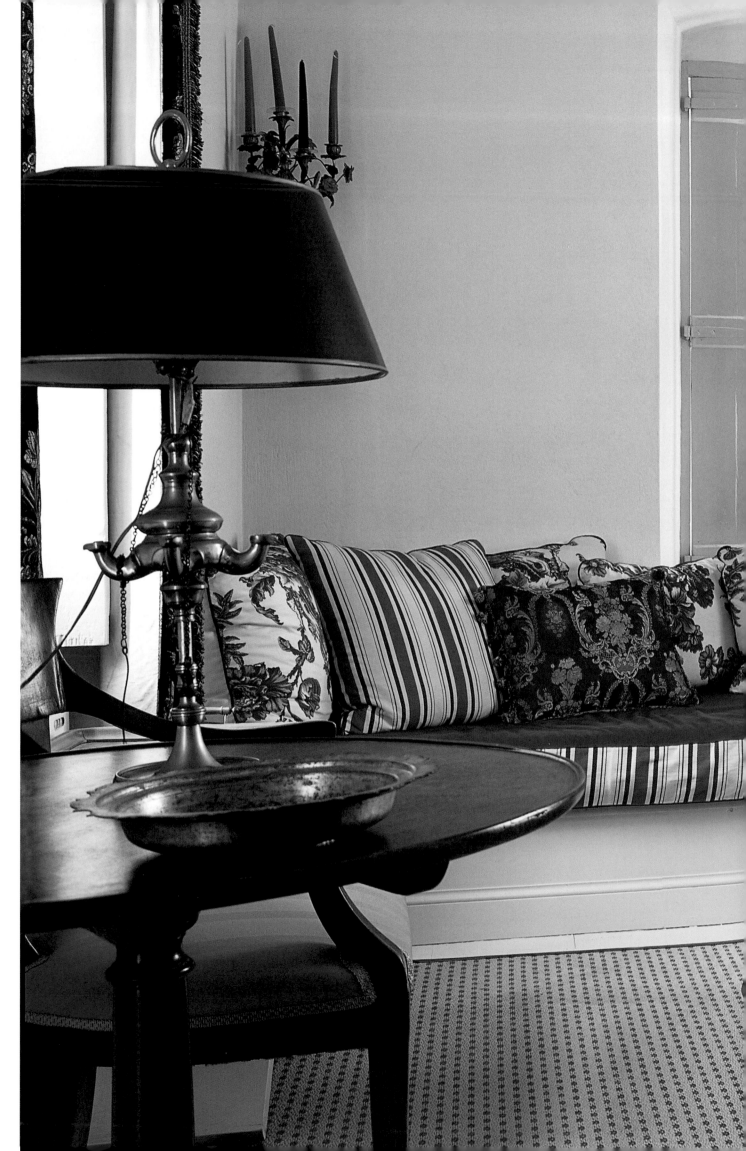

RIGHT: *a Turkish bench, designed by the architect, in the living room. The cushions are covered in 18th century fabrics, as well as fabrics designed by Bennison and Comoglio.*
FOLLOWING PAGES, LEFT: *The shutters are closed during the hours of siesta.*
FOLLOWING PAGES, RIGHT: *an earthenware terrine filled with seashells and a terracotta plaque attributed to Thorvaldsen.*

RECHTS: *Das von Tseghis entworfene Sofa im türkischen Stil verschwindet fast unter den Kissen, die mit Stoffen aus dem 18. Jahrhundert und modernen Kreationen von Bennison und Comoglio bezogen sind.*
FOLGENDE DOPPEL-SEITE LINKS: *Während der Mittagsruhe bleiben die Fensterläden geschlossen.*
FOLGENDE DOPPEL-SEITE RECHTS: *Über der mit Muscheln dekorierten Fayence-Terrine hängt ein Terrakotta-Relief, das Thorvaldsen zugeschrieben wird.*

A DROITE: *Dans le séjour, une banquette à la turque dessinée par l'architecte disparaît sous un amoncellement de coussins revêtus de tissus 18e et de créations contemporaines de chez Bennison et Comoglio.*
DOUBLE PAGE SUIVANTE, A GAUCHE: *C'est l'heure de la sieste et les Tseghis ont fermé les volets.*
DOUBLE PAGE SUIVANTE, A DROITE: *Au-dessus d'une terrine en faïence remplie de coquillages, Tseghis a accroché une plaquette en terre cuite attribuée à Thorvaldsen.*

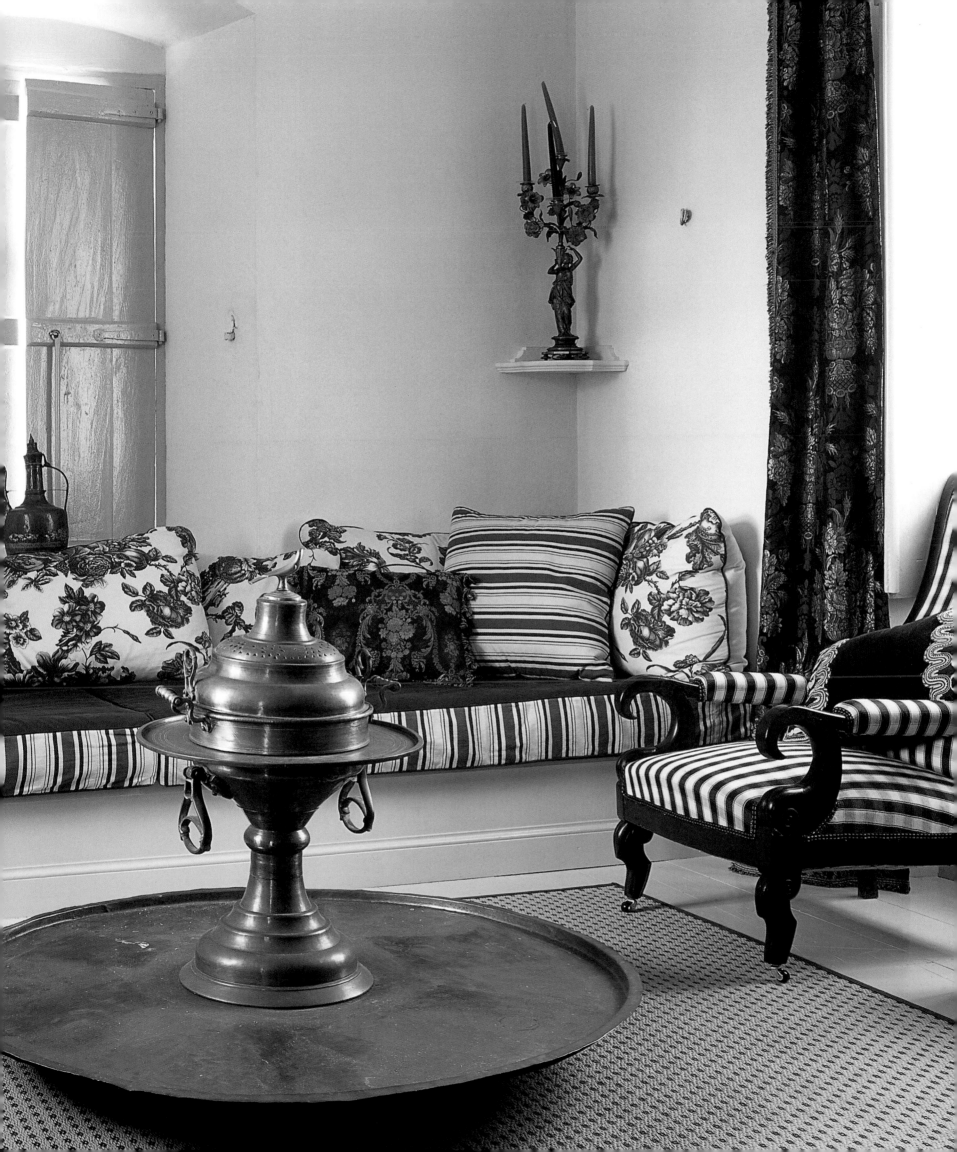

ABOVE: *the sunny yellow of the kitchen walls, blue and white antique china, and floral cushion fabrics.*
RIGHT: *the chimneypiece, clad with geometrical tiles.*
FACING PAGE: *The rock seems literally to burst into one end of the kitchen.*

OBEN: *Das Sonnenblumengelb der Küchenwände passt zu dem alten weißblauen Porzellan und harmoniert mit den Blumenmotiven der Kissenbezüge.*
RECHTS: *Der Kamin ist mit einer geometrisch gemusterten Kachelung verkleidet.*
RECHTE SEITE: *Der Felsen scheint geradezu in die Küche hereinbrechen zu wollen.*

CI-DESSUS: *Le jaune ensoleillé des murs de la cuisine sied aux porcelaines anciennes bleues et blanches et s'harmonise avec les coussins garnis de tissus floraux inspirés par des ouvrages d'époque.*
A DROITE: *La cheminée est habillée d'un carrelage à motifs géométriques.*
PAGE DE DROITE: *Le rocher semble vouloir faire irruption dans la cuisine.*

\mathcal{K}OURMADA
Audrey and Robert Browning
Hydra

The climb to "Kourmada", the second home of Audrey and Robert Browning, is long and difficult – only mules don't get out of breath – but the destination is worth it. 20 years ago the Brownings found something extraordinary up here. "Kourmada" is an imposing construction, perched on a hill from which it overlooks a labyrinth of tiny streets. According to the locals, the house used to belong to one of the island's more prominent families, and the property included a number of adjoining buildings and a chapel. Inside you find yourself in a hallway worthy of a Florentine palace, and when you see the more than generous dimensions of the other rooms you understand why it is that some people have compared "Kourmada" to Tuscan villas. Audrey and her husband have furnished their Hydriot home in perfect and quintessentially English taste, with the emphasis on 18th century porcelain and Georgian and Victorian furniture; their bed is a remarkable four-poster hung with embroidered voile against a pink background, and the bathroom is sky blue with neoclassical touches. "Kourmada" has become a veritable three-dimensional poem, entirely worthy of the descendant of a great English poet ...

A terracotta vase standing on the lip of a wall.

Die Terrakotta-Vase setzt auf dem Mauersims einen schönen Akzent.

Un vase en terre cuite repose sur le rebord d'un mur.

Der Aufstieg nach »Kourmada«, dem Zweitwohnsitz von Audrey und Robert Browning, ist beschwerlich – nur die Maulesel kommen mühelos dorthin. Doch die Anstrengung lohnt sich, denn die Brownings haben vor etwa 20 Jahren ein außergewöhnliches Haus ausfindig gemacht. »Kourmada« ist ein stattliches Gebäude hoch oben auf einem Hügel gelegen, inmitten eines Labyrinths von Gassen. Wie die Bewohner sagen, gehörte das Gebäude einst einer der größten Familien der Insel und der Besitz umfasste auch angrenzende Häuser sowie die Kapelle. Durch den Eingang gelangt man in einen Saal, der sich in einem florentinischen Palast befinden könnte, und angesichts der mehr als großzügigen Abmessungen der übrigen Räume kann man es sich nicht versagen, »Kourmada« mit der Pracht toskanischer Villen zu vergleichen. Audrey und Robert Browning haben ihren Wohnsitz auf Hydra mit erlesenem, typisch englischem Geschmack eingerichtet. Besonderes Augenmerk lag auf Porzellan des 18. Jahrhunderts und auf georgianischen sowie viktorianischen Möbeln. Ihr mit besticktem Voile drapiertes Himmelbett wurde vor rosafarbenem Hintergrund aufgestellt und das himmelblaue Badezimmer hat eine klassizistische Anmutung. »Kourmada« ist zu einer regelrecht dichterischen Komposition geworden, wie es einem Nachfahren des berühmten englischen Dichters gebührt ...

Elle est bien longue et difficile l'ascension vers «Kourmada», la résidence secondaire d'Audrey et Robert Browning – seuls les mulets ne sont pas essoufflés –, mais l'effort en vaut la peine car les Browning ont déniché, il y a une vingtaine d'années, une maison exceptionnelle. «Kourmada» est une construction imposante, juchée sur une colline d'où elle domine un labyrinthe de ruelles. Selon les habitants, la demeure appartenait jadis à l'une des plus grandes familles de l'île et englobait aussi les maisons et la chapelle adjacente. Le seuil franchi, le visiteur se trouve dans un hall digne de quelque palais florentin et, devant les dimensions plus que généreuses des autres pièces, il ne peut s'empêcher de comparer «Kourmada» aux splendeurs des villas de Toscane. Audrey et son mari ont meublé leur gîte hydriot avec un goût exquis et typiquement anglais, insistant sur des porcelaines 18e, des meubles georgiens et victoriens, installant un lit à baldaquin drapé de voile brodé sur fond rose et une salle de bains bleu ciel aux accents néoclassiques. «Kourmada» est devenue un véritable poème en trois dimensions, tout à fait digne d'un descendant du célèbre poète anglais ...

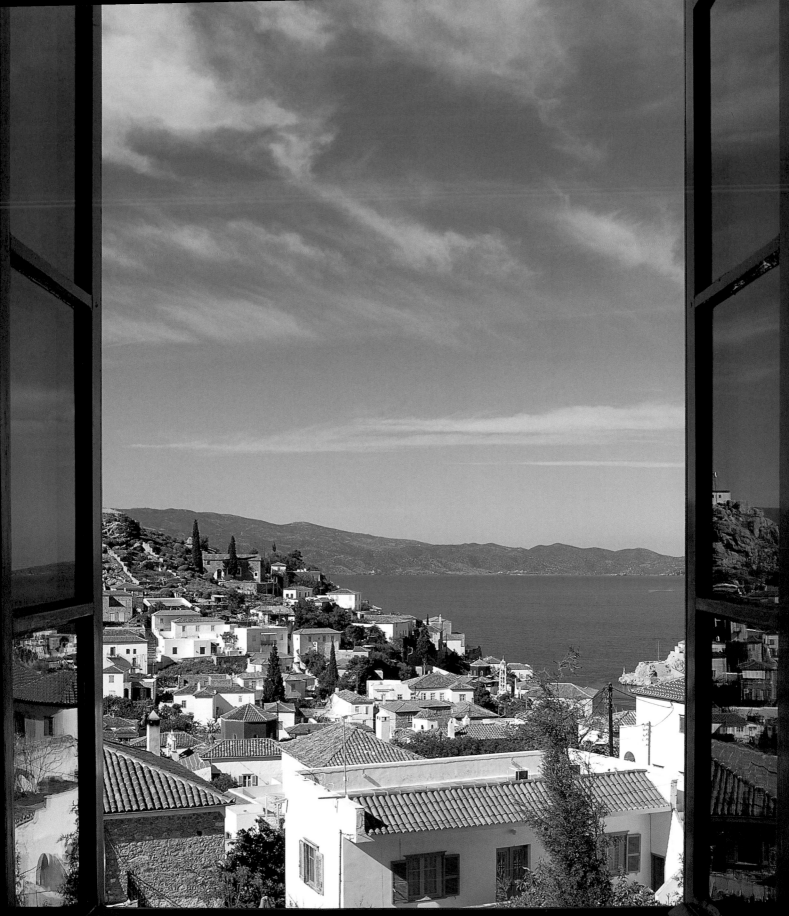

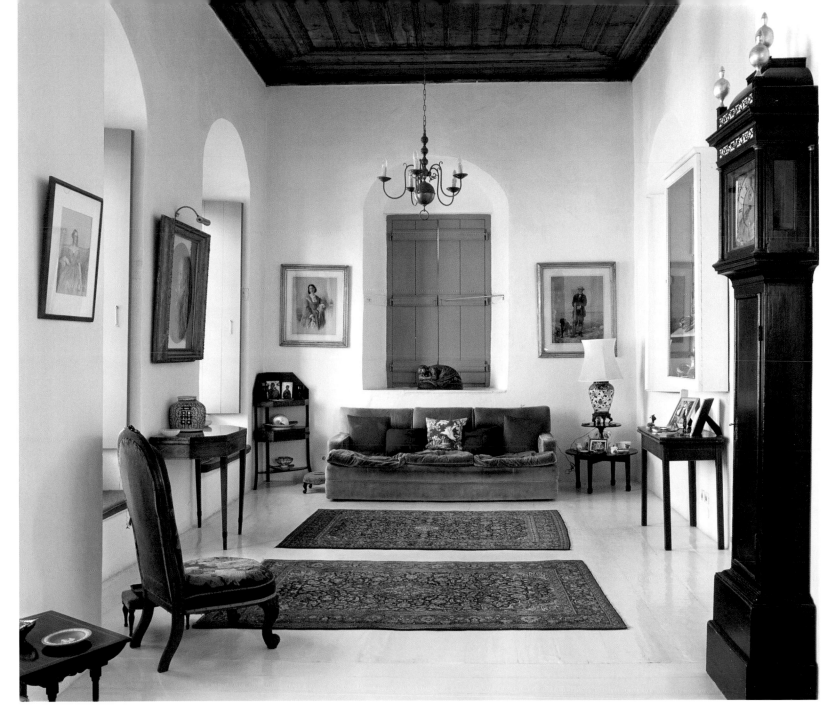

FACING PAGE: *Roof-tops and the horseshoe-shaped Bay of Hydra, framed by a window.*
ABOVE: *The Brown-ings' elegant salon, reflecting their taste for the classic British style.*
RIGHT: *The unusual chimneypiece, designed by the owner.*

LINKE SEITE: *Es gibt wohl kaum etwas Faszi-nierenderes, als sich hier niederzulassen und auf Hydra und seine huf-eisenförmige Bucht zu schauen.*
OBEN: *Der elegant möblierte Salon spiegelt die Vorliebe der Brown-ings für klassische, aus-gesprochen »britische« Möbel.*
RECHTS: *Der nach einem Entwurf des Hausherrn gefertigte Kamin sticht durch seine außergewöhnliche Form hervor.*

PAGE DE GAUCHE: *Rien de plus fascinant que de s'asseoir ici et de contempler Hydra et sa baie en forme de fer à cheval.*
CI-DESSUS: *Meublé avec élégance, le séjour des Browning reflète leur penchant pour le classique très «british».*
A DROITE: *Exécutée d'après un dessin du maître de maison, la cheminée étonne par sa forme insolite.*

By including such classic features as a Victorian chair, an 18th century clock, a Regency looking glass, the portrait of an ancestor and a niche filled with china – the Brownings have created a quiet and elegant interior.

Durch Einbeziehung klassischer Elemente wie des viktorianischen Sessels, der Pendeluhr aus dem 18. Jahrhundert, eines Regency-Spiegels und einer Nische mit schönen Porzellanstücken haben die Brownings ein vornehmes und klares Interieur geschaffen.

En y intégrant des éléments classiques – un siège victorien, une horloge 18e, un miroir Regency, un portrait d'ancêtre et une niche remplie de porcelaines – les Browning ont créé un intérieur sobre et distingué.

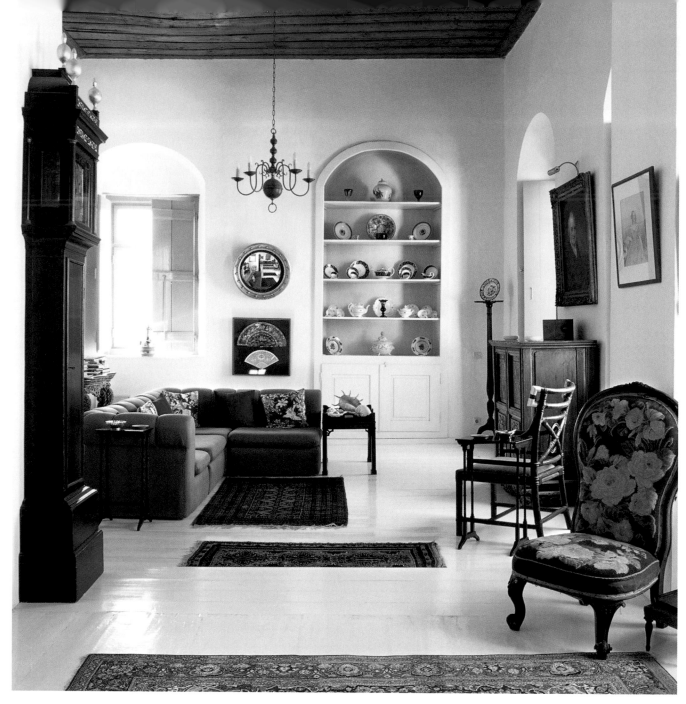

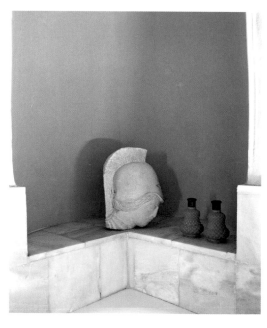

FAR LEFT: *in the hall, an antique silk carpet against a raspberry-coloured background.*
LEFT: *in the bathroom, a stone head of Athena by Audrey.*
FACING PAGE: *The wall of the terrace, covered in blue wash, sets off the shells and coral at its base.*

GANZ LINKS: *Der alte Seidenteppich kontrastiert im Vestibül mit der himbeerroten Wand.*

LINKS: *Den Kopf der Athene im Badezimmer hat Audrey in Stein gemeißelt.*

RECHTE SEITE: *Vor den blau lavierten Terrassenmauern kommen die Muscheln und Korallen besonders schön zur Geltung.*

A L'EXTREME GAUCHE: *Dans le hall, un tapis en soie ancien se détache sur un mur couleur framboise.*
A GAUCHE: *Dans la salle de bains, une tête d'Athéna sculptée dans la pierre porte la signature d'Audrey.*
PAGE DE DROITE: *Les murs de la terrasse, recouverts d'un lavis bleu, mettent en valeur les coquillages et les coraux.*

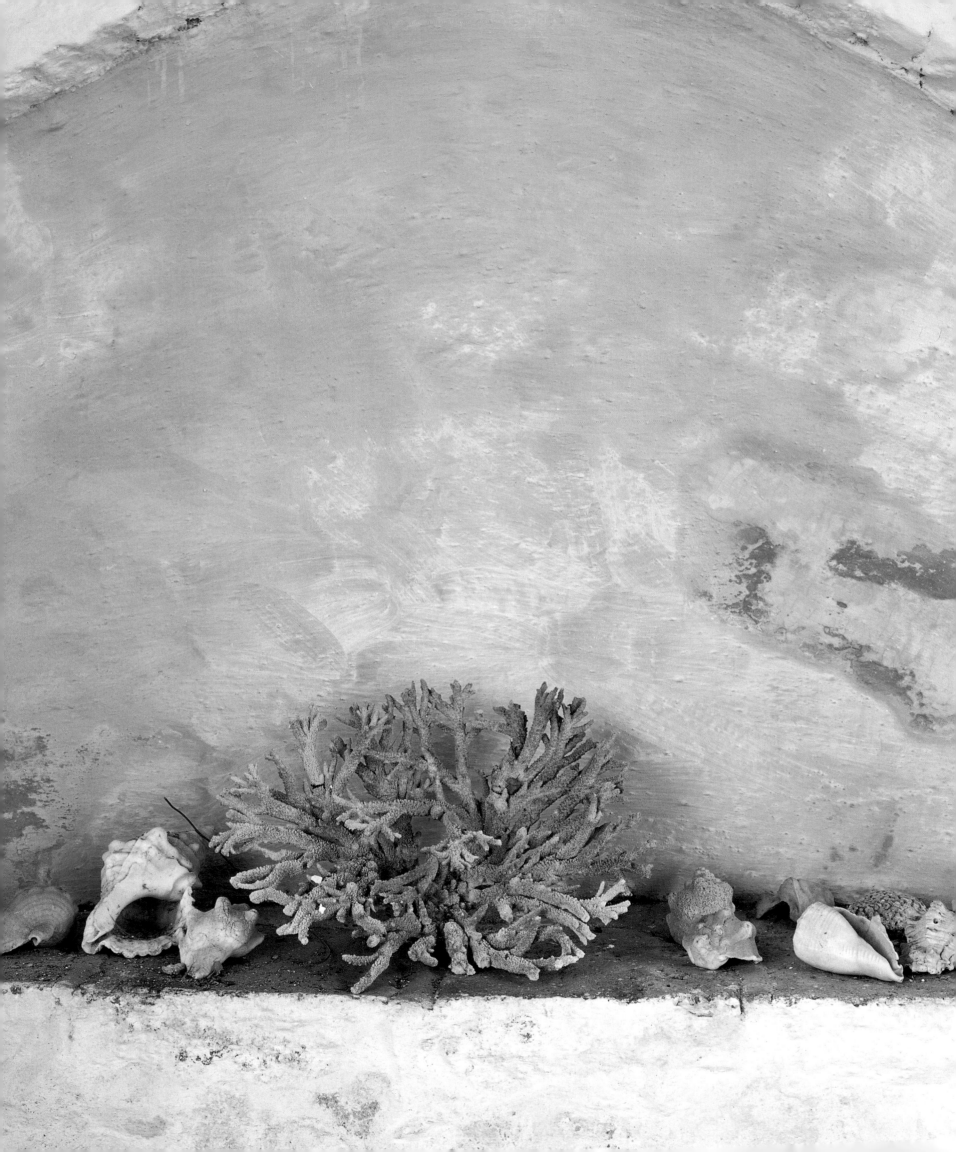

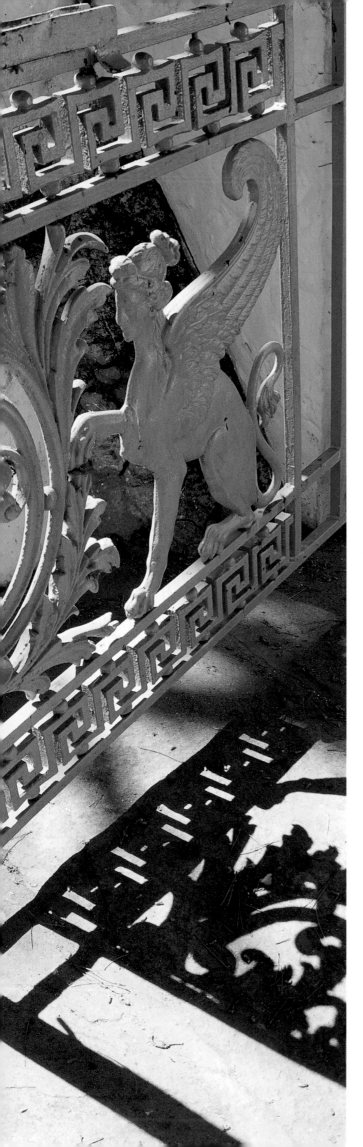

THE SCHNEIDER FAMILY

Hydra

The beautiful white house of Elmar Schneider has an astonishing effect on people. Perhaps it's the cast iron gateway, inspired by the German neoclassical style and the architectural ideas of Karl Friedrich Schinkel; it could also be the austere interior, or the bare entrance hall whose only décor is a dark 18th century wooden bench and a few black-and-gold framed family portraits from the same period. There is really nothing ostentatious about the Schneiders' taste; apart from a spacious, imposing veranda furnished with cushion-strewn couches, there seems to be a deliberate avoidance of obvious effect. Country chairs, robust sofas, an old rug on a white-lacquered floor, a trunk buried under a mountain of straw hats, a pure white bedroom, a four-poster whose slender black lines are clothed with diaphanous voile curtains, and a rustic white-tiled kitchen – all these things are perfectly modulated to the needs of a pair of aesthetes who value calm and restfulness above all else, and who have made their holiday house a perfect reflection of both.

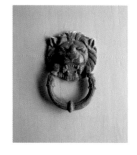

LEFT: *a detail of the gate with its motif of winged sphinxes.*
ABOVE: *the lion's head doorknocker.*

LINKS: *ein Detail des Torgitters mit dem Motiv einer geflügelten Sphinx.*
OBEN: *der Türklopfer in Gestalt eines Löwenkopfes.*

A GAUCHE: *un détail de la grille d'entrée avec son motif de sphinges ailées.*
CI-DESSUS: *le heurtoir en forme de tête de lion.*

Wenn man das schöne weiße Haus von Elmar Schneider besucht, ist man überrascht. Es lässt sich kaum sagen, ob das an dem gusseisernen Torgitter liegt, das an den deutschen Klassizismus und die architektonische Formensprache Karl Friedrich Schinkels anknüpft, oder an dem klar strukturierten Interieur. Der Besucher betritt eine streng gestaltete Eingangshalle, deren ganzer Schmuck in einer dunklen Holzbank aus dem 18. Jahrhundert und in schwarzgoldenen Rahmen eingefassten Ahnenbildnissen besteht. Ostentative »Hingucker« gehören offenkundig nicht zum dekorativen Vokabular der Schneiders. Eine Ausnahme macht vielleicht die stattliche und sehr weitläufige Veranda, die mit weißblau gestreiften Sofas bestückt ist. Landhausstühle und robuste Sofas, ein alter Teppich auf weiß lackiertem Boden, eine Garderobe, die unter einem Gewirr von Strohhüten verschwindet, ein Schlafzimmer in jungfräulichem Weiß, ein Himmelbett, an dessen zartem schwarzem Gestell Vorhänge aus diaphanem Voile angebracht wurden, und eine rustikale Küche mit weißen Kacheln – all dies passt zu den Ästheten auf der Suche nach Ruhe und Erholung und macht dieses Ferienhaus zu einem idealen Ort der Entspannung.

La belle maison blanche d'Elmar Schneider étonne le visiteur. Impossible de dire si cela tient à sa grille d'accès en fonte inspirée du néoclassique allemand et au langage architectural de Karl Friedrich Schinkel ou à son intérieur dépouillé où l'œil est surpris par un hall d'entrée sévère orné d'une banquette en bois sombre 18ᵉ et de portraits d'ancêtres de la même époque, enchâssés dans des cadres noirs et or. L'ostentatoire et le « tape-à-l'œil » ne font manifestement pas partie du vocabulaire décoratif des Schneider. Et hormis une véranda imposante et très spacieuse, meublée de canapés couverts de coussins revêtus de toile rayée bleue et blanche, on s'éloigne volontiers de l'effet trop évident. Des sièges campagnards et des canapés robustes, un tapis ancien sur un sol laqué blanc, un portemanteau qui disparaît sous un amoncellement de chapeaux de paille, une chambre à coucher d'un blanc virginal, un lit à baldaquin dont le mince squelette noir est habillé de rideaux en voile diaphane, et une cuisine rustique carrelée de blanc, voilà ce qui convient à ces esthètes en quête de calme et de repos et qui fait de cette maison de vacances un lieu de détente idéal.

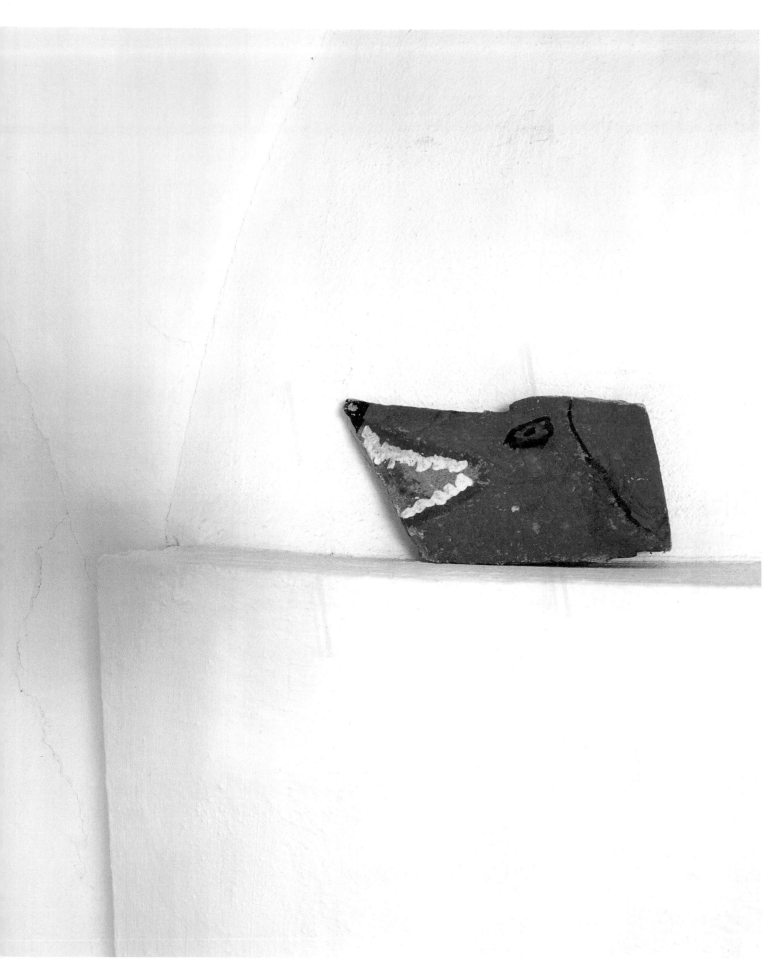

LEFT: *On a mantel, Elmar Schneider has placed a tile painted by one of his children with the head of a "snarling dog".*
FACING PAGE: *The kitchen utensils form a composition not unlike a constructivist painting.*

LINKS: *Den Dachziegel auf dem Kaminsims hat eines der Kinder von Elmar Schneider mit dem Kopf eines »bissigen Hundes« bemalt.*
RECHTE SEITE: *Die Anordnung der Küchenutensilien erinnert an eine konstruktivistische Komposition.*

A GAUCHE: *Sur le rebord d'une cheminée, Elmar Schneider a posé une tuile peinte par un de ses enfants, et qui représente une tête de «chien méchant».*
PAGE DE DROITE: *Les ustensiles de cuisine forment une composition évoquant un tableau constructiviste.*

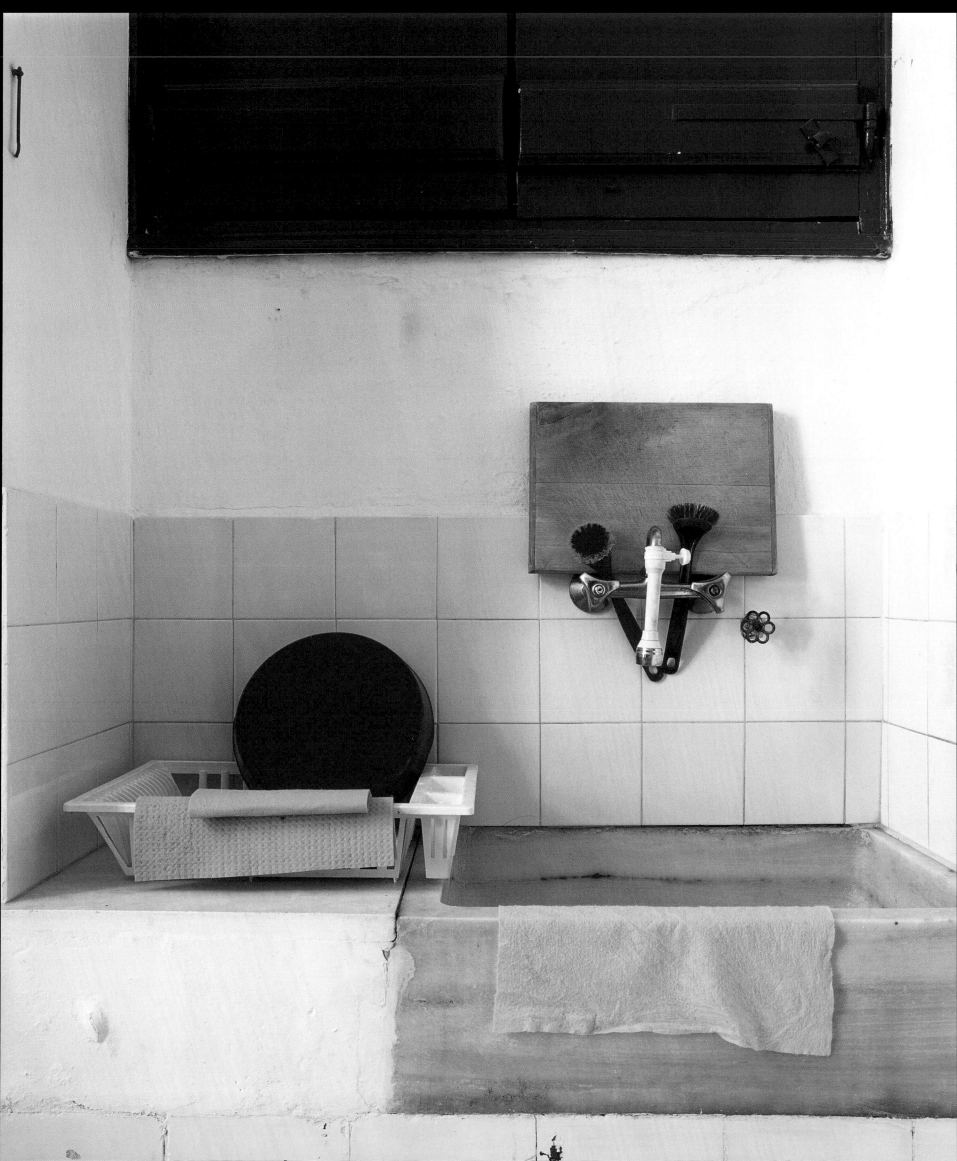

LEFT: *in the bedroom, a collection of receptacles and fans in an open cupboard.*
FACING PAGE: *The wrought iron bed in this spartan room is hung with white cotton voile.*

LINKS: *Ein offener Schrank im Schlafzimmer zeigt eine Sammlung von Gefäßen und Fächern.*
RECHTE SEITE: *Am schmiedeeisernen Bett in diesem spartanischen Schlafzimmer sind weiße Vorhänge aus Baumwolle befestigt.*

A GAUCHE: *Dans la chambre à coucher, un placard s'ouvre sur une collection de récipients et d'éventails.*
PAGE DE DROITE: *Le lit en fer forgé de cette chambre monacale s'habille de rideaux blancs en voile de coton.*

RIGHT: *the family straw hats hanging on their pegs.*

RECHTS: *Im Eingangsbereich warten die Strohhüte auf die Rückkehr der Familie.*

A DROITE: *Dans l'entrée, les chapeaux de paille attendent l'arrivée de la famille.*

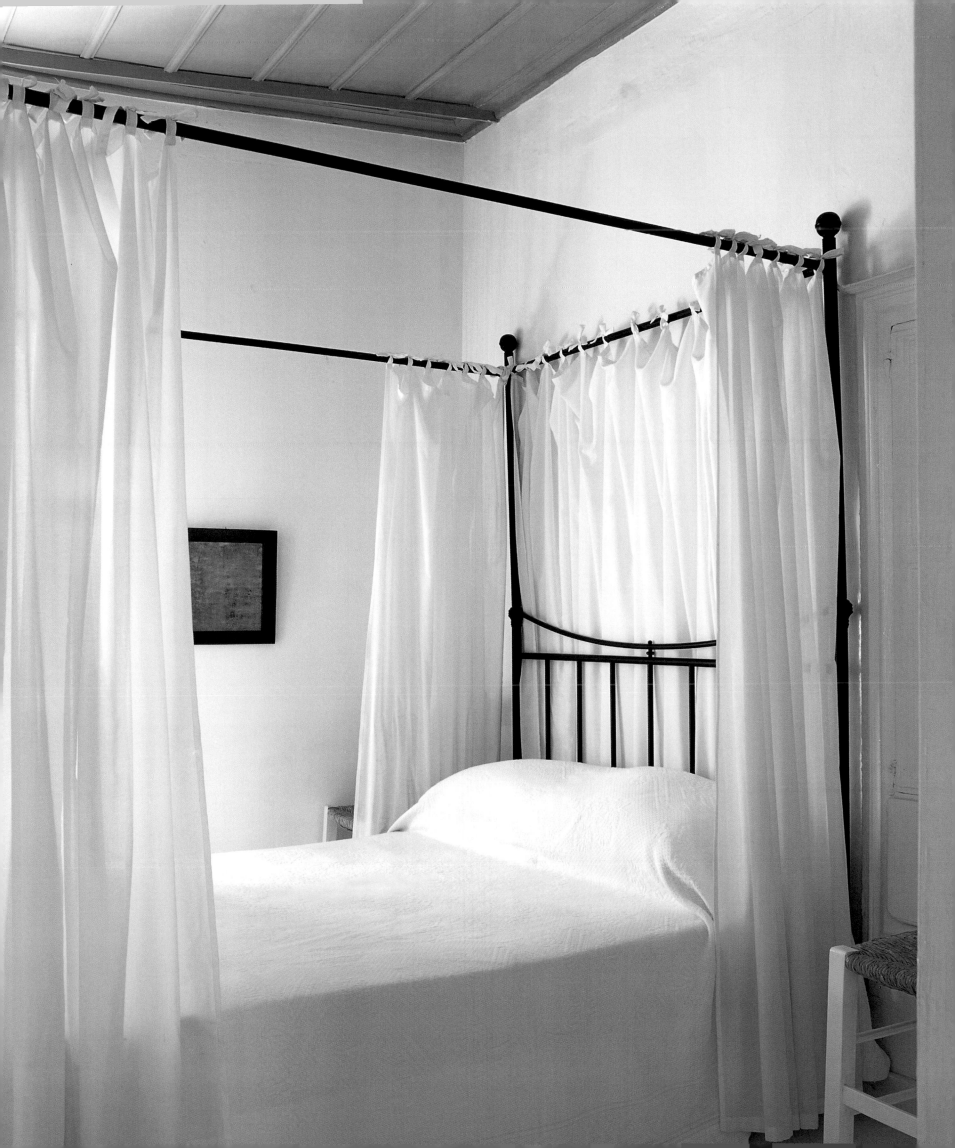

A bedroom, with almost no furnishings other than two chairs, whose striped black and white seat fabric is the only departure from the surrounding white.

In dem karg möblierten Schlafzimmer unterbrechen nur die schwarzweiß gestreiften Sitzflächen der Stühle das monochrome Erscheinungsbild.

Un rien meuble cette chambre à coucher. Seuls les assises des sièges, garnis d'un tissu rayé blanc et noir, se démarquent de la palette monochrome.

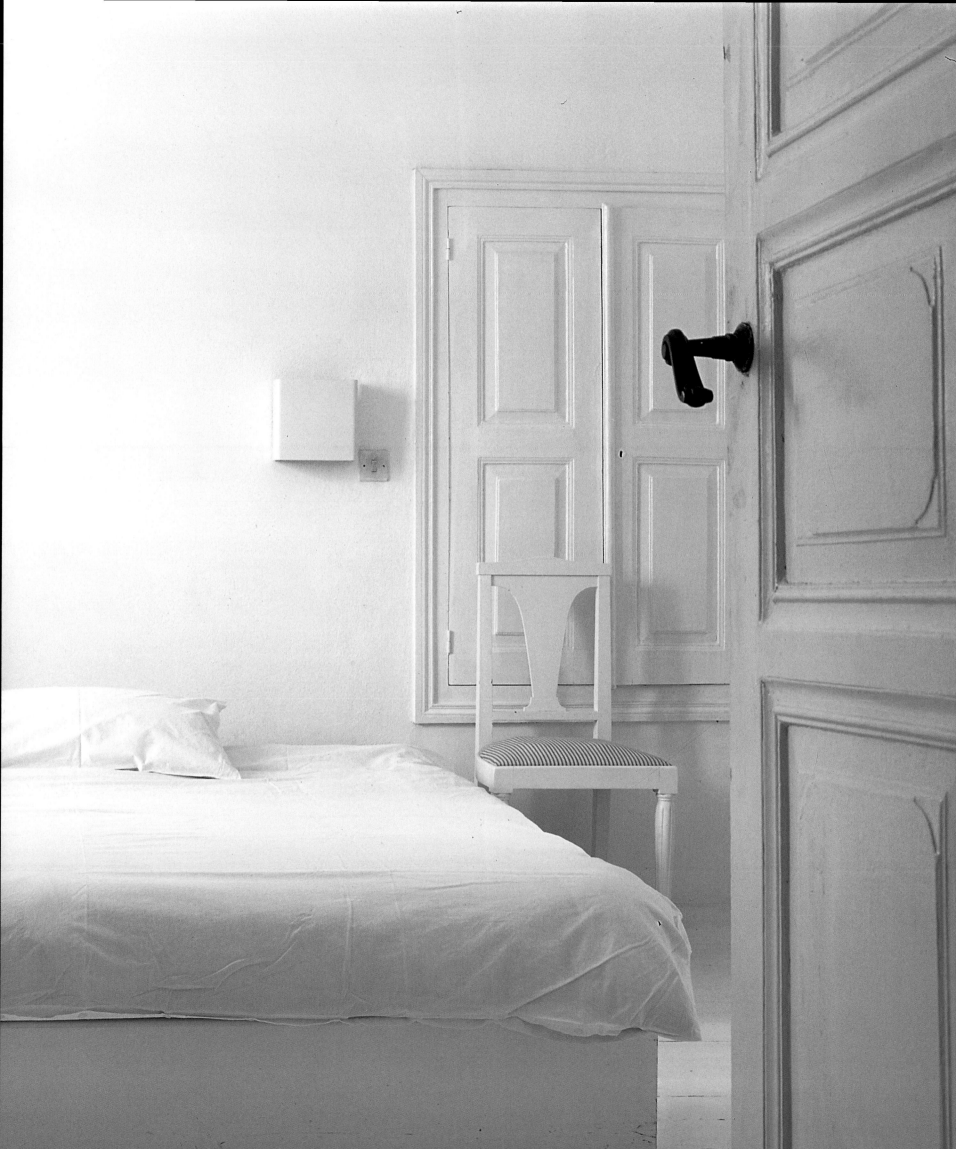

DINA NIKOLAOU

Hydra

The house of Dina Nikolaou is hidden at the end of a steep alley, behind a lime-rendered wall and a mustard-coloured door. It isn't that the owner of this place wants to live the life of a recluse, far from it; Dina is a warm-hearted, generous person, a woman full of life whose entourage and simple pleasures – books, literature and good meals on her terrace overlooking the sea – have helped to get over the loss of her husband. In this modest-looking Greek village house which surprises the visitor with its warren of rooms, she has surrounded herself with everything most dear to her. Among other things there is family furniture that reflects the bourgeois taste of the 19th century, portraits of ancestors, icons, religious images, shells, old china and – inevitably – fine carpets, embroidered fabrics, and immaculate lace-bordered antimacassars. We should also mention the kitchen, with its forthright colours; for this is the blessed source of many a delectable dish cooked by Dina. Her candied orange peel, by the way, is the best in the world.

PREVIOUS PAGES AND LEFT: *Dina has painted the front door and a part of the pavement with a mustard coloured enamel.*

VORHERGEHENDE DOPPELSEITE UND LINKS: *Dina hat die Eingangstür und einen Teil des Weges mit senfgelber Emailfarbe angestrichen.*

DOUBLE PAGE PRECEDENTE ET A GAUCHE: *Dina a peint la porte d'entrée – et une partie du trottoir – avec une peinture émail couleur moutarde.*

Das Haus von Dina Nikolaou verbirgt sich am Ende einer steil abfallenden Gasse hinter einer kalkgetünchten Mauer und einer senfgelben Tür. Die Hausherrin möchte aber keineswegs ein einsiedlerisches Leben führen. Dina ist im Gegenteil eine warmherzige und gastfreundliche Person, eine lebhafte Frau, die es mit Hilfe ihrer Umgebung und der Freude an einfachen Dingen – schmackhaften Mahlzeiten auf der Terrasse mit Meerblick und Buchlektüre – geschafft hat, über den Verlust ihres Mannes hinwegzukommen. In dem bescheidenen Haus, das den Besucher jedoch mit seinen zahlreichen Räumen und den für griechische Dorfbauten typischen »labyrinthischen« Verschachtelung überrascht, hat Dina die Gegenstände und Erinnerungen versammelt, an denen ihr am meisten liegt. Dazu gehören die Familienmöbel, die den bürgerlichen Geschmack des 19. Jahrhunderts widerspiegeln, die Ahnenbildnisse, die Ikonen, die Andachtsbilder, die Muscheln, das alte Porzellangeschirr, die Teppiche, die bestickten Stoffe und die makellosen Teekannen mit ihren Spitzenhüllen. Nicht vergessen sollte man die in klaren Farben gehaltene Küche, in der sie köstliche Gerichte und himmlische kandierte Orangenschalen zubereitet.

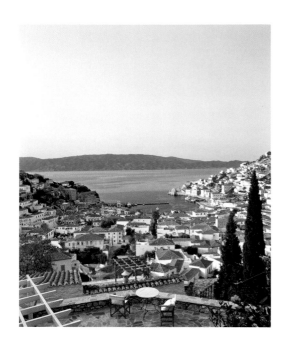

La maison de Dina Nikolaou est dissimulée au bout d'une ruelle en pente raide, derrière un mur crépi à la chaux et une porte couleur moutarde. Ce n'est pas que la maîtresse des lieux veut vivre en recluse, loin de là … Dina est une personne chaleureuse et accueillante, une femme pleine de vie que son entourage et les plaisirs simples – un bon repas sur sa terrasse avec vue sur la mer, ses livres et la littérature – ont aidé à surmonter la perte de son mari. Dans cette maison d'apparence modeste, mais qui surprend le visiteur par ses nombreuses pièces et ce côté «labyrinthe» caractéristique des maisons villageoises grecques, elle s'est entourée de tout ce qui la touche et des objets et souvenirs auxquels elle tient le plus. Citons les meubles de famille qui reflètent le goût bourgeois du 19e siècle, les portraits d'ancêtres, les icônes, les images pieuses, les coquillages, les porcelaines anciennes et – inévitables – les tapis, les tissus brodés et les têtières immaculées bordées de dentelle. N'oublions pas de faire l'éloge de sa cuisine aux couleurs franches, dans laquelle elle mitonne des plats délicieux et des pelures d'orange confites inégalées.

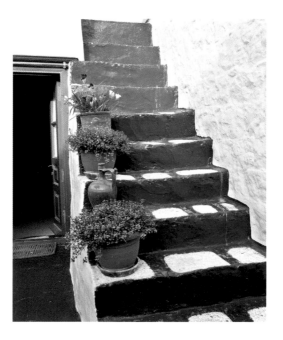

The steps of the staircase leading to the terrace are painted green, with pot plants and herbs to the side.

Auf den grün gestrichenen Stufen der zur Terrasse führenden Treppe stehen Topfpflanzen und Kräuter.

Les marches de l'escalier qui mène à la terrasse sont peintes en vert et accueillent des plantes et des herbes en pot.

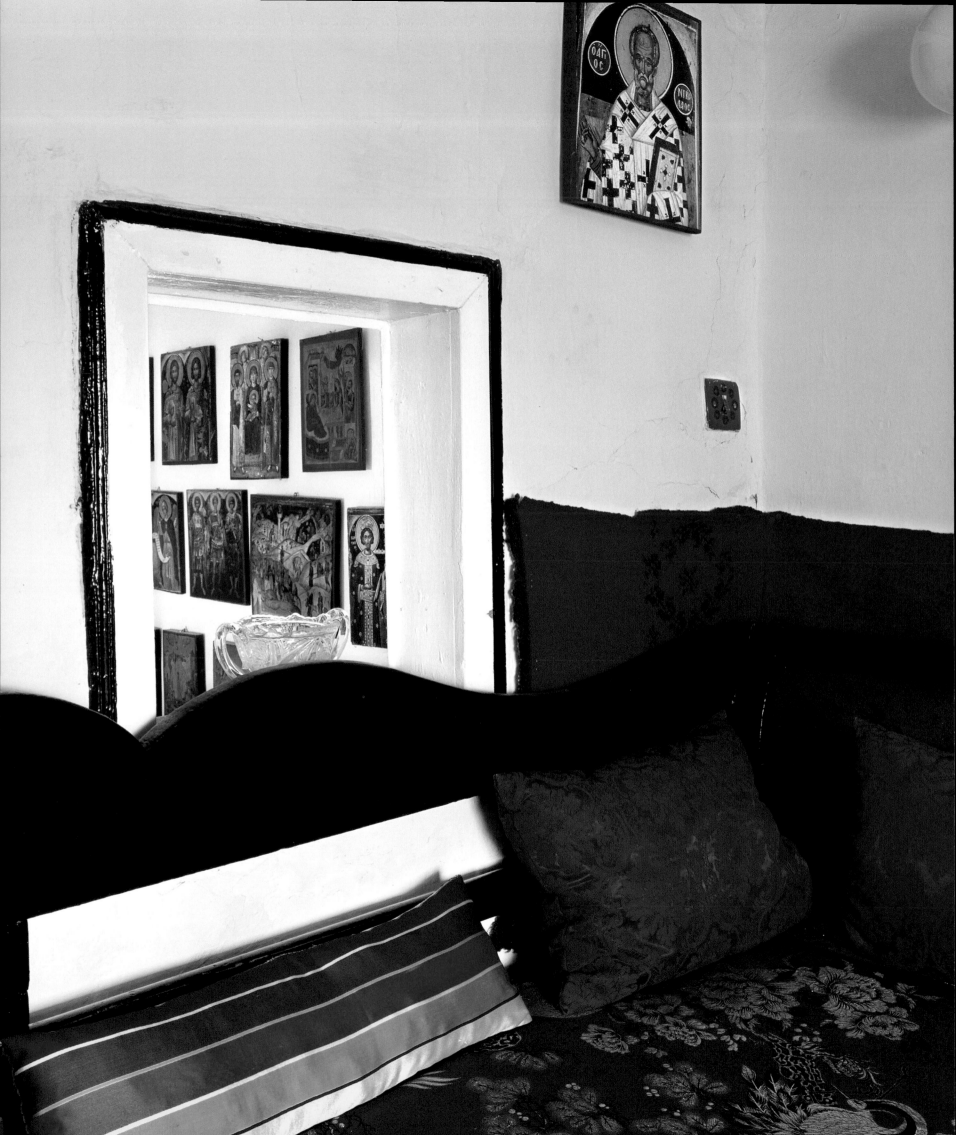

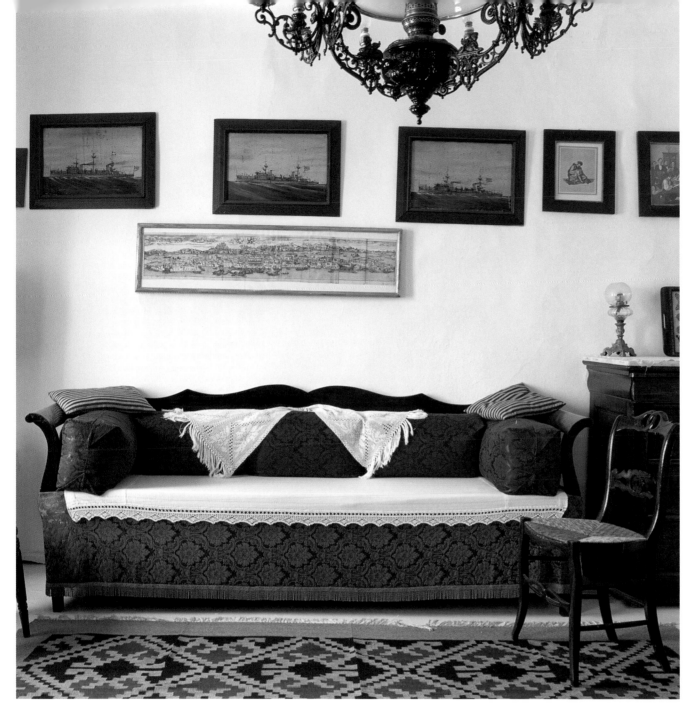

The traditional, formal ambience of the reception room, whose main feature is a Hydriot couch upholstered in red and white.

Ein traditionelles und förmliches Ambiente bestimmt diesen Empfangsraum. Blickfang ist ein rotweißes Kanapee aus Hydra.

Ambiance traditionnelle et formelle pour ce salon de réception où domine un canapé hydriote habillé de rouge et de blanc.

FACING PAGE AND RIGHT: *From the couch in one corner of the mezzanine bedroom, you can see the iconostasis at the bottom of the stairwell. The wrought iron and copper bed is 19th century.*
FAR RIGHT: *the kitchen with its two hundred year old fireplace.*

LINKE SEITE UND RECHTS: *Vom Kanapee, das in der Ecke des Schlafzimmers im Mezzanin steht, kann man die Bildersammlung an der Rückwand des Treppenhauses betrachten.Das mit* Kupferelementen verzierte schmiedeeiserne Bett stammt aus dem 19. Jahrhundert.
GANZ RECHTS: *die Küche mit ihrer 200 Jahre alten Feuerstelle.*

PAGE DE GAUCHE ET A DROITE: *Du canapé situé dans un angle d'une chambre à coucher en mezzanine, on peut contempler l'iconostase qui se trouve au fond de la cage d'escalier. Le lit en fer forgé orné d'éléments en cuivre est 19°.*
A L'EXTREME DROITE: *la cuisine avec son âtre bicentenaire.*

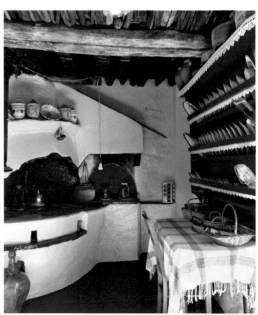

TILLY AND BASILE TOULOUMTZOGLOU

Hydra

To get to Kaminia, a charming village in the upper part of Hydra, you have a choice: either you go by way of a maze of streets and stairways, or else you go by sea. Tilly and Basile Touloumtzoglou know both ways by heart because they've been going to and fro on them for a very long time. This is where Basile – a keen former pilot who used to work for the Onassis family – has chosen to retire and where Tilly likes to entertain her children, her grandchildren and her many friends. Tilly is Dutch and Basile is Greek; for both of them, Hydra means well-being and beautiful days on their terrace in the shade of a broad white parasol, lounging on a splendid banquette. In their eyes, the house and garden are sacred places; and the beautiful domain they share with their cats Mavros and Kanelli is made even more special by the presence of family furniture and souvenirs, an elegant antique painted metalwork lantern, a thoroughly cosy kitchen and beautiful old embroidered fabrics. And all this lies at the end of the two ways that lead to Kaminia.

LEFT: *the kitchen sink, filled with oranges and lemons.*
ABOVE: *an earthenware roof ornament in a wall niche.*

LINKS: *Orangen und Zitronen füllen den Spülstein in der Küche.*
OBEN: *In der Nische der Wand steht ein Dachornament aus Terrakotta.*

A GAUCHE: *Dans la cuisine, l'évier est rempli d'oranges et de citrons.*
CI-DESSUS: *Un ornement de toit en terre cuite a trouvé refuge dans une niche.*

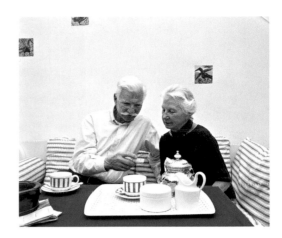

Um nach Kaminia, einem zauberhaften Dorf in den Hochlagen Hydras, zu gelangen, stehen einem zwei Wege offen: Der eine führt durch ein Straßengewirr und über Hunderte von Stufen, und der andere schlägt Wellen, denn er wird mit dem Schiff zurückgelegt. Tilly und Basile Touloumtzoglou kennen sie beide in- und auswendig, wohnen sie doch seit Ewigkeiten auf der Insel. Hierhin nämlich beschloss Basile – ehemals ein von der Familie Onassis sehr geschätzter Privatpilot – seinen Ruhesitz zu verlegen und hier empfängt Tilly mit Freude ihre Kinder, Enkel und zahlreichen Freunde. Für Tilly, die Holländerin, und Basile, den Griechen, ist Hydra ein Synonym für »es sich gut gehen lassen« und schöne Tage auf der Terrasse, ausgestreckt auf einer hübschen Liege im Schatten eines großen weißen Sonnenschirms. Den Touloumtzoglous sind Haus und Garten heilig. Das schöne Anwesen, das sie mit ihren Katzen Mavros und Kanelli teilen, zeichnet sich aus durch Möbel und Andenken aus dem Familienerbe, durch die elegante Form einer lackierten altertümlichen Blechlaterne, durch eine sehr gemütliche Küche und alte bestickte Stoffe. Und all dies liegt am Ende der zwei Wege, die nach Kaminia führen.

Pour se rendre à Kaminia, un village charmant sur les hauteurs d'Hydra, on peut choisir entre deux chemins: l'un est composé d'un dédale de rues et de centaines de marches et l'autre fait des vagues puisqu'il s'effectue en bateau. Tilly et Basile Touloumtzoglou les connaissent tous les deux par cœur car cela fait une éternité qu'ils sillonnent l'île. C'est ici en effet que Basile – un ancien pilote privé, très apprécié par la famille Onassis – a choisi de se retirer et que Tilly aime recevoir ses enfants, ses petits-enfants et ses nombreux amis. Pour Tilly la Hollandaise et Basile le Grec, Hydra est synonyme de bien-être et de belles journées sur la terrasse à l'ombre d'un grand parasol blanc, allongés sur une belle banquette. Pour les Touloumtzoglou, la maison et le jardin sont des endroits sacrés et le beau domaine qu'ils partagent avec leurs chats Mavros et Kanelli se distingue par la présence d'un mobilier et des souvenirs de famille, la forme élégante d'une lanterne en tôle peinte ancienne, d'une cuisine très «cosy» et de tissus anciens brodés. Et tout cela au bout de deux chemins qui mènent à Kaminia …

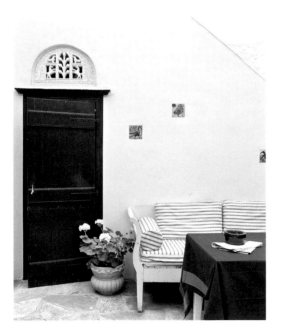

The blue and white terrace owes its refined decor to Tilly.

Das raffinierte Dekor der blauweißen Terrasse ist Tilly zu verdanken.

Le terrasse bleue et blanche doit son décor raffiné à Tilly.

The kitchen table, set for a family dinner. Tilly Touloumtzoglou is a notable cook whose "crème de bananes" is famous on the island.

Der Küchentisch ist für eine Mahlzeit im Familienkreis gedeckt. Mit ihrer berühmten »Bananencreme« wird die Hausherrin ihre Kochkünste unter Beweis stellen.

La table de cuisine est dressée pour un dîner en famille. La maîtresse de maison prouvera ses talents de cordon bleu en servant sa fameuse «crème de bananes».

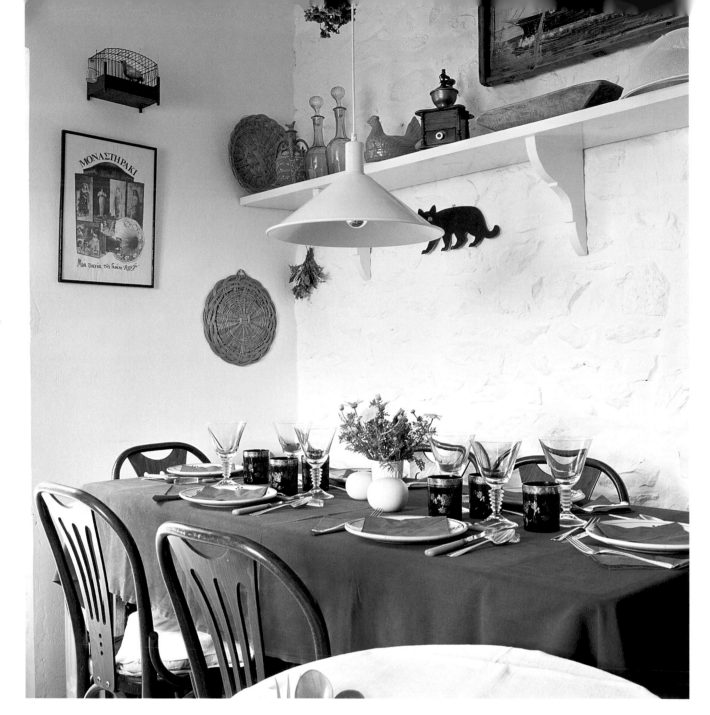

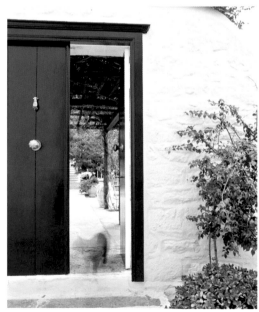

FAR LEFT: *Mavros, the cat, silhouetted in the front doorway.*
LEFT: *on the landing, a white painted tin lantern and a country chair.*
FACING PAGE: *Basile's brush beside a potted geranium, after a day's work in the garden.*

GANZ LINKS: *die Silhouette des Katers Mavros am Eingang.*
LINKS: *Eine lackierte Blechlampe hat ihren Platz auf einem rustikalen Stuhl im Obergeschoss gefunden.*
RECHTE SEITE: *Nach der Gartenarbeit hat Basile den breiten Pin-sel neben dem Gerani-entopf abgestellt.*

A L'EXTREME GAUCHE: *Sur le palier, une lanterne en tôle peinte a trouvé sa place sur une chaise rustique.*
A GAUCHE: *Tiens, le modèle a bougé. Près de l'entrée, la silhouette du chat Mavros ressemble à un spectre.*

PAGE DE DROITE: *Basile a terminé ses tra-vaux dans le jardin et il vient de poser sa brosse à côté d'un géranium en pot.*

LEFT: *Tilly collects antique cooking utensils. Sometimes their shapes resemble contemporary sculptures.*
FACING PAGE: *In the red and white guest bedroom, a superb piece of antique embroidery supplies a bedhead.*

LINKS: *Tilly sammelt alte Küchengeräte, deren Formen mitunter an moderne Skulpturen erinnern.*
RECHTE SEITE: *Eine prächtige alte Stickarbeit dient im rotweißen Gästezimmer als Wandschmuck neben dem Bett.*

A GAUCHE: *Tilly collectionne les ustensiles de cuisine anciens dont les formes évoquent parfois les sculptures contemporaines.*
PAGE DE DROITE: *Dans la chambre d'amis rouge et blanche, une superbe broderie ancienne fait office de fond de lit.*

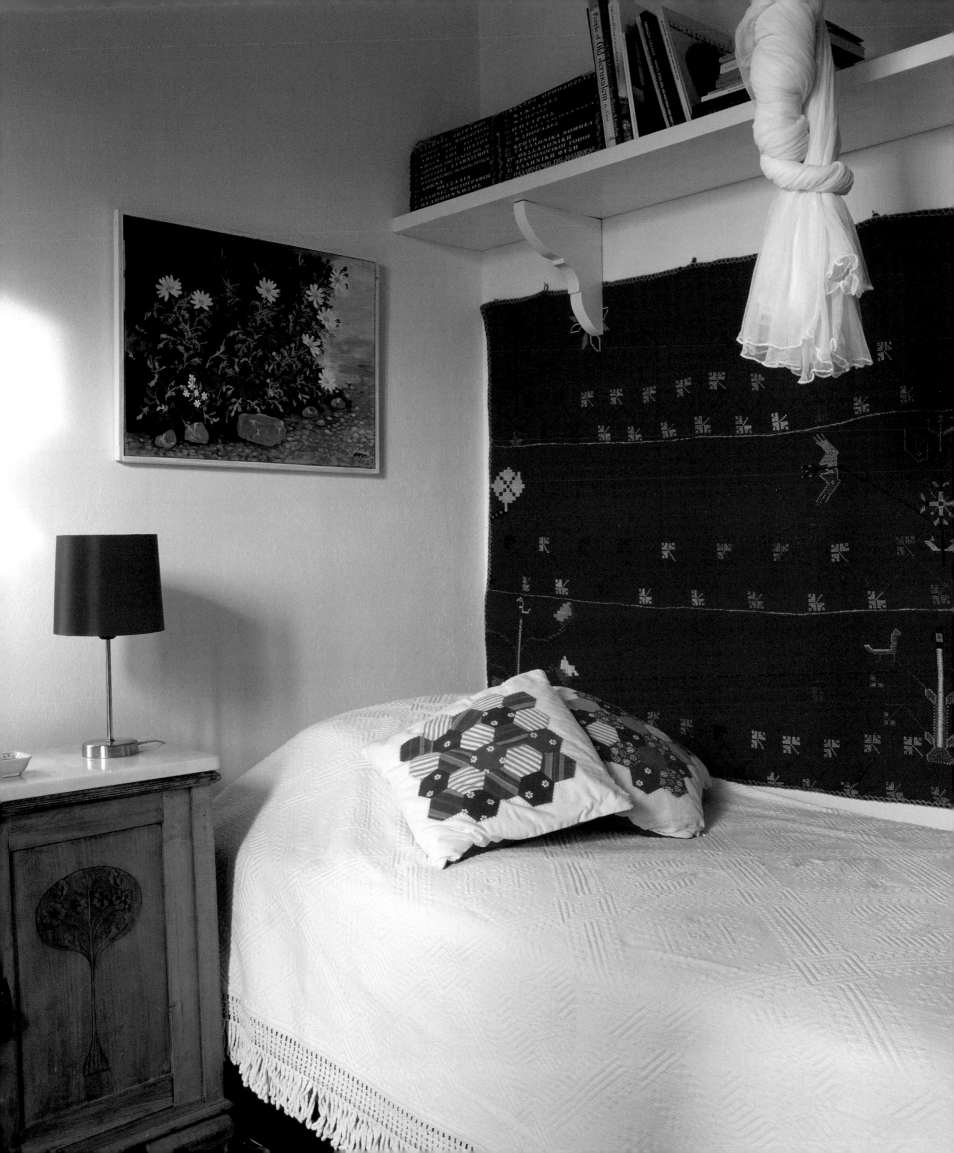

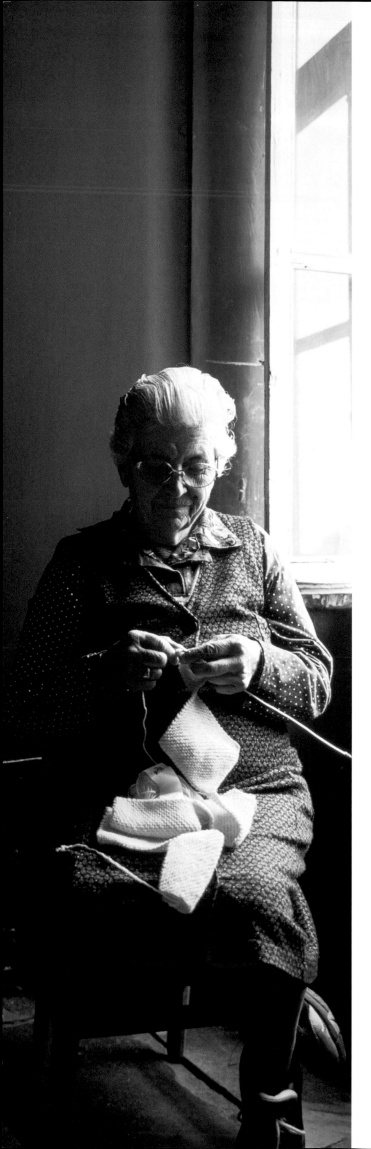

THE GOVERNOR'S PALACE

Argo-Saronic Islands

Built in the 18th century, under Ali Pasha's Turkish occupation, as a home for the Ottoman governor, this immense and aristocratic house is one of the best-kept secrets of the Argo-Saronic Islands. The access is difficult: you must either resign yourself to a primitive, winding path, or undertake the sea crossing, which can be rough and dangerous. Much admired by lovers of classical architecture, the former Governor's House is today inhabited by a large farming family, whose resources don't stretch to restoring the original refined décor, or acquiring fine old furniture and pictures. Instead, they have filled the great marble rooms with ordinary things: a simple couch covered with a crocheted rug, a vase of artificial flowers, a birdcage with a singing canary, and other homely items.

The farmer's wife, knitting beside her window.

Die am Fenster sitzende Bäuerin scheint völlig in ihre Arbeit versunken.

Assise près de la fenêtre, la fermière semble totalement absorbée par son ouvrage.

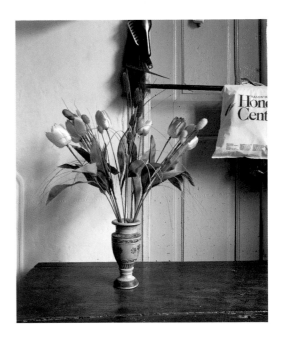

Der »Palast des Statthalters« wurde unter der türkischen Besetzung in der Regierungszeit von Ali Pascha im 18. Jahrhundert als Residenz des königlichen Repräsentanten erbaut. Das Gebäude scheint eines der bestgehüteten Geheimnisse auf dieser Argosaronischen Insel zu sein, selbst der Zugang zu dem weitläufigen Adelssitz ist schwierig. Entweder muss man einen urtümlichen Schleichpfad nehmen oder sich auf dem oft wild bewegten und gefährlichen Seeweg nähern. Der von Freunden klassischer Architektur bewunderte und von den Kunsthistorikern als seltene Perle beschriebene Palast beherbergt heute die vielköpfige Familie eines bescheidenen Landwirts, dessen Mittel es nicht erlauben, das raffinierte Dekor zu restaurieren, altes Mobiliar bereitzustellen und wertvolle Gemälde und Kunstgegenstände anzuschaffen. Die Familie, die in den geräumigen, mit Marmorböden belegten Sälen wohnt, begnügt sich mit einfachen Einrichtungsgegenständen, einem schlichten Sofa, auf dem ein Häkelteppich liegt, einer Vase mit künstlichen Blumen, einem Vogelkäfig, in dem ein lustiger Kanarienvogel tiriliert, und jener Fülle unvermeidlicher Sachen, die man vorzugsweise unter der Bezeichnung »Kitsch« zusammenfasst.

Construit au 18ᵉ siècle sous l'occupation turque et le règne d'Ali Pacha pour y loger le gouverneur, le «Palais du Gouverneur» semble être l'un des secrets les mieux gardés de cette île Argo-Saronique. Même l'accès à cette vaste demeure aristocratique est difficile. En effet, pour y accéder, il faut soit emprunter un chemin primitif et tortueux, soit naviguer sur une mer souvent agitée et dangereuse. Admiré par les amateurs d'architecture classique, décrit par les historiens d'art comme une perle rare, le palais abrite aujourd'hui la famille nombreuse d'un agriculteur modeste, dont les ressources, modestes elles aussi, ne permettent point la restauration d'un décor raffiné, la présence d'un mobilier ancien et l'acquisition de tableaux et d'objets d'art de valeur. Occupant les vastes salles dallées de marbre, la famille du fermier se contente d'un mobilier modeste, d'un simple canapé recouvert d'un tapis crocheté, d'un vase rempli de fleurs artificielles, d'une cage d'oiseaux où s'égosille un gai canari et de cette multitude d'objets inévitables qu'on réunit de préférence sous la dénomination de «kitsch».

The big rooms and marble floors speak volumes about the palace's past. Today, its farming inhabitants are content with simple furniture and the bright colours of crocheted bedcovers and the doorways.

Die weitläufigen Räumlichkeiten und Marmorfußböden deuten auf die vornehme Vergangenheit des Palastes hin. Seine heutigen Bewohner begnügen sich mit bescheidenen Möbeln und ein paar Farbtupfern wie etwa bunt gehäkelten Bettüberwürfen und himmelblau lackierten Türen und Einfassungen.

Les volumes spacieux et les sols en marbre trahissent le passé prestigieux de l'ancien palais. Aujourd'hui, les fermiers se contentent d'un mobilier modeste et de quelques notes de couleur apportées par des couvre-lits crochetés bariolés et des chambranles et des portes laqués bleu ciel.

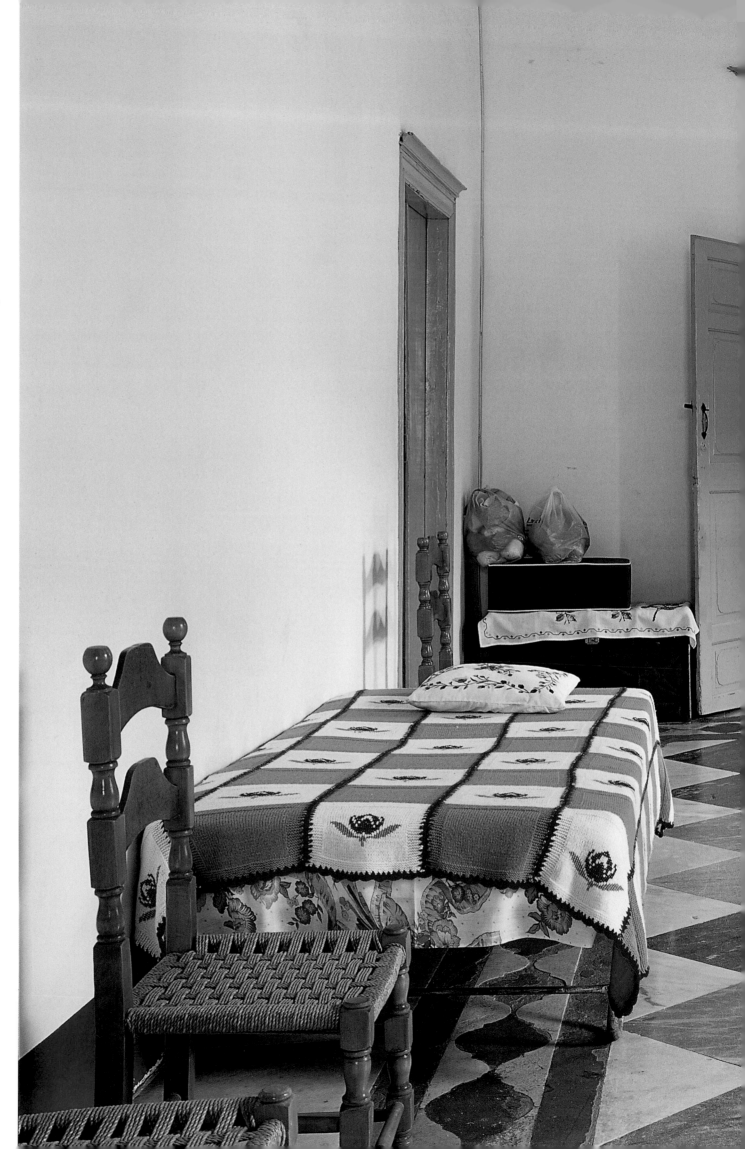

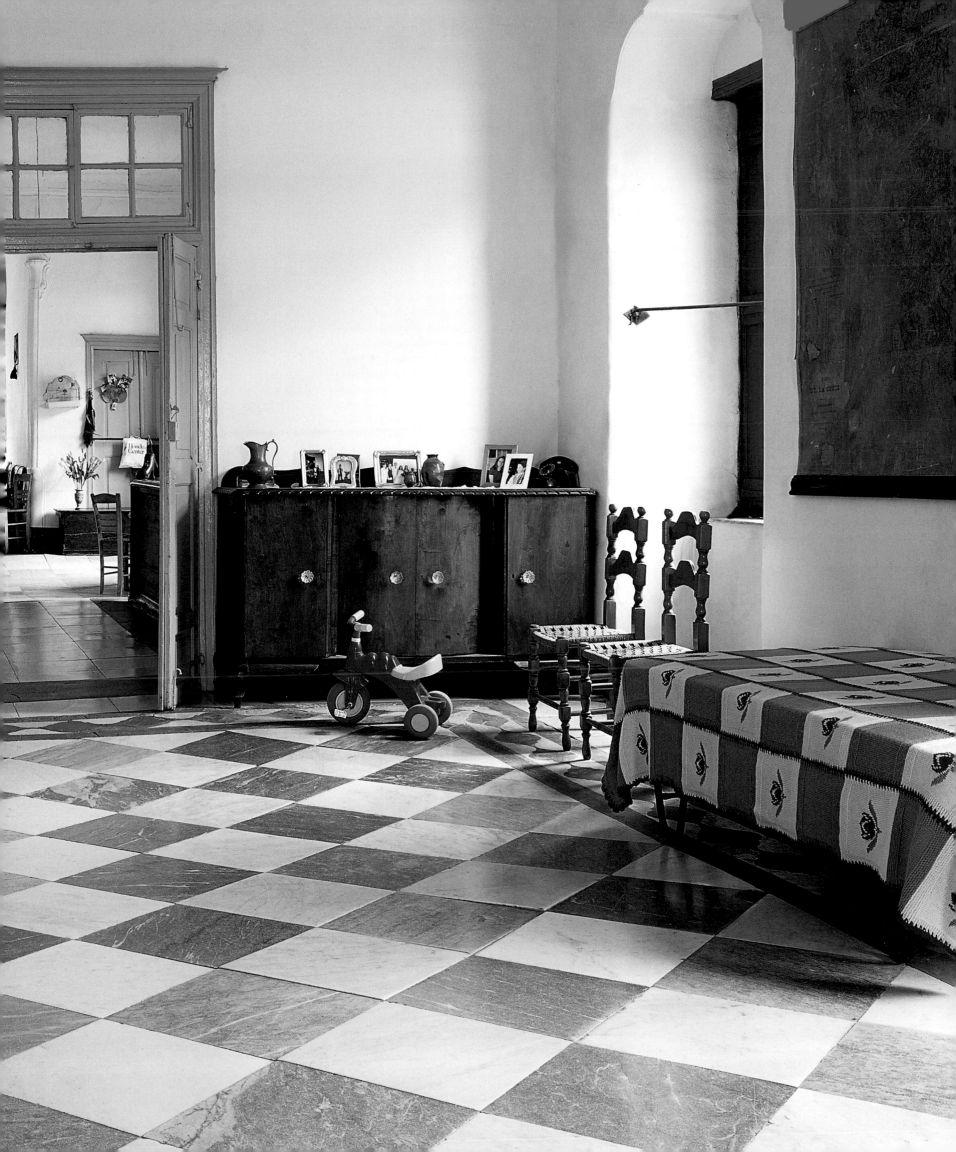

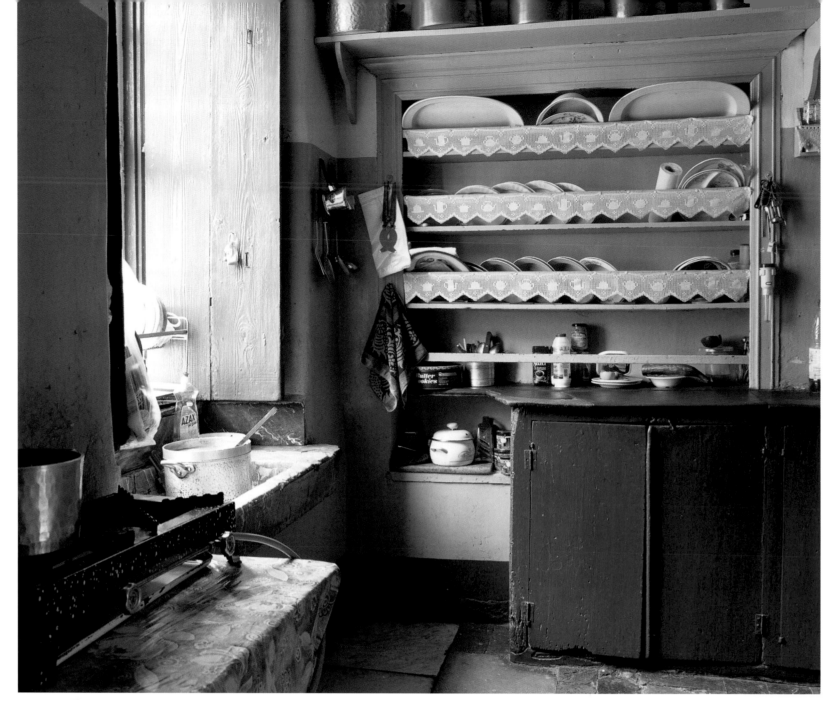

ABOVE: *The kitchen hasn't changed since the 18th century, if you don't count the favourite blues and greens of the inhabitants.*
RIGHT: *A rug on the wall of one of the bedrooms: "The Lion and the Infant".*
FACING PAGE: *Plastic flowers, a plastic bag, and a canary that sings all day at the top of its voice.*

OBEN: *Die Küche hat sich seit dem 18. Jahrhundert nicht verändert, allerdings haben die Bauersleute sie mit ihrem Lieblingsblau und -grün versehen.*
RECHTS: *Der Wandteppich »Kind und Löwe« verschönert dieses Schlafzimmer.*
RECHTE SEITE: *Plastikblumen und Plastiktüte – das 21. Jahrhundert macht sich bemerkbar. Der Kanarienvogel pfeift darauf und zwar aus Leibeskräften.*

CI-DESSUS: *La cuisine n'a pas changé depuis le 18ᵉ siècle, mais les fermiers lui ont imposé leur bleu et leur vert favoris.*
A DROITE: *Dans une chambre à coucher, un tapis à sujet sentimental – «L'enfant et le lion» – est censé embellir la pièce.*
PAGE DE DROITE: *Fleurs en plastique, sac en plastique … le 21ᵉ siècle est bien là. Le canari n'en a cure et chante à tue-tête.*

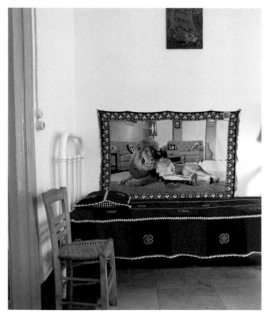

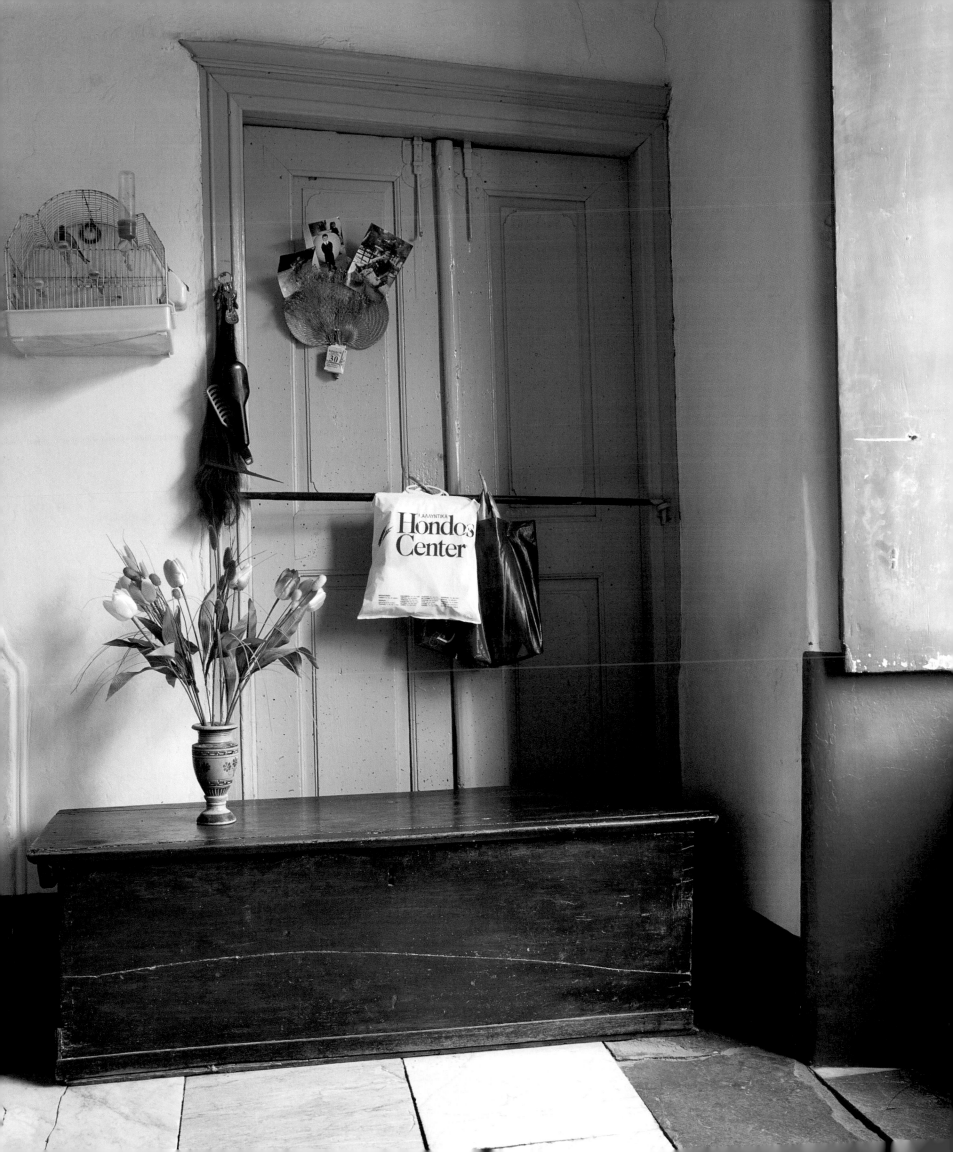

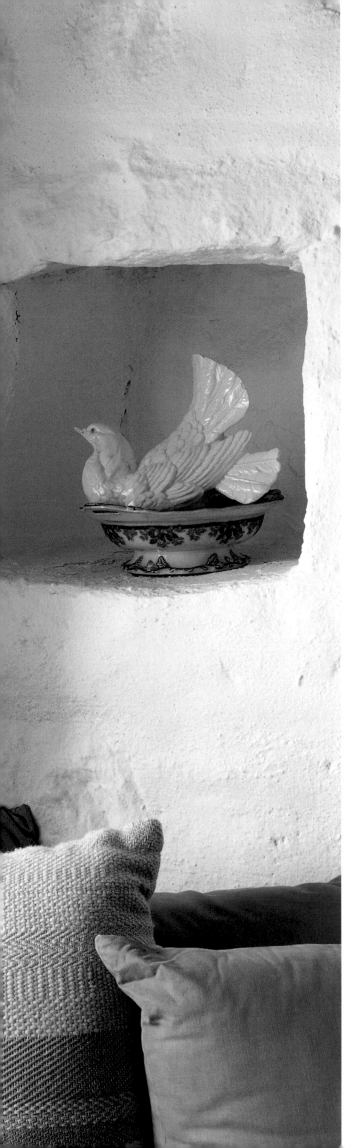

VASSILY TSEGHIS

Serifos

25 years ago, the architect Vassily Tseghis discovered the island of Serifos, on the edge of the magic circle of the Cyclades. As soon as he saw it, he was fascinated by the strange landscape of arid hills, whose tops are crowned with rocky outcrops or white villages with narrow streets. At that time, the village of Chora was innocent of tourists. And apart from Tseghis himself, who immediately bought a whole group of small houses on the hilltop, nobody seemed to realize that it was here, on this oddly-shaped rock with its Byzantine chapel, that the mythical Perseus chopped off the head of the Gorgon. Today, the small cabins restored by Vassily form a maze of charming houses; these are much in demand by members of the jet set, in search of a little peace in surroundings of great beauty. And since Tseghis's style – a harmony of blues and whites, Victorian couches and armchairs, Turkish sofas and neoclassical objects – corresponds to their need for discreet luxury – indeed Tseghis's own house serves as a showcase for these ones – the former lair of the Medusa has become an unlikely shrine of good taste.

PREVIOUS PAGES: *The view from the terrace, towards the rock where Perseus is said to have killed the Gorgon.* LEFT: *a 19th century ceramic dish with the effigy of a dove.*

VORHERGEHENDE DOPPELSEITE: *Die Terrasse bietet einen spektakulären Ausblick auf die Kapelle und den Felsen, wo Perseus die Medusa enthauptet haben soll.* LINKS: *eine Porzellanterrine aus dem 19. Jahrhundert, auf der eine Taubenfigur aufliegt.*

DOUBLE PAGE PRECEDENTE: *La terrasse offre une vue spectaculaire sur la chapelle et sur le rocher où Persée – dit-on – tua la Gorgone.* A GAUCHE: *Une terrine en céramique 19ᵉ surmontée de l'effigie d'un pigeon a été mise en sécurité dans une niche.*

Vor einem Vierteljahrhundert entdeckte der Architekt Vassily Tseghis am Saum des magischen Kreises, den die Kykladen bilden, die Insel Seriphos. Vom ersten Augenblick an war er fasziniert von der fremdartigen und kargen Hügellandschaft, deren Kuppen Felsmassen oder gänzlich weiße Ortschaften mit engen Gassen krönen. Damals war den Touristen das Dorf Chora kein Begriff. Und außer Tseghis, der sich sofort eine ganze Häusergruppe oben auf dem Gipfel sicherte, schien niemanden zu interessieren, dass gerade auf diesem bizarr geformten, von einer bzyantinischen Kirche überragten Felsen, Perseus der fürchterlichen Medusa das Haupt abschlug. Heute sind die kleinen Hütten, die Vassily in ein Labyrinth charmanter Häuschen umgewandelt hat, sehr gefragt in den Kreisen des Jetsets, der es stets auf Stille und Schönheit abgesehen hat. Das harmonische Zusammenspiel von Blau- und Weißtönen, viktorianischen Couchs und Sesseln, türkischen Sofas und klassizistischen Objekten kommt dem Bedürfnis dieser Menschen nach diskretem Luxus entgegen. Da Tseghis' Haus diesem Stil vollkommen entspricht, ist die einstige Landmarke der Medusa zu einer Hochburg des guten Geschmacks geworden.

Voilà un quart de siècle, l'architecte Vassily Tseghis découvrait l'île de Sérifos, située à l'orée du cercle magique formé par les Cyclades. Dès le premier coup d'œil, il fut fasciné par ce paysage étrange de collines arides dont les sommets sont couronnés d'une masse rocheuse ou d'un village tout blanc aux petites rues étroites. En ce temps-là, le village de Chora était ignoré des foules. Et hormis Tseghis, qui s'empara sans trop réfléchir de tout un ensemble de petites maison juchées au sommet, personne ne semblait s'aviser que c'est ici même, sur ce rocher aux formes bizarres dominé par une chapelle byzantine, que Persée réussit à couper la tête de l'horrible Gorgone. Aujourd'hui, les petites cabanes, transformées par Vassily en un dédale de maisonnettes charmantes, font l'envie d'un jet-set toujours avide de calme et de beauté. Et comme le style Tseghis – une harmonie de bleus et de blancs, canapés et fauteuils victoriens, sofas à la turque et objets néoclassiques – correspond à leur besoin de luxe discret et que sa maison fait office de maison modèle, l'ancien repère de la Méduse est devenu un haut lieu du bon goût.

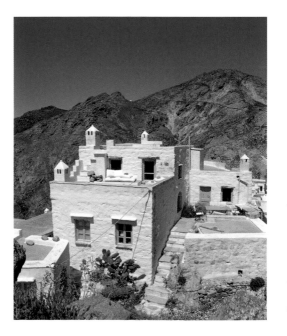

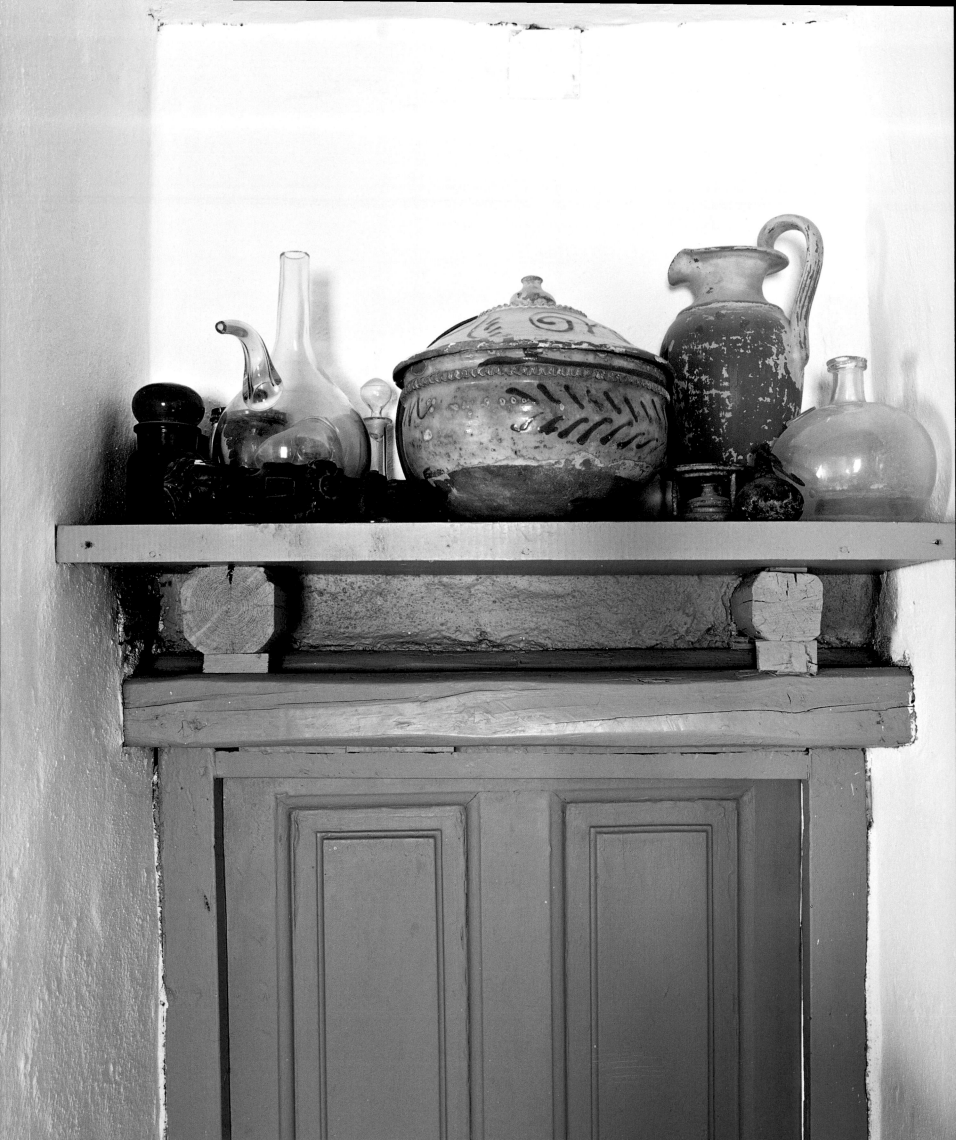

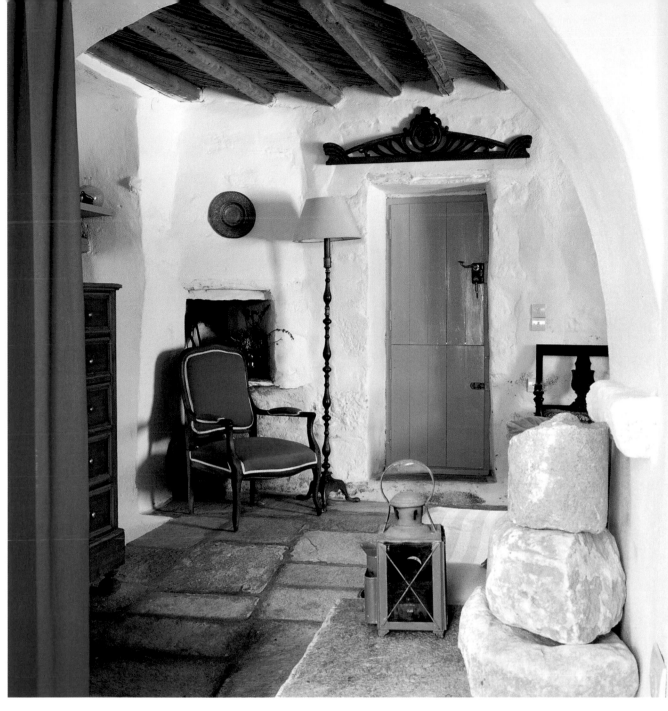

Vassily loves blue and white above all other colours, and it shows in every corner of his house.

Von Vassilys Leiden-schaft für Blau und Weiß kündet in seinem Haus jeder Winkel.

Vassily adore le bleu et le blanc et chaque coin de sa maison témoigne de sa passion.

FACING PAGE: *above the door, a collection of random objects.*
RIGHT: *a corner of the kitchen. The niche contains pots of jam and honey.*
FAR RIGHT: *In the "chora's" old bakery, now used as a guest annexe by Tseghis, a kitchenette is concealed in the cupboard.*

LINKE SEITE: *Über der Tür hat der Archi-tekt ein Still-Leben arrangiert.*
RECHTS: *Blick in eine Ecke der Küche. In der Nische stehen Marmela-dengläser und Honig.*

GANZ RECHTS: *In den Schrank der frühe-ren Backstube, die nun als Gästehaus dient, wurde eine Kochnische eingebaut.*

PAGE DE GAUCHE: *Au-dessus de la porte, l'architecte a créé une nature morte.*
A DROITE: *un coin de la cuisine. La niche contient des pots de confiture et de miel.*
A L'EXTREME DROI-TE: *Dans l'ancien four à pain du «chora», devenu la maison d'amis de Tseghis, la kitchenette se trouve dans le placard.*

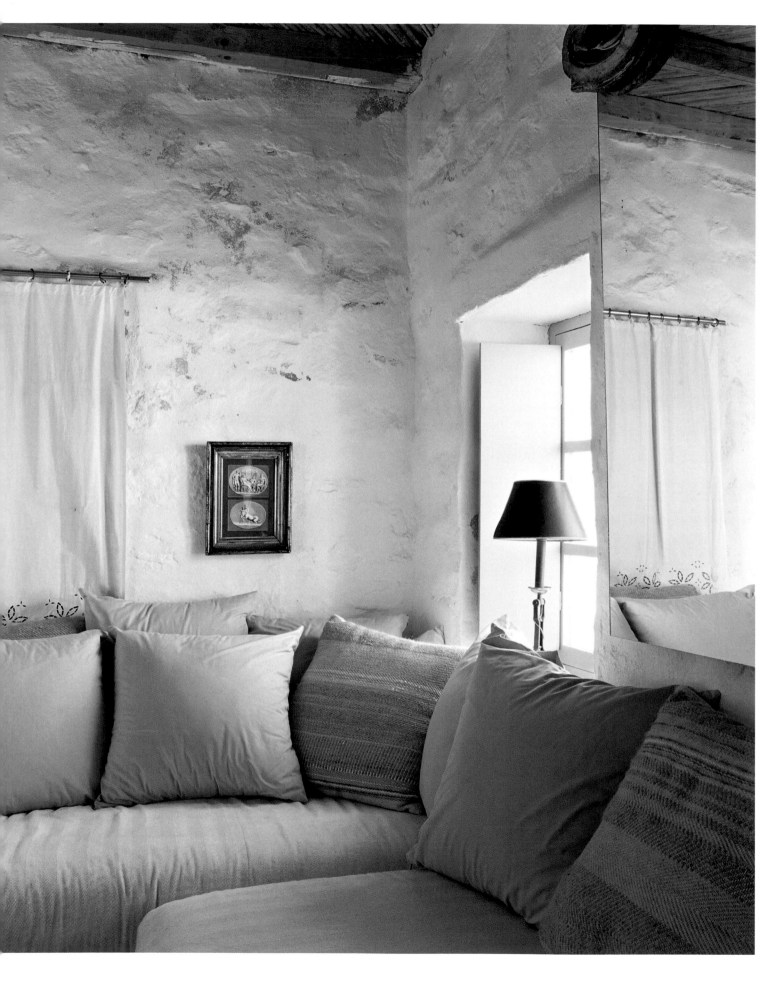

LEFT: *Comfortable sofas, couches and Turkish-style beds fill every spare corner.*
FACING PAGE: *an engraving framed in gold and Tyrrhenian pink, hanging on a blue door.*

LINKS: *Tseghis hat es gern gemütlich und so finden sich in seinem Haus zahlreiche Sofas, Couchs und türkische Betten, die zum Ausspannen einladen.*
RECHTE SEITE: *An einer blauen Tür hat der Architekt eine mit Gold und tyrrhenischem Rosa gerahmte alte Gravur aufgehängt.*

A GAUCHE: *Tseghis aime le confort, et sa maison abrite de nombreux sofas, des canapés et des lits à la turque qui invitent au repos.*
PAGE DE DROITE: *Sur une porte bleue, l'architecte a accroché une gravure ancienne encadrée d'or et de rose tyrrhénien.*

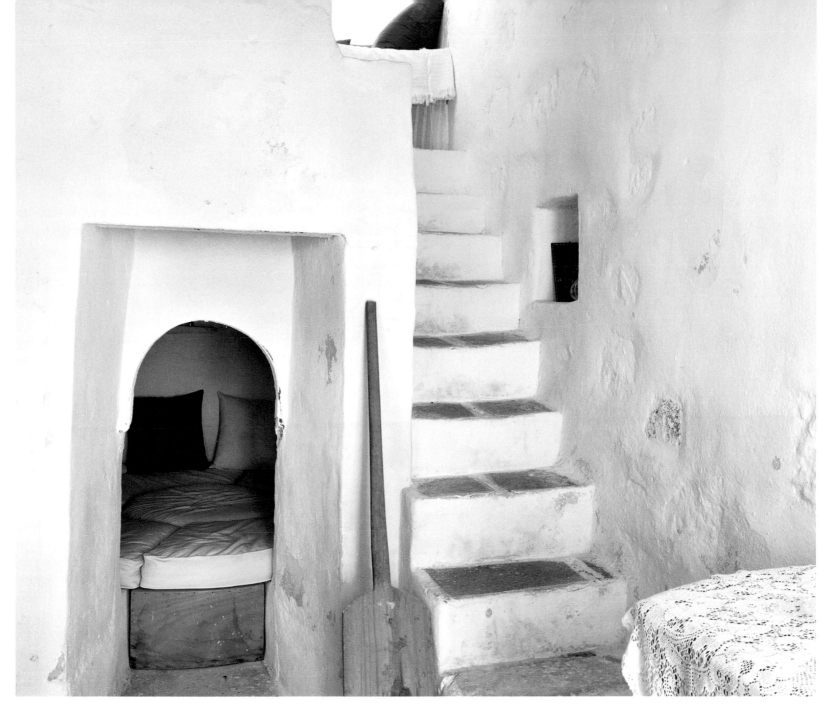

FACING PAGE: *the narrow street leading up to the "fournos", the old baking oven, with its brightly coloured doors and shutters.*

LINKE SEITE: *die Gasse zum »fournos«, dem alten Ofen, mit seinen farbenfrohen Fensterläden und Türen.*

PAGE DE GAUCHE: *la petite ruelle qui mène à l'ancien four – le «fournos» –, avec ses volets et ses portes aux couleurs vives.*

ABOVE: *In the old baking oven a broad circular sofa-bed has replaced the loaves and the wood fire.*

FOLLOWING PAGES LEFT: *A glass cross, a gift from a dear friend, hangs near the door.*

FOLLOWING PAGES RIGHT: *In the bakery, a mirror hung over the bed offers a view of what's going on in the street.*

OBEN: *In dem alten Ofen befindet sich statt Teigfladen und Holzfeuer ein großes rundes Bett.*

FOLGENDE DOPPELSEITE LINKS: *Das gläserne Kreuz, Geschenk eines engen Freundes, hängt neben der Tür.*

FOLGENDE DOPPELSEITE RECHTS: *Im Spiegel über dem Bett kann man aus dem Gästehaus beobachten, was in der Gasse geschieht.*

CI-DESSUS: *Dans l'ancien four un grand canapé-lit circulaire a remplacé les galettes de farine et le feu de bois.*

DOUBLE PAGE SUIVANTE A GAUCHE: *Une croix en verre, cadeau d'un ami cher, a trouvé une place d'honneur près de la porte.*

DOUBLE PAGE SUIVANTE A DROITE: *Dans le «fournos», un miroir accroché au-dessus du lit permet d'observer ce qui se passe dans la ruelle.*

\mathcal{N}IKOS KOSTOPOULOS

Serifos

Nikos Kostopoulos is a publisher of art books. In addition to his passion for all things beautiful, he has always been deeply in love with his native country. Having sailed all round Greece and its surrounding seas with the curiosity of a true explorer, he discovered a lost world of his own when he dropped anchor at Serifos, one of the most fascinating islands in the Cyclades. Buffeted from June to September by the "meltémi" – a stiff wind which blows steadily night and day – Serifos is nick-named "The Bald" because of its sparse vegetation. Its pride and joy are its mediaeval cloister – the Moni Taxiarchon – and its "chora", with a 15th century Venetian "kastro". But what most attracted Kostopoulos about the ancient refuge of Danae and her son Perseus, was a feature that had nothing to do with nature, history, or mythology. Instead it was a small square house of blinding whiteness, which he filled little by little with everything that attached him to "his" Greece, the Greece he loved: traditional furniture, seashells, fragments of antique statues, model ships, starfish, terracotta urns and a pasha's bed hidden in a corner niche.

A time-worn stone holds open the inside shutters.

Zum Fixieren der Innenläden dient ein uralter Stein.

Une grosse pierre, usée par le temps, sert à caler les volets intérieurs.

Nikos Kostopoulos ist Kunstbuchverleger, doch neben seiner Passion für alles Schöne verbindet ihn eine ausgesprochen innige Liebe mit seinem Heimatland. Er, der Griechenland in alle Himmelsrichtungen durchstreift und mit der Wissbegierde und dem Wagemut eines Entdeckers die hellenischen Meere durchquert hat, entdeckte seinen verlorenen »Kontinent«, als er auf einer der schönsten Kykladeninseln vor Anker ging. Das Eiland, das von Juli bis September vom »meltémi«, einem ununterbrochen wehenden starken Wind, durchfegt wird und wegen seiner spärlichen Vegetation den Beinamen »die Kahle« trägt, ist stolz auf sein mittelalterliches Kloster Moni Taxiarchon und auf seine »chora« mit einem venzianischen »kastro« aus dem 15. Jahrhundert. Doch was Kostopoulos zur uralten Zufluchtsstätte der Danae und ihres Sohnes Perseus zog, hatte nichts mit Natur, Geschichte oder Mythologie zu tun. Es war ein strahlend weißes quadratisches Häuschen, das er nach und nach mit all den Dingen füllte, die ihn mit »seinem« Griechenland verbinden: traditionelle Möbel, Muscheln, Fragmente antiker Statuen, Bootsmodelle, Seesterne, Terrakotta-Krüge und ein tief in einer Nische verborgenes Paschabett.

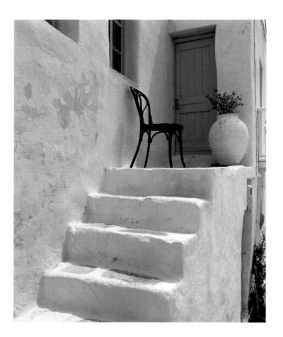

RIGHT: *a chair in the sunshine.*
FOLLOWING PAGES: *unpretentious objects which are the very soul of Greece.*

RECHTS: *ein Stuhl im Sonnenschein.*
FOLGENDE DOPPEL-SEITE: *unprätentiöse Dinge, die den eigentümlichen Reiz Griechenlands ausmachen.*

A DROITE: *Nikos a sorti une chaise pour profiter du soleil.*

DOUBLE PAGE SUIVANTE: *des objets sans prétention, qui incarnent la Grèce.*

Nikos Kostopoulos est éditeur de livres d'art, mais en dehors de sa passion pour tout ce qui touche à la beauté, il vit une histoire d'amour d'une intensité remarquable avec son pays natal. Ayant parcouru la Grèce en tous sens et sillonné ses mers avec la curiosité et le courage d'un explorateur, il découvrit son «continent» perdu en jetant l'ancre à Serifos, une des îles les plus fascinantes des Cyclades. Visitée de juillet à septembre par le «meltémi» – un vent puissant qui souffle sans interruption – et surnommée «La Chauve» à cause de sa végétation clairsemée, Serifos est fière de son cloître médiéval – le Moni Taxiarchon – et de son «chora» avec un «kastro» vénitien du 15e siècle. Mais ce qui a attiré Kostopoulos dans le très ancien refuge de Danaë et de son fils Persée, n'avait rien à voir avec la nature, l'histoire ou la mythologie, et prit la forme inattendue d'une petite maison carrée d'une blancheur éclatante qu'il a remplie peu à peu de tout ce qui l'attache à «sa» Grèce: meubles traditionnels, coquillages, fragments de statues antiques, maquettes de bateaux, étoiles de mer, jarres en terre cuite et un lit de pacha caché au fond d'une niche.

Donkeys and mules have been used for transport on the island from time immemorial.

Seit jeher gibt es auf der Insel Maultiere und Esel für den Transport.

Sur l'île, les ânes et les mulets assurent le transport depuis toujours.

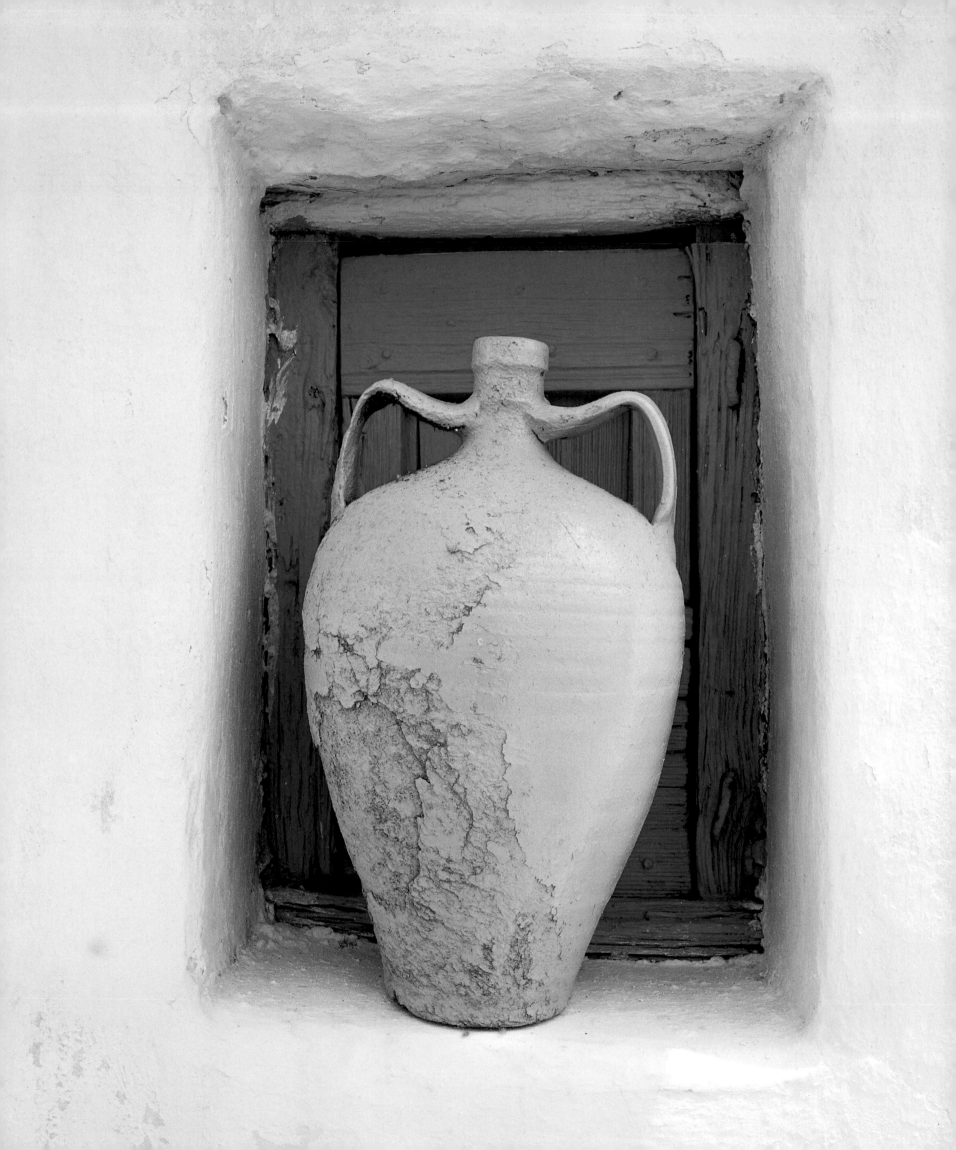

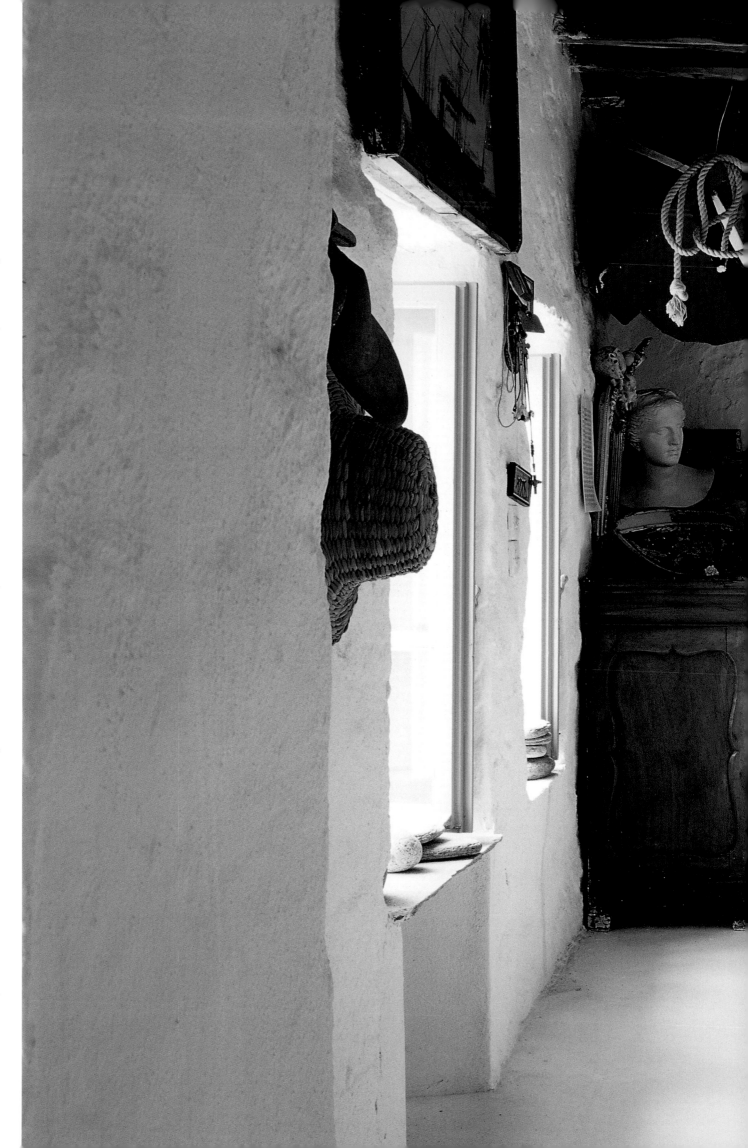

RIGHT: *"Happy is he who, like Ulysses, has travelled far"* … *The objects in the publisher's house all have a story to tell.*
FOLLOWING PAGE LEFT: *Nikos is an inveterate collector, and countless stones, pebbles, seashells and mirrors have found their way to his house on Serifos. The head of the Venus de Milo stands here as a homage to Greek beauty.*
FOLLOWING PAGE RIGHT: *a model fishing boat above a canape with blue cushions.*

RECHTS: *»Glücklich, wer wie Odysseus eine lange Reise tat« … Im Haus des Verlegers erzählen Erinnerungsstücke vom Meer und von fernen Gegenden.*
FOLGENDE DOPPELSEITE LINKS: *Als eingefleischter Sammler hortet Nikos Steine, Kiesel, Muscheln und Spiegel in seinem Haus auf Seriphos. Das Haupt der Venus von Milo ist eine Huldigung an die griechische Schönheit.*
FOLGENDE DOPPELSEITE RECHTS: *das Modell eines Fischerbootes über einem Sofa mit blauen Kissen.*

A DROITE: *«Heureux qui comme Ulysse a fait un long voyage» … Dans la maison de l'éditeur, les objets nous parlent de la mer et de contrées lointaines.*
DOUBLE PAGE SUIVANTE A GAUCHE: *Nikos est un collectionneur invétéré et nombre de pierres, de galets, de coquillages et de miroirs ont trouvé le chemin de Serifos. La tête de la Vénus de Milo est un hommage à la beauté grecque.*
DOUBLE PAGE SUIVANTE A DROITE: *Le modèle réduit d'un bateau de pêche navigue au-dessus d'un canapé aux coussins bleus.*

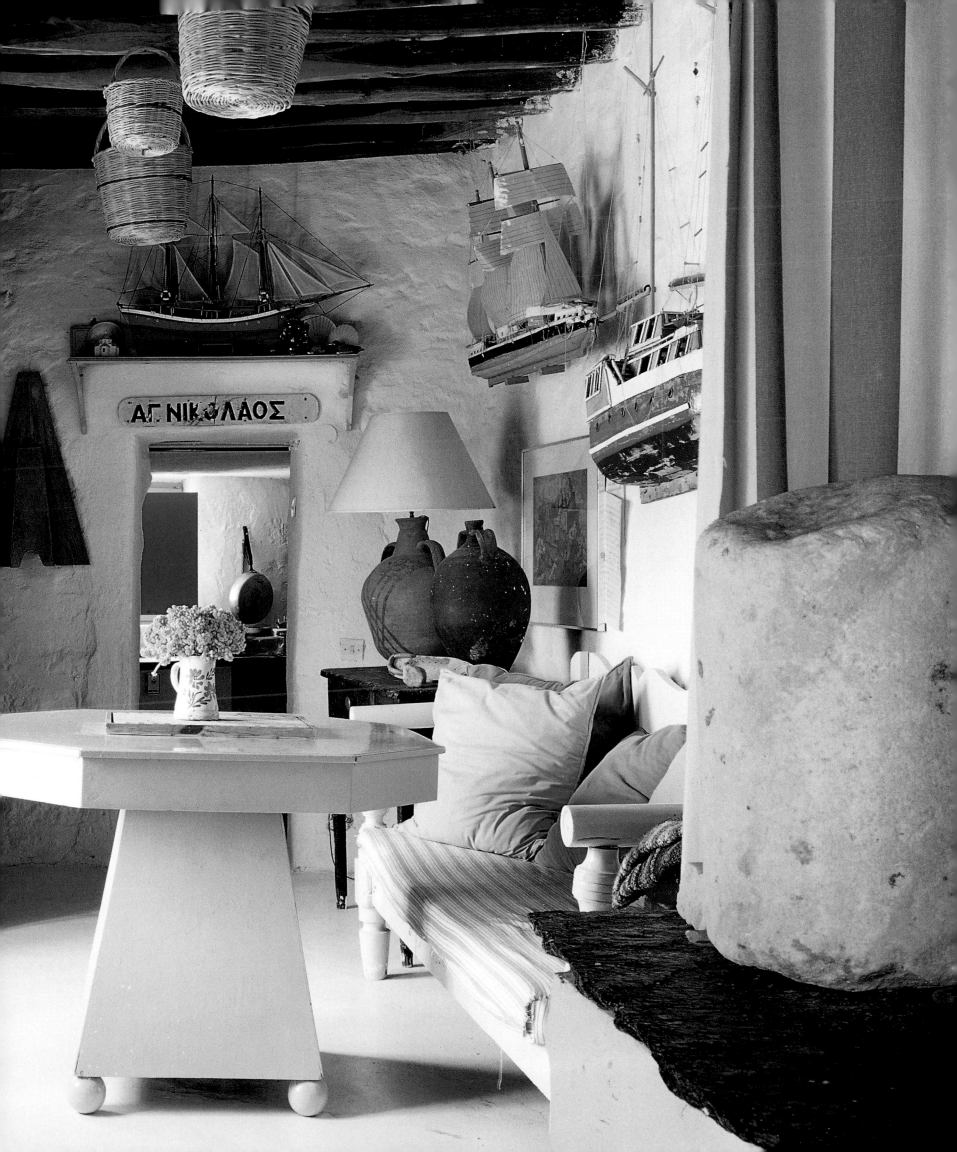

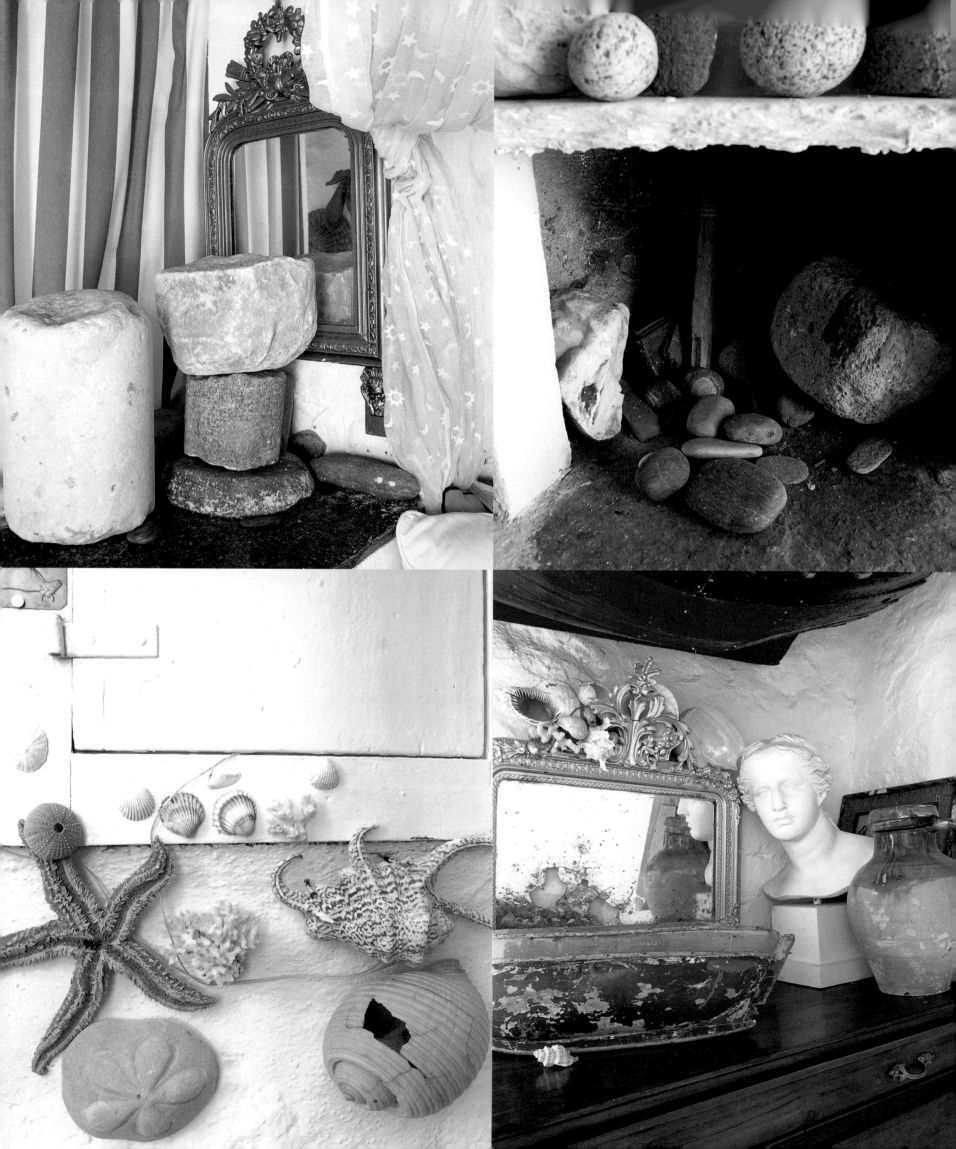

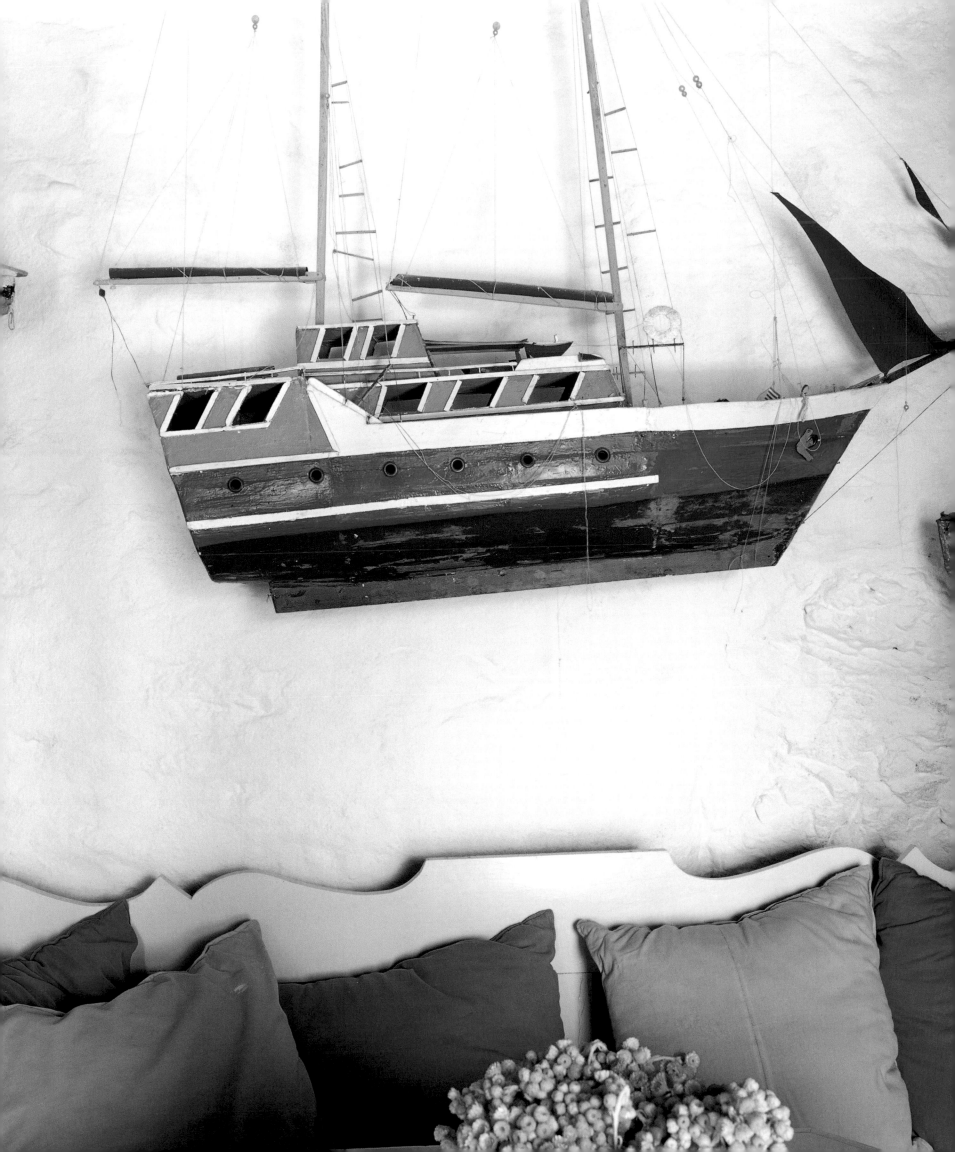

\mathcal{M} IRIAM FRANK

Serifos

Miriam Frank divides her time between London and the island of Serifos. She has spent the last six months in her small "chora" house, engrossed in the writing of her first full-length book. Around her the silence is complete, except for the voices of occasional passersby on their way to the church. When you see Miriam's everyday décor, you understand why she chose to buy this beautiful, comfortable house, entirely restored and decorated, which perfectly reflected her tastes and in which she could spend all her time writing. Saved in extremis a few years ago by the architect Vassily Tseghis, her neighbour, who turned the three existing tumbledown cabins into an attractive guesthouse, the white "spiti" has everything a writer could desire. Miriam loves to tell how she first arrived here, how she came down the steep steps leading to the front door, and how she had her first sight of the turn-of-the-century furniture, the Thonet chairs and the pure white décor with its touches of red and raspberry-coloured fabrics. And then came the first night in the old brass four-poster … she had found her dream, made to measure, at the end of a narrow street on Serifos.

The traditional white-washed Greek exterior.

Wie so viele griechische Häuser ist auch dieses gekälkt.

Comme bien d'autres maisons grecques, celle-ci est blanchie à la chaux.

Miriam Frank lebt in London und auf der Insel Seriphos. Während der vergangenen sechs Monate, die sie in ihrem kleinen Haus in der »chora«, dem Hauptort, verbrachte, hat Miriam an ihrem ersten großen Buch gearbeitet. Die Stille um sie herum wird kaum unterbrochen von den vereinzelten Passanten, die zur Kirche hinaufsteigen. Schaut man sich in ihrer Umgebung um, so leuchtet ein, weshalb Miriam einen schönen und komfortablen Wohnsitz gekauft hat. In dem rundum restaurierten und vollständig ausgestatteten Haus, das ganz nach ihrem Geschmack ist, kann sie schreiben. Vor einigen Jahren hatte der Architekt Vassily Tseghis, ihr Nachbar, drei zerfallene Gemäuer im letzten Moment gerettet und in ein gemütliches Gästehaus verwandelt. Der »spiti«, das Haus, hatte alle Eigenschaften, um der Autorin zu gefallen. Mit Vorliebe erzählt sie von ihrem ersten Besuch, wie sie die steilen Stufen zur kleinen Eingangstür hinabstieg, vom ersten Blick auf das Mobiliar der Jahrhundertwende, die Thonet-Stühle und die blütenweiße, von roten und himbeerfarbenen Stoffen aufgelockerte Dekoration. Und dann folgte die erste Nacht in dem alten Himmelbett aus Kupfer. Für sie realisierte sich ein Traum, am Ende einer engen Gasse auf Seriphos.

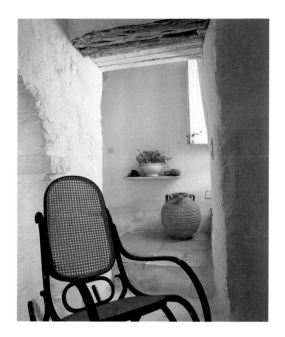

Behind the rocking chair, a stone staircase leads to the entrance hall.

Die Treppe hinter dem Schaukelstuhl führt zur Eingangstür.

Derrière le fauteuil à bascule, un escalier en pierre mène à la porte d'entrée.

Elle partage son temps entre Londres et l'île de Serifos et, durant les six mois passés dans sa petite maison du «chora», Miriam Frank s'applique à écrire son premier grand livre. Autour d'elle, le silence est à peine interrompu par les voix des rares passants qui montent vers l'église. Et en observant son décor quotidien, on comprend pourquoi Miriam a choisi d'acquérir une demeure belle et confortable, une maison entièrement restaurée et décorée, qui reflétait parfaitement ses goûts et dans laquelle elle pourrait se consacrer à l'écriture. Sauvé «in extremis» il y a quelques années par l'architecte Vassily Tseghis, son voisin, qui a transformé trois maisonnettes délabrées en une maison d'amis accueillante, le «spiti» tout blanc avait tout pour plaire à l'écrivain. Elle adore évoquer sa première visite et la descente des marches raides menant à la petite porte d'entrée. Le premier coup d'œil sur le mobilier fin de siècle, les chaises Thonet et le décor tout blanc rehaussé par des tissus rouges et framboise. Et la première nuit passée dans l'ancien lit à baldaquin en cuivre. Un rêve sur mesure, qui l'attendait au bout d'une ruelle étroite de Serifos …

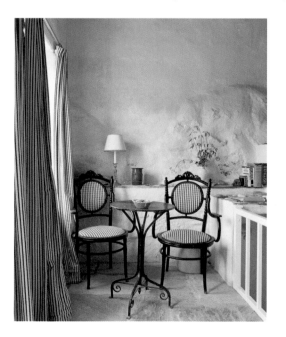

Beside the window, a pedestal table and a pair of Thonet-style chairs.

Am Fenster hat der Architekt einen kleinen runden Tisch und Stühle im Thonet-Stil platziert.

Près de la fenêtre, l'architecte a installé un guéridon et une paire de chaises de style Thonet.

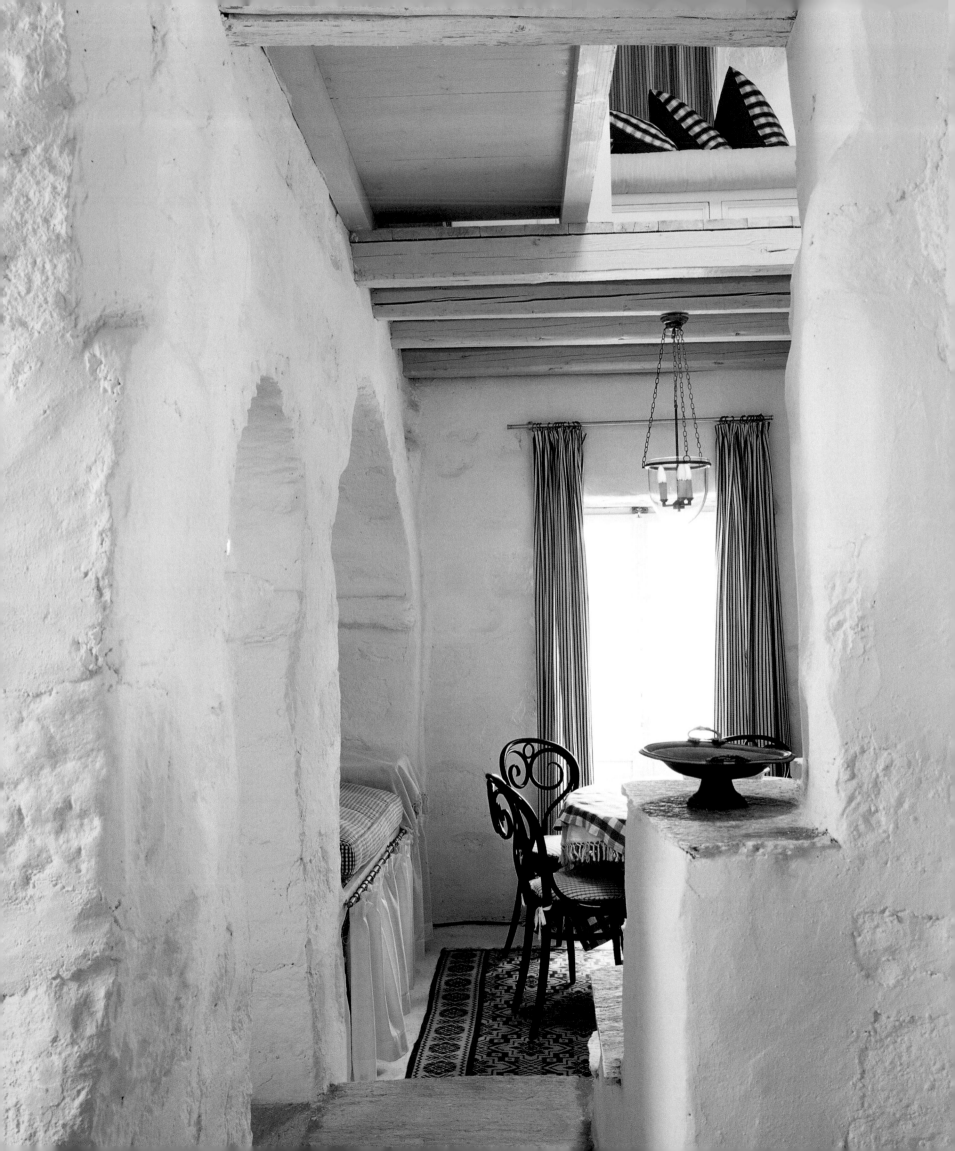

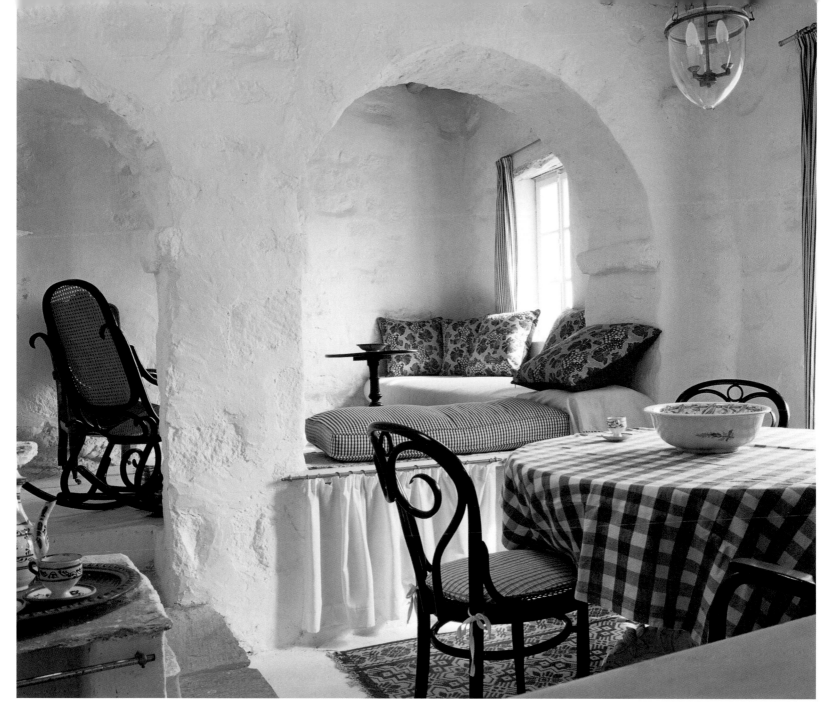

FACING PAGE: *Miriam Frank immediately fell in love with the house and the colours chosen for it by Tseghis.*
ABOVE: *Checks, stripes, a geometrically-patterned rug and flowered cushions exist here in harmony, thanks to their shared palette of red and white.*
RIGHT: *The kitchen is in the lower area of the house. Here too, red and white predominate.*

LINKE SEITE: *Miriam Frank hat sich auf Anhieb in dieses Haus und die von Tseghis ausgewählten Farben verliebt.*
OBEN: *Karos, Streifen, ein geometrisch gemusterter Teppich und geblümte Kissen harmonieren dank der rot-weißen Farbpalette.*
RECHTS: *Die Küche befindet sich im unteren Teil des Hauses. Auch hier geben Rot und Weiß den Ton an.*

PAGE DE GAUCHE: *Miriam Frank s'est tout de suite éprise de la maison et des couleurs choisies par Tseghis.*
CI-DESSUS: *Des carreaux, des rayures, un tapis à motifs géométriques et des coussins fleuris s'harmonisent grâce à la palette rouge et blanche.*
A DROITE: *La cuisine se trouve dans la partie basse de la maison. Ici aussi, règnent le rouge et le blanc.*

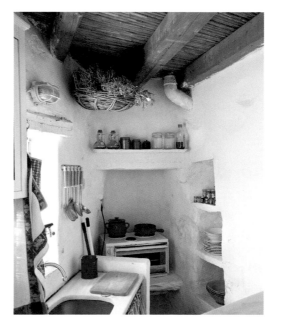

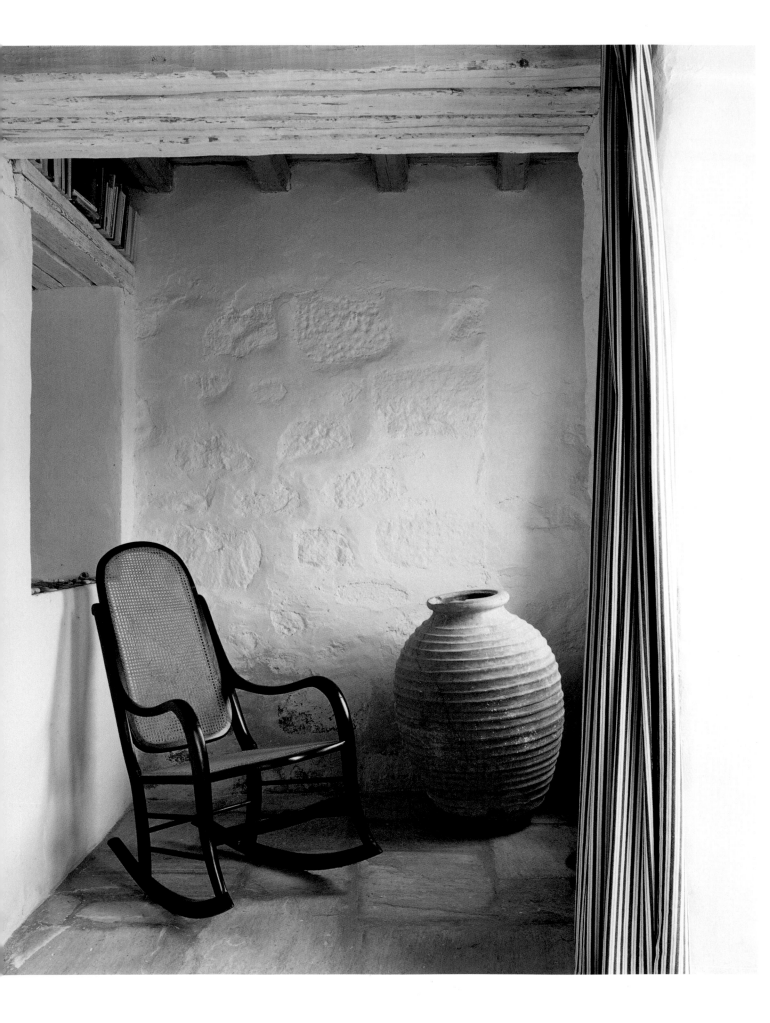

LEFT: *calm and silence and a bare room.*
FACING PAGE: *This bench is Miriam's favourite place to rest: from the window there's a perfect view of the sea and the surrounding landscape.*

LINKS: *Nichts geht über eine schlichte ausgewogene Einrichtung.*
RECHTE SEITE: *Miriam liebt diese Bank, denn von hier hat sie einen herrlichen Ausblick auf Landschaft, Himmel und Meer.*

A GAUCHE: *Rien de tel qu'un décor dépouillé où rien ne vient troubler la sérénité.*
PAGE DE DROITE: *Miriam adore se reposer sur cette banquette et, de la fenêtre, elle a une vue merveilleuse sur le paysage, le ciel et la mer.*

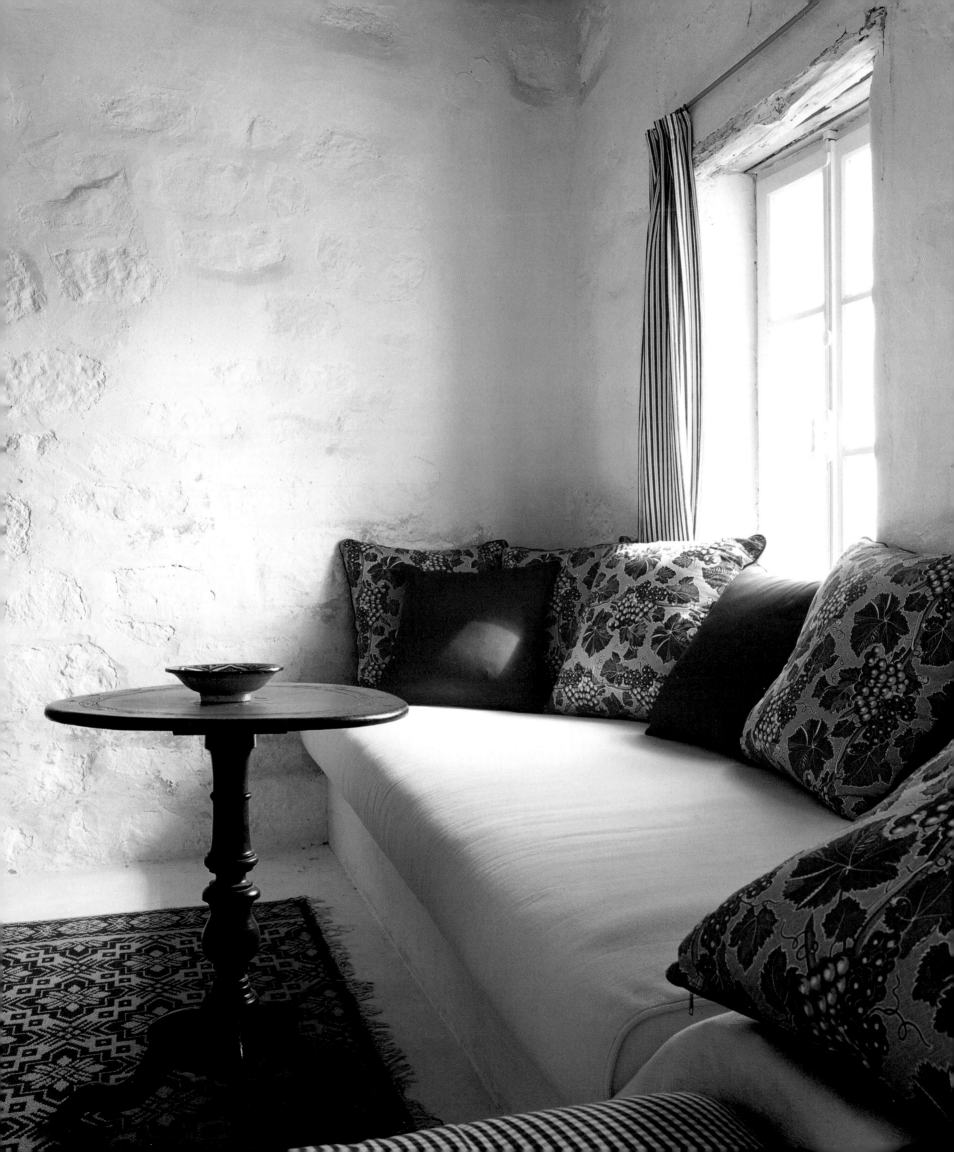

Tseghis is a master of the use of space: in this writer's house, a labyrinth of narrow staircases and landings lead through to the main bedroom.

Geschickt jongliert Tseghis mit Volumen und Ebenen. Im Haus der Schriftstellerin führt ein Labyrinth von Treppchen und Stufen ins Schlafzimmer.

Tseghis sait jongler avec les volumes et les niveaux et, dans la maison de l'écrivain, un labyrinthe de petits escaliers et de paliers mène à la chambre à coucher.

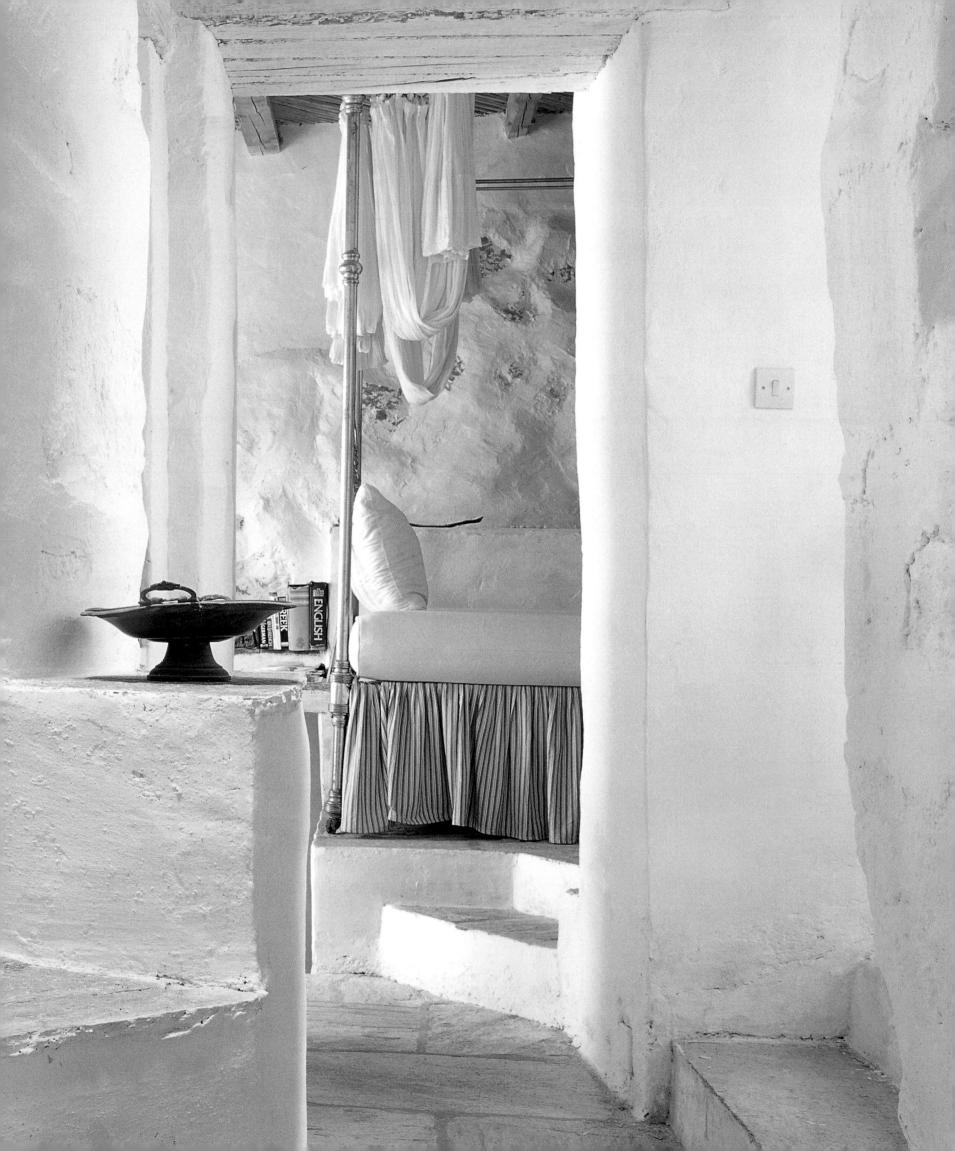

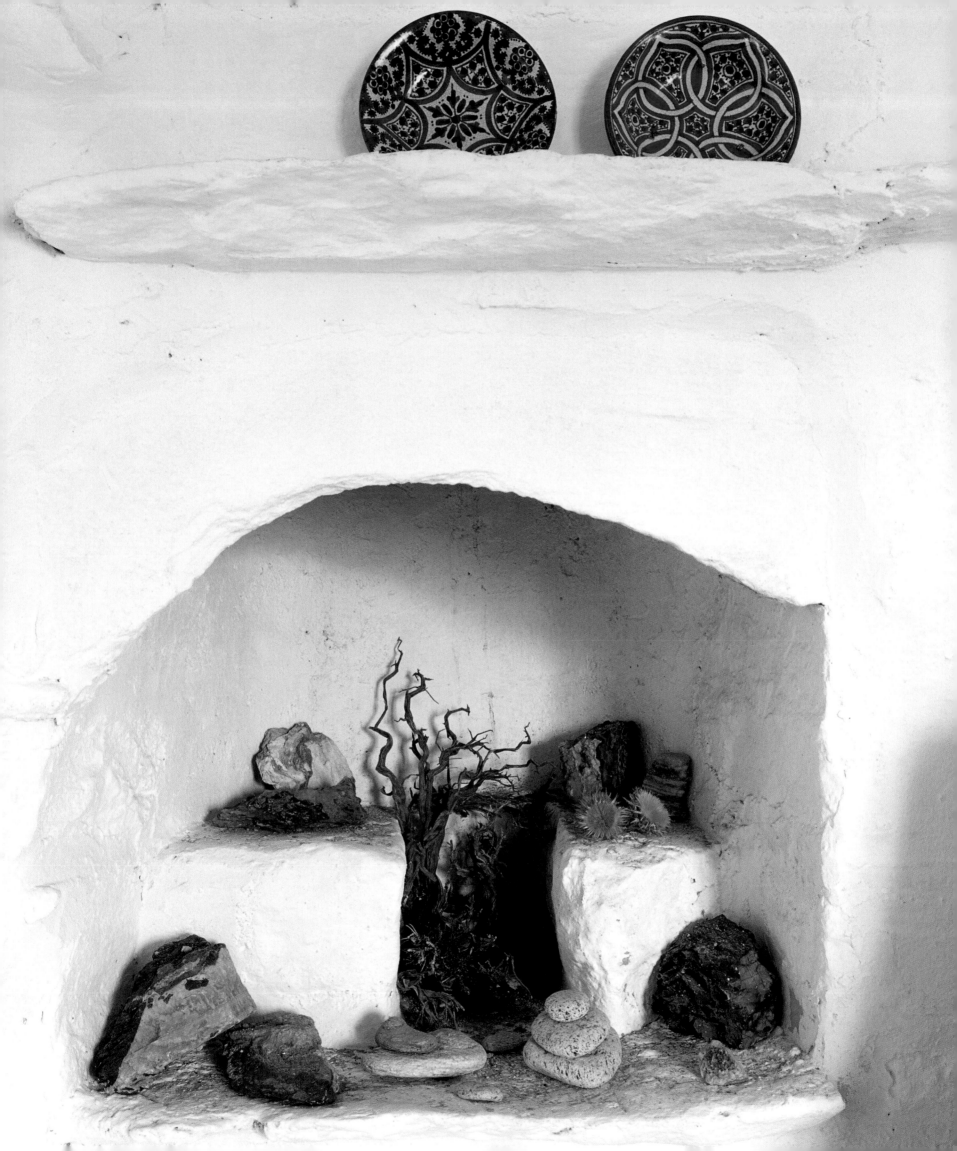

LEFT: *Here Tseghis has installed a small but thoroughly practical bathroom in a space behind the bedhead.*

LINKS: *In einem Raum hinter der Kopfseite des Bettes hat Tseghis ein bescheidenes, aber sehr praktisches Badezimmer eingerichtet.*

A GAUCHE: *Tseghis a installé une salle de bains modeste, mais très pratique, dans un espace derrière la tête du lit.*

FACING PAGE: *When there's no fire in the grate, Miriam decorates the fireplace with things she's found. The oriental dishes add a note of colour.*
RIGHT: *an old brass four-poster bed on its stone platform in the bedroom.*

LINKE SEITE: *Wenn Miriam den Kamin nicht nutzt, dekoriert sie die Feuerstelle mit Fundstücken. Die orientalischen Teller setzen schöne Farbtupfer.*
RECHTS: *Auf dem Steinpodest im Schlafzimmer erhebt sich ein altes kupfernes Himmelbett.*

PAGE DE GAUCHE: *Quand elle ne fait pas de feu, Miriam décore l'âtre avec ses trouvailles. Les plats orientaux apportent une note de couleur.*
A DROITE: *Un ancien lit à baldaquin en cuivre trône sur la plateforme en pierre de la chambre à coucher.*

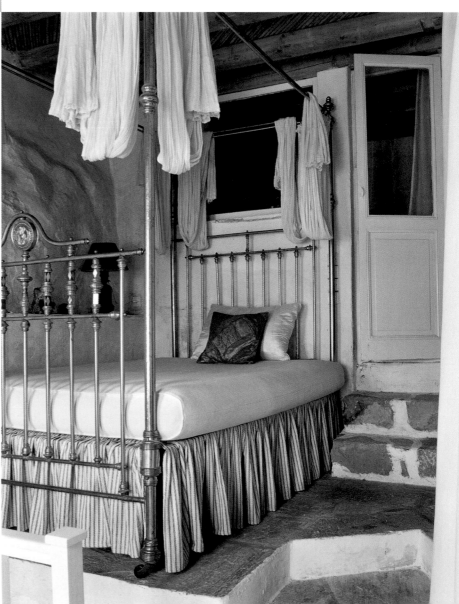

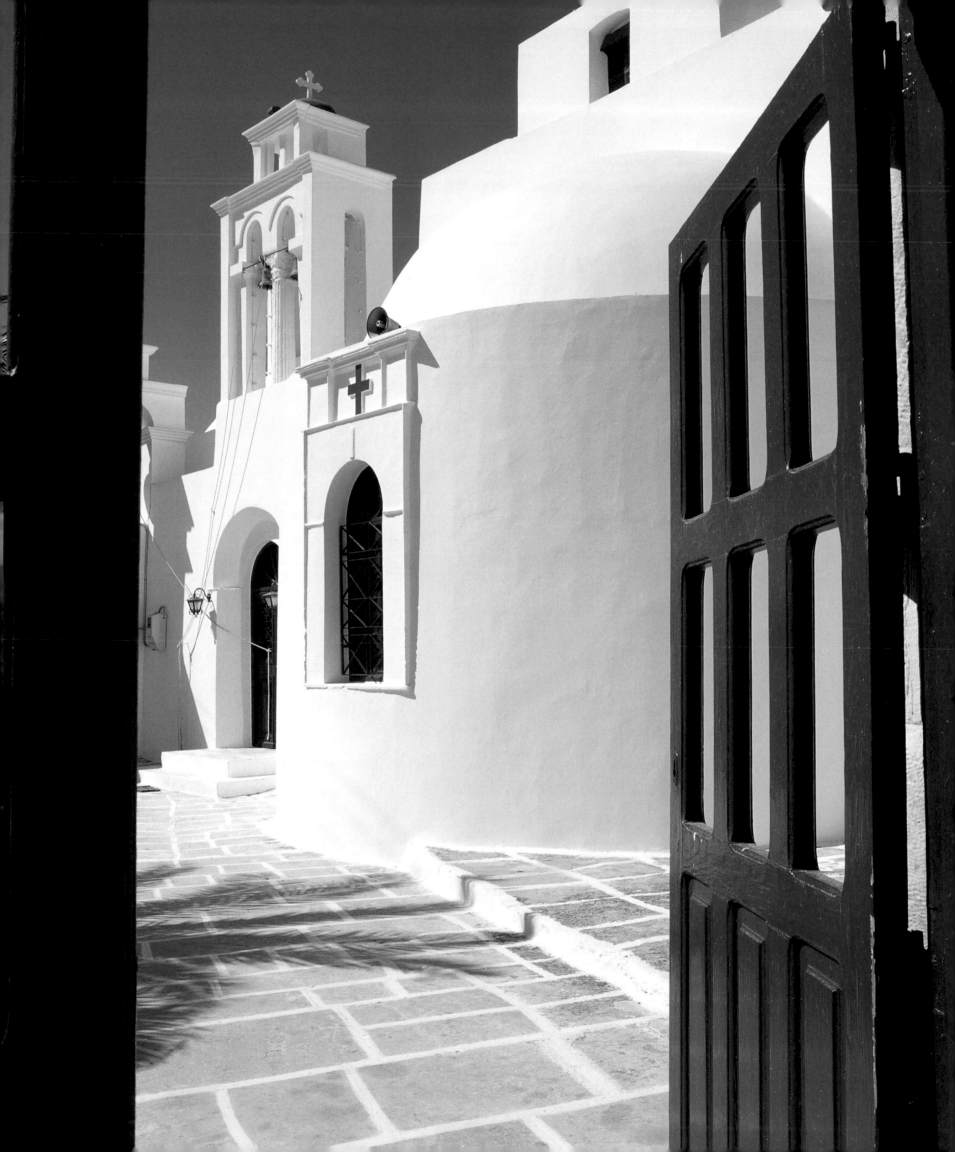

PREVIOUS PAGES:
The "chora" of Serifos
has a beautiful "pla-
teia", with a church and
blue-and-white houses
in the best traditions of
Greek architecture.
LEFT: Zorbas's "tav-
erna" is a homage to all
the tavernas in Greece –
strings of dried tomatoes
and rows of bottles and
glasses.
FACING PAGE: The
walls of the taverna are
covered in photos, naive
paintings and super-
annuated advertise-
ments.

VORHERGEHENDE
DOPPELSEITE: Die
»chora« von Seriphos
hat eine wunderschöne
»plateia«, einen Platz
mit Blick auf die Kirche
und die traditionellen
weißblauen Häuser.
LINKS: Zorbas' »taver-
na« hält den Stil grie-
chischer Gasthäuser in
Ehren und pflegt den
Brauch, aufgefädelte
getrocknete Tomaten an
der Decke aufzuhängen
und Flaschen und Glä-
ser aufzureihen.
RECHTE SEITE: Die
Wände der »taverna«
sind übersät von Fotos,
naiven Gemälden und
altmodischen Werbe-
schildern.

DOUBLE PAGE PRE-
CEDENTE: Le «chora»
de Serifos séduit par le
charme de son «pla-
teia», où le regard s'at-
tarde sur une église
et des maisons bleues
et blanches dans la
meilleure tradition
grecque.
A GAUCHE: La «taver-
na» de Zorbas est un
hommage à toutes les
tavernas de Grèce et
perpétue la tradition des
guirlandes de tomates
séchées et des rangées de
bouteilles et de verres.
PAGE DE DROITE: Les
murs de la «taverna»
sont couverts de photos,
de tableaux naïfs et
d'affiches publicitaires
surannées.

\mathcal{P}ANOS
ALEXOPOULOS

Serifos

It's been many years since Panos Alexopoulos first discovered the island of Serifos and laid claim to a group of small houses at the foot of the mediaeval "kastro". Undeterred by their dilapidated state, he set about injecting new life into these old stones – with such success that today, at the dawn of the third millennium, what was once a ruin has become a beautiful white house, magnificent in its austerity and simplicity. Under the watchful eye of the architect Vassily Tseghis (an old friend), the project emerged as a series of spaces that seem to overlap one into the next with effortless logic. From the living room with its ample sofa bed and cushions covered in geometrical motifs, to the mezzanine where the architect has managed to fit in a bedroom and bathroom, you have the clear impression that you're in a space much larger than is really the case. Furthermore, the windows offer a stunning view of the port, and the ubiquitous blue of the paint marries perfectly with the sunlight of Greece: all of which adds to the charm of this most original house.

All Greek island houses seem to contain some kind of reference to the sea.

Immer findet man in den Inselhäusern Hinweise auf das Meer.

Partout dans les maisons des îles, on trouve des références à la mer.

Etliche Jahre ist es nun her, dass Panos Alexopoulos die Insel Seriphos entdeckte und ein Auge auf eine Gruppe kleiner Häuser am Fuß des mittelalterlichen »kastro«, der Burg, warf. Der Anblick eines von der Zeit zerfressenen Trümmerhaufens schreckte ihn nicht ab und er ließ diesen Phönix aus seiner Asche auferstehen. Zu Beginn des dritten Jahrtausends ist nichts mehr von der früheren Ruine zu erkennen: Das steinerne Wrack hat die Gestalt eines schönen weißen Hauses angenommen, schlicht und schnörkellos. Unter dem wachsamen Auge des Architekten Vassily Tseghis (ein Freund seit jeher) sind Räume entstanden, die wie selbstverständlich ineinander verschachtelt sind. Angefangen beim Wohnraum, in dem sich ein großes Bettsofa mit geometrisch gemusterten Kissen befindet, bis hin zum Mezzanin, in dem ein Schlafzimmer und ein Bad untergebracht sind – stets hat man den Eindruck sich in einem sehr viel weitläufigeren Raum aufzuhalten. Auch die Fenster, die einen fantastischen Blick auf den Hafen freigeben, und das kräftige Blau, das so gut mit dem griechischen Licht harmoniert, verleihen diesem Haus Charme.

Voilà bien des années que Panos Alexopoulos a découvert l'île de Serifos et qu'il a jeté son dévolu sur un groupe de petites maisons au pied du «kastro» médiéval. Alexopoulos ne se laissa pas décourager par la vue d'un tas de pierres rongées par le temps et entama des travaux qui feraient renaître ce phœnix de ses cendres. A l'aube du troisième millénaire, rien ne subsiste de l'ancienne ruine et l'épave en pierre a pris l'aspect d'une belle maison blanche toute de dépouillement et de simplicité. Sous l'œil vigilant de l'architecte Vassily Tseghis (un ami de toujours) est né un jeu de volumes qui semblent s'imbriquer l'un dans l'autre de manière presque évidente. Du séjour avec son grand canapé-lit et ses coussins aux motifs géométriques, à la mezzanine où l'architecte a réussi à loger une chambre à coucher et une salle de bains, on garde l'impression de se trouver dans un espace beaucoup plus vaste. Et puis, il y a les fenêtres qui donnent une merveilleuse vue sur le port, et la présence du bleu vif qui va de pair avec la lumière grecque et contribue au charme de cette maison charismatique.

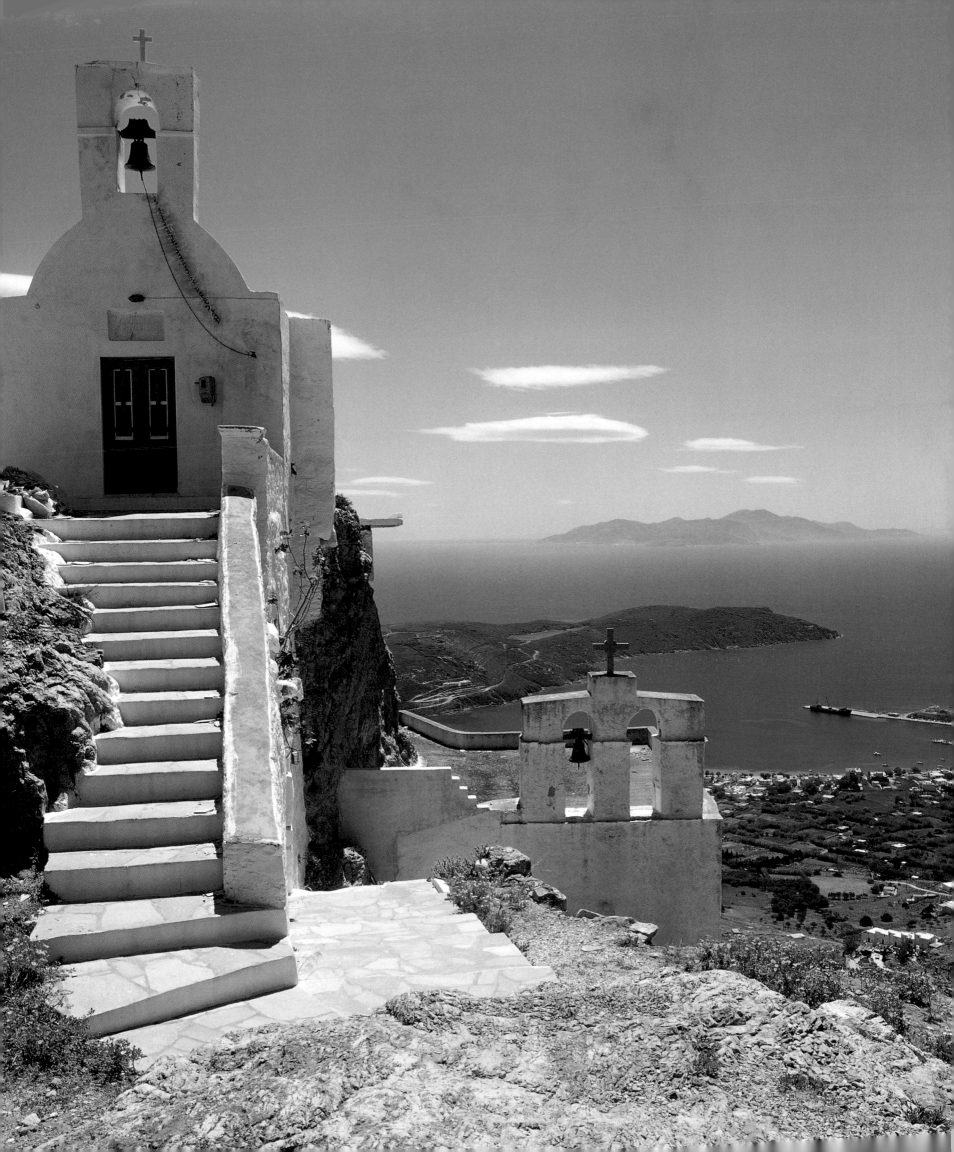

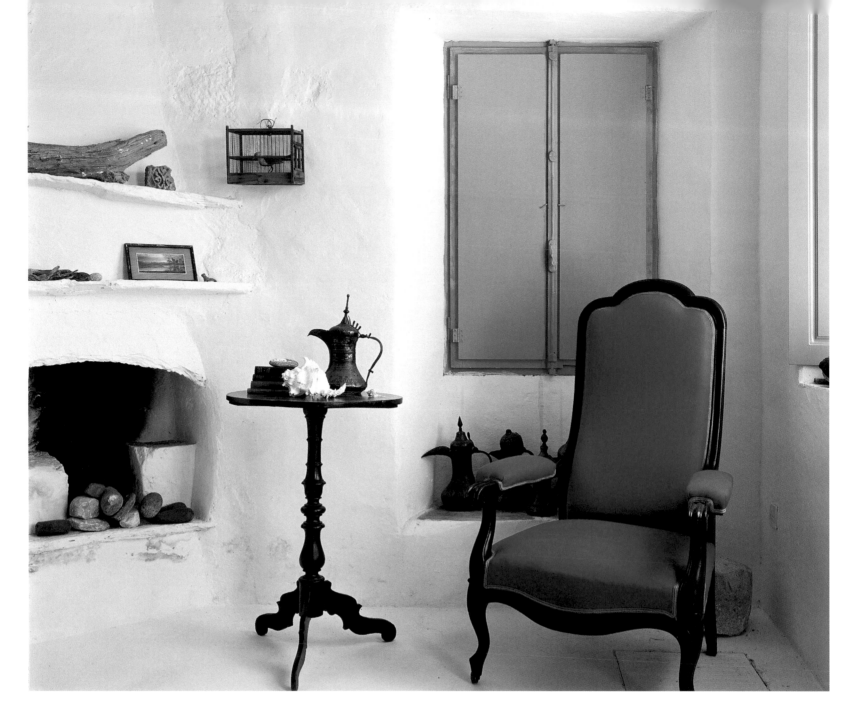

PREVIOUS PAGES: *the small chapel of the "chora", with its blue door and simple cross, and the spectacular view across the port of Livadi.*
ABOVE: *a Victorian chair covered with bright blue fabric, which heightens the effect of the surrounding décor.*
RIGHT: *an old well pulley brought back from Saudi Arabia by Panos.*
FACING PAGE: *a conch shell caught by the sun's rays.*

VORHERGEHENDE DOPPELSEITE: *die kleine Kapelle der »chora« mit ihrer durch ein schlichtes Kreuz verzierten Tür und die spektakuläre Sicht auf den Hafen von Livadi.*
OBEN: *Das äußerst kräftige Blau des viktorianischen Sessels lässt die übrige Einrichtung zurücktreten.*
RECHTS: *Diese uralte Brunnenwinde hat Panos von einem Aufenthalt in Saudi-Arabien mitgebracht.*
RECHTE SEITE: *die Muschel leuchtet in der Sonne.*

DOUBLE PAGE PRECEDENTE: *la petite chapelle du «chora», avec sa porte bleue garnie d'une simple croix, et la vue spectaculaire sur le port de Livadi.*
CI-DESSUS: *Le siège victorien a été recouvert de tissu bleu vif et sa tache de couleur estompe le reste du décor.*
A DROITE: *une très ancienne poulie de puits rapportée par Panos d'un séjour en Arabie saoudite.*
PAGE DE DROITE: *Un rayon de soleil effleure un coquillage.*

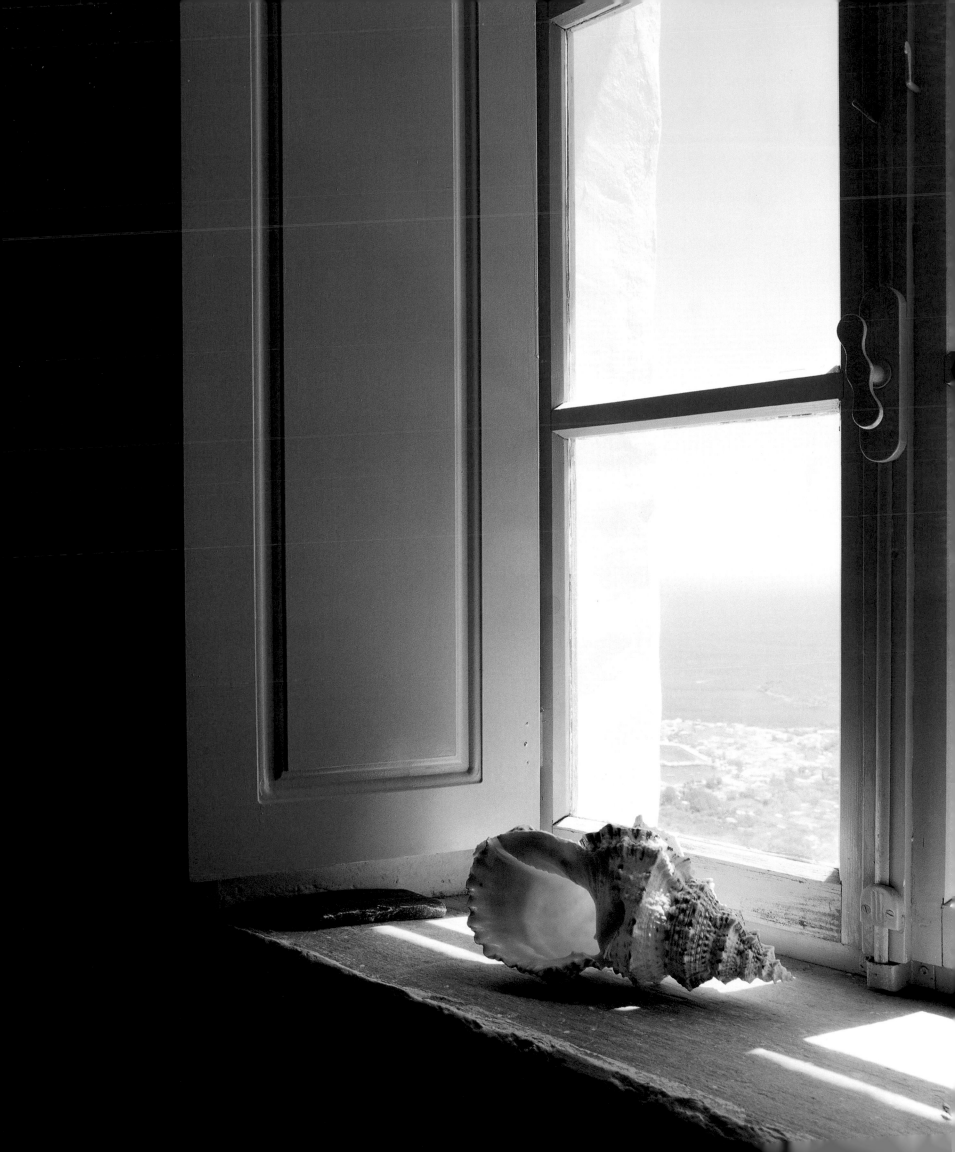

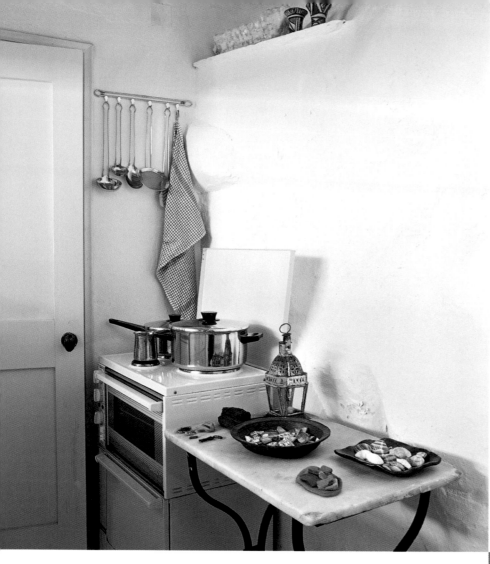

LEFT: *The kitchen is functional but like everywhere else in this house there's always room for a charming detail such as a white wrought iron lantern or a tray of stones and seashells.*

FACING PAGE: *the sofa bed and its pile of geometrically patterned cushions, all designed by the architect. The 19th century mirror frame has been painted white to go with the rest of the room.*

LINKS: *Wie überall im Haus, findet sich bei aller Zweckmäßigkeit auch in der Küche ein Plätzchen für reizvolle Details, hier eine Laterne aus Weißblech und Schalen, die mit Kieseln und Muscheln gefüllt sind.*

RECHTE SEITE: *Auf dem Bettsofa tummeln sich Kissen, deren geometrische Muster der* Architekt selbst entworfen hat. Der Spiegel aus dem 19. Jahrhundert wurde passend zu Mauern, Deckenbalken und Boden weiß gestrichen.

A GAUCHE: *La cuisine est fonctionnelle mais, comme partout dans cette maison, il y a toujours de la place pour un détail charmant tels cette lanterne en fer blanc et ces plateaux remplis de galets et de coquillages.*

PAGE DE DROITE: *Le canapé-lit et son amoncellement de coussins à motifs géométriques dessinés par l'architecte. Et pour s'harmoniser à la blancheur des murs, des poutres et du sol, le cadre du miroir 19ᵉ a été badigeonné de peinture blanche.*

RIGHT: *The staircase leading to the first floor runs up the back wall of the room.*

RECHTS: *Die Treppe zum Obergeschoss schmiegt sich eng an die rückwärtige Wand des Raumes.*

A DROITE: *L'escalier qui mène à l'étage se blottit contre le mur du fond.*

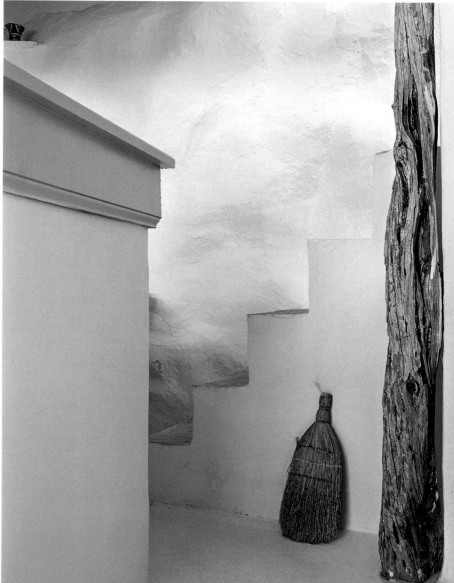

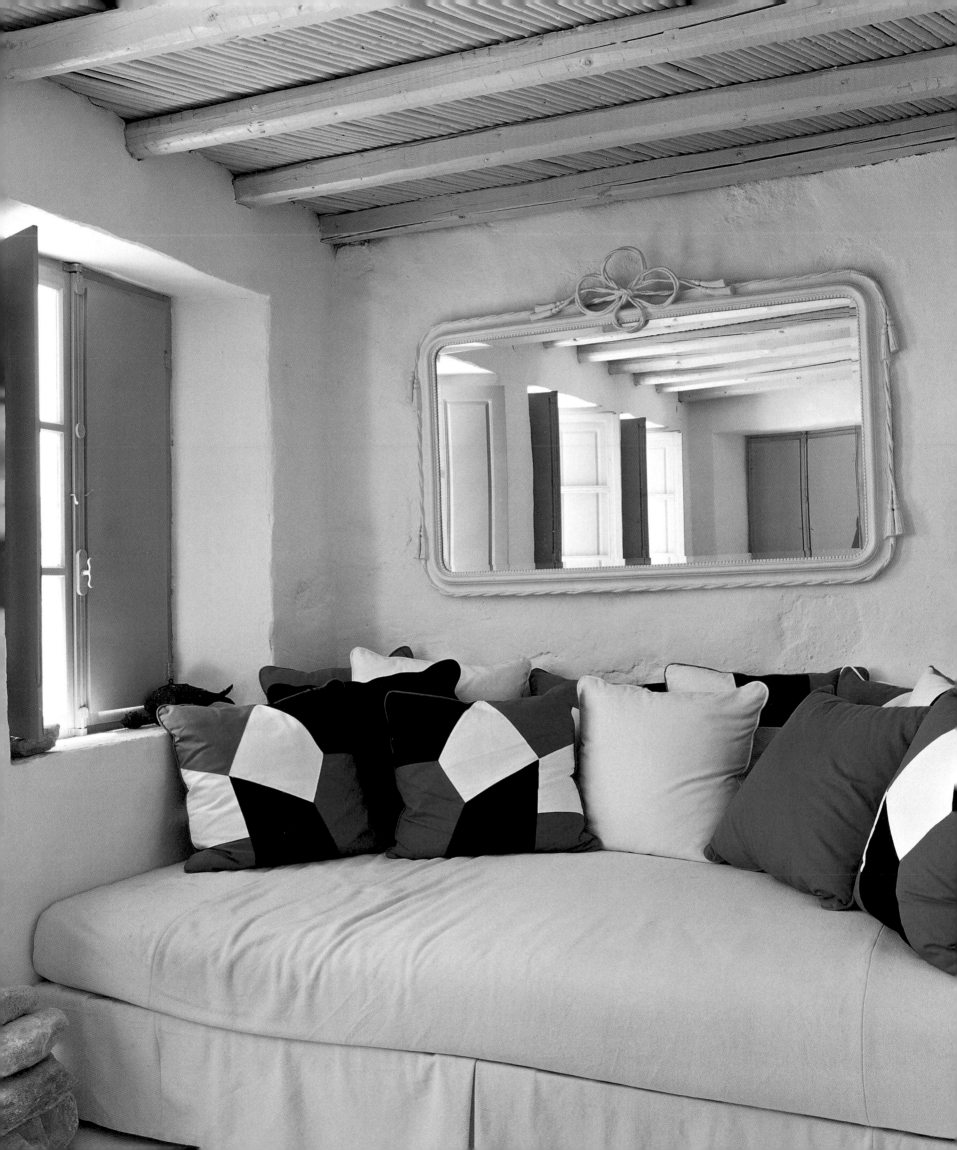

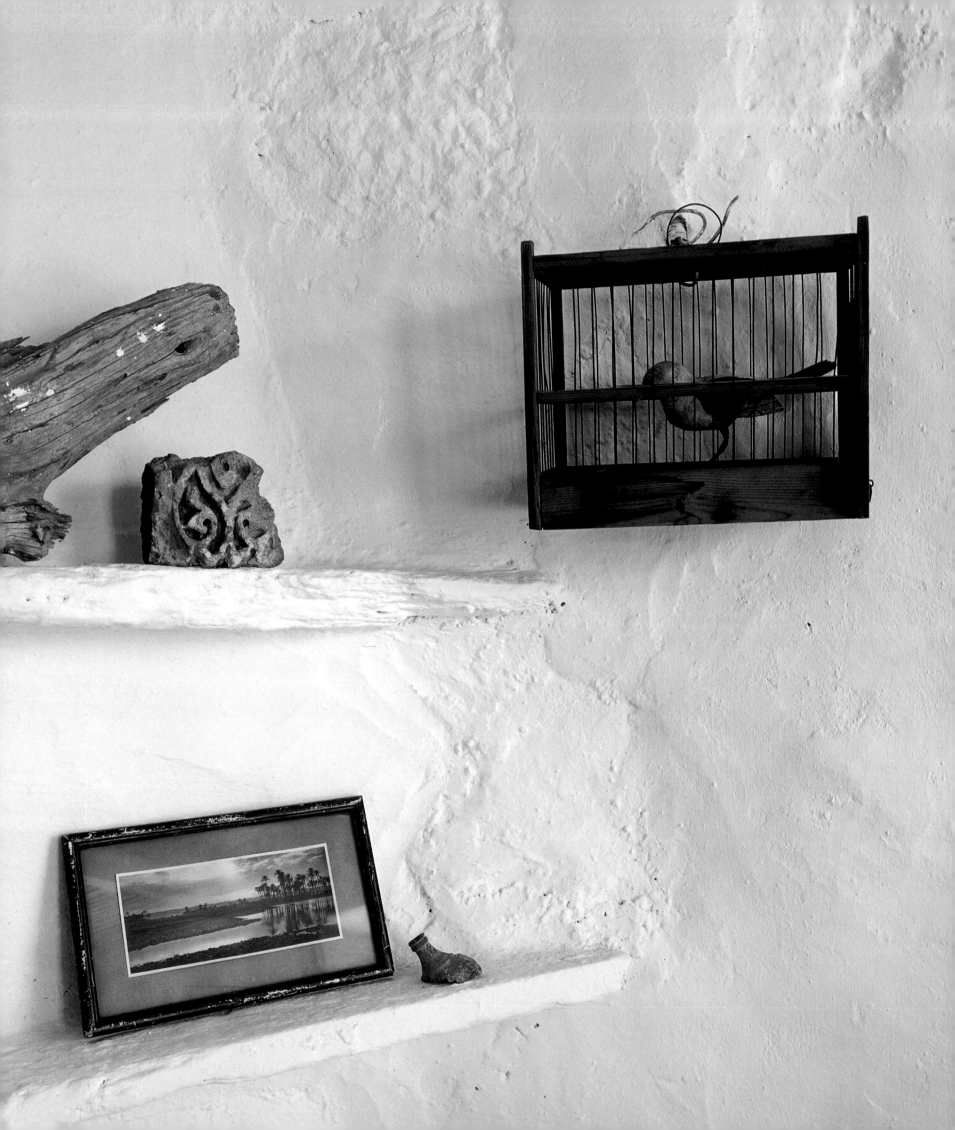

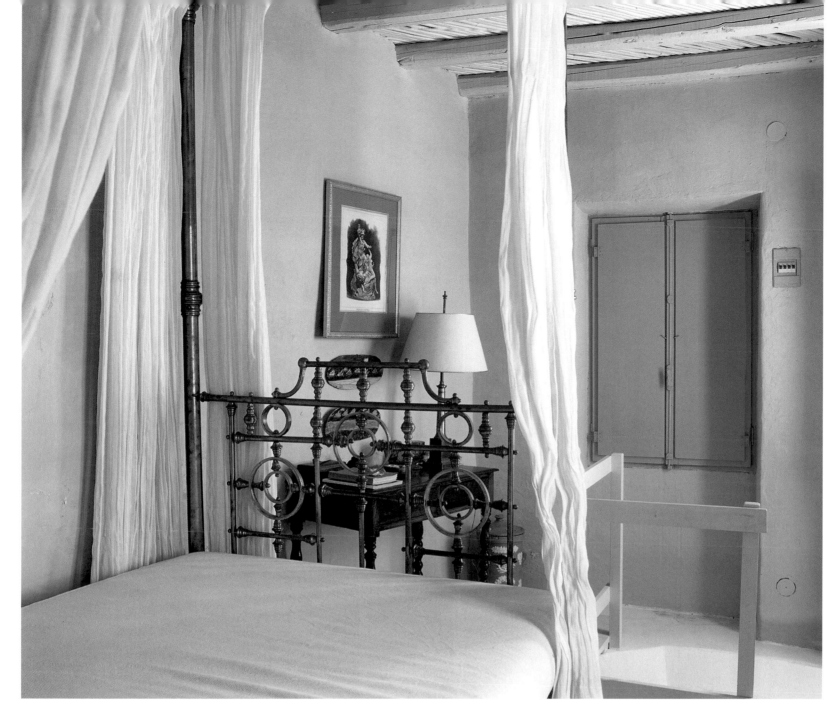

FACING PAGE: *a corner by the fireplace, with a collection of souvenirs, including a wooden bird in a wooden cage.*
ABOVE: *It took talent and an exceptional eye to fit a four-poster bed and a writing table on this cramped mezzanine.*
RIGHT: *the toilet, decorated with engravings and stones found on the beach.*

LINKE SEITE: *eine Ecke neben dem Kamin mit Erinnerungsstücken, darunter ein kleiner Holzkäfig mit einem Vogel aus Holz.*
OBEN: *Es ist ein kleines Kunststück auf dem begrenztem Raum dieses Halbgeschosses ein Himmelbett sowie einen kleinen Schreibtisch unterzubringen.*
RECHTS: *Mit den Stichen und Strandkieseln erhielt auch die Toilette eine stimmungsvolle Dekoration.*

PAGE DE GAUCHE: *C'est à côté de la cheminée que Panos a rassemblé des souvenirs sentimentaux et une petite cage en bois qui abrite un oiseau sculpté dans la même matière.*
CI-DESSUS: *Il faut du talent et un œil exceptionnel pour aménager un étage en mezzanine dans un espace limité et y loger un lit à baldaquin et une petite table d'écriture.*
A DROITE: *Les toilettes ont été décorées avec des gravures et des galets trouvés sur la plage.*

\mathcal{L}ANGADA
Dolly Contoyanni
Patmos

Positioned as it is in a part of the island which is all green hills and crags falling away to the sea, "Langada", Dolly Contoyanni's holiday home, offers a generous helping of this island's past. This venerable farmhouse has witnessed the strivings of generations of farming people. Its heart is a square courtyard planted with trees, leading to a series of monastic rooms and a small chapel whose interior dates back over a hundred years. Dolly and her forebears have done little to alter this stern architecture, and the darkened beams and whitewashed walls have been allowed to keep their rustic veneer. When she's in residence, Dolly never forgets to light the little lamps and the coral-coloured candles in the chapel. What else is needed in a timeless place like this, if not a Turkish-style bed, a mosquito net, a few yellowed photographs and a kitchen filled with old earthenware, baskets and copper utensils? Because the family that lives here is determined that it should remain just as it has always been, "Langada" is an object lesson in simplicity.

PREVIOUS PAGES: *the rocks of Patmos and the clear sea.*
LEFT: *an ancient amphora.*
ABOVE: *White roses cover the walls of the garden.*

VORHERGEHENDE DOPPELSEITE: *die Klippen von Patmos und das kristallklare Meer.*
LINKS: *eine antike Amphore.*
OBEN: *Entlang der Gartenmauern blühen weiße Rosen.*

DOUBLE PAGE PRECEDENTE: *les rochers de Patmos et la mer limpide.*
A GAUCHE: *une amphore antique.*
CI-DESSUS: *Dans le jardin, les roses blanches courent le long des murs.*

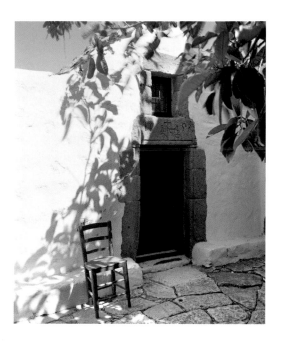

In dem Teil der Insel, der aus grünen Hügeln und schroffen, zum Meer abfallenden Klippen besteht, liegt Dolly Contoyannis Ferienhaus »Langada« und kündet von einer fernen Vergangenheit. Denn in diesem ehemaligen Bauernhaus, in dem die Zeit still steht, haben Generationen von Landwirten ihren zähen Existenzkampf geführt. Das Herz von »Langada« ist ein mit Bäumen bepflanzter quadratischer Innenhof. Von hier aus gelangt man in die klösterlich anmutenden Zimmer und in eine kleine Kapelle, deren Ausstattung aus dem 19. Jahrhundert stammt. Weder jene Vorfahren noch Dolly haben diese strenge Architektur angetastet, so haben die gekälkten Wände und die dunklen Balken ihr rustikales Aussehen bewahrt. Während ihres Aufenthalts vergisst die Hausherrin nie, in der Kapelle kleine Lichtlein und korallenfarbene Kerzen zu entzünden. Was braucht es mehr an diesem zeitlosen Ort als ein Bett im türkischen Stil, ein Moskitonetz, sepiabraune Fotos und eine Küche, in der es von Fayencen, Körben und altem Kupfergeschirr wimmelt? Dank einer Familie, die auf den Erhalt der ursprünglichen Gestalt Wert legt, erweist sich »Langada« als eine wahre Lektion in Sachen Einfachheit.

Située dans une partie de l'île toute de collines verdoyantes et de rochers rugueux qui descendent vers la mer, «Langada», la maison de vacances de Dolly Contoyanni, révèle un passé lointain. En effet, c'est dans cette ancienne ferme où le temps semble s'être arrêté que des générations d'agriculteurs ont livré une lutte acharnée contre la nature et les éléments. Le cœur de «Langada» est une cour carrée plantée d'arbres, qui donne accès à des pièces où règne une ambiance monacale et à une petite chapelle dont l'intérieur date du 19e siècle. Dolly et ses ancêtres ont à peine touché à cette architecture sévère; les murs blanchis à la chaux et les poutres sombres ont gardé leur aspect rustique et, durant son séjour, la maîtresse de maison n'oublie jamais d'allumer les petites lampes et les cierges couleur corail dans le lieu de prière. Que faut-il de plus dans cet endroit intemporel – un lit «à la turque», une moustiquaire, des photos jaunies et une cuisine regorgeant de faïences, de paniers et d'ustensiles en cuivre anciens? Grâce à une famille soucieuse de lui garder son aspect d'origine «Langada» est une véritable leçon de simplicité.

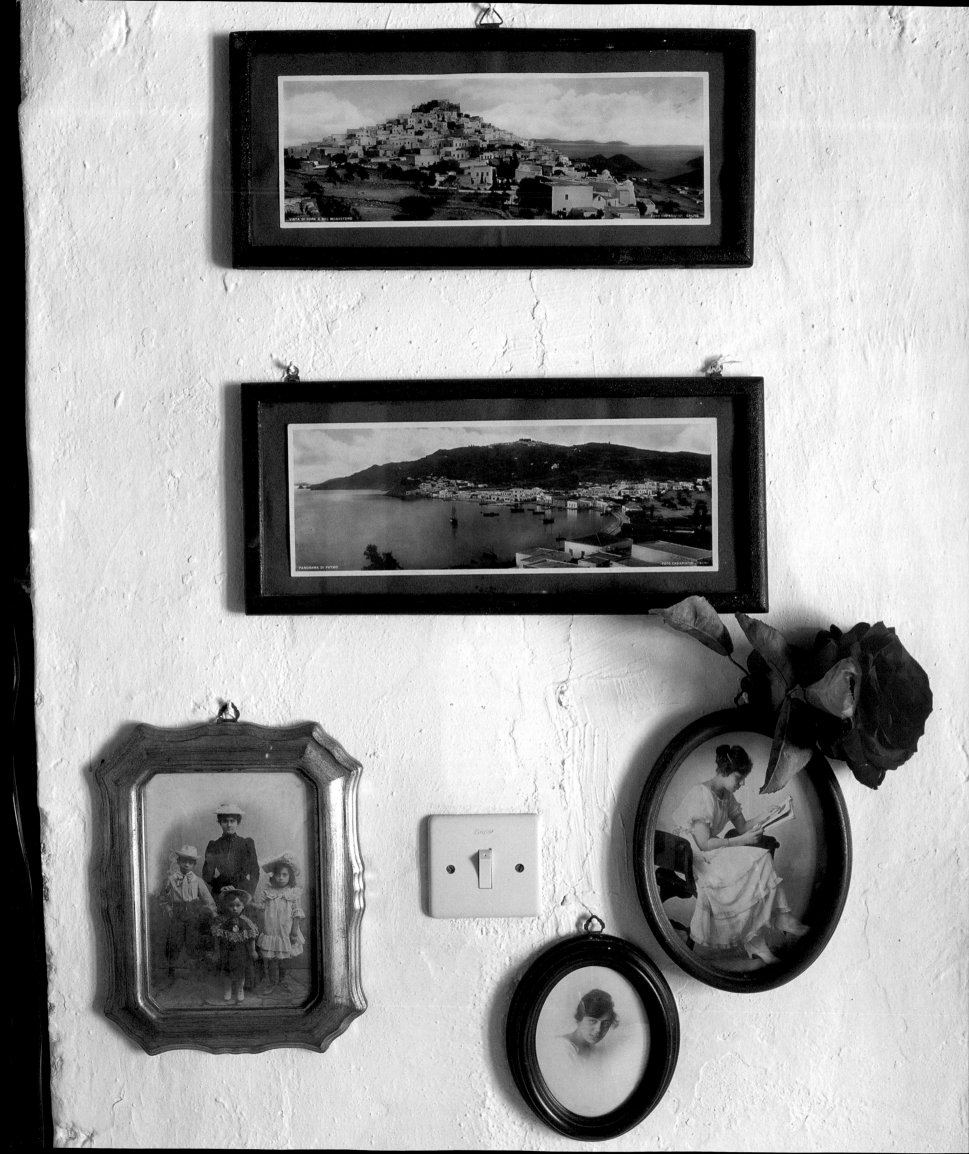

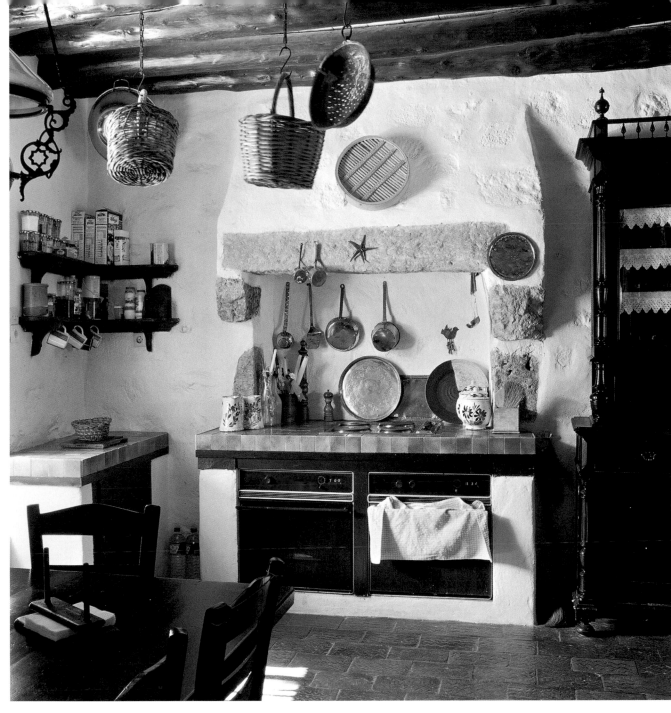

The stone fireplace in the kitchen, with its copper saucepans, baskets and early 20th century furniture.

In der Küche finden sich noch die gemauerte Feuerstelle, die Kupferkasserollen, Körbe und Einrichtungsgegenstände vom Beginn des 20. Jahrhunderts.

La cuisine a gardé son foyer en pierre, ses casseroles en cuivre, ses paniers et son mobilier du début du 20ᵉ siècle.

FACING PAGE: *in one of the bedrooms, a wall hung with family photographs and views of Patmos, whose romantic sepia tone speaks of the Belle Epoque.*
RIGHT: *Each bedroom has its own prayer icon.*
FAR RIGHT: *A painting of Dolly's mother hangs over the table by the entrance.*

LINKE SEITE: *Im Sepiaton der Familienfotos und Ansichten von Patmos, die im Schlafzimmer aufgehängt sind, scheint die Romantik der Belle Epoque auf.*
RECHTS: *In allen Zim-* *mern lädt eine Ikone zum Gebet ein.*
GANZ RECHTS: *Das Gemälde im Eingangsbereich zeigt Dollys Mutter.*

PAGE DE GAUCHE: *Dans une chambre à coucher, un pan de mur est couvert de photos de famille et de vues de Patmos dont le ton sépia trahit le romantisme cher à la Belle Epoque.*
A DROITE: *Dans chaque chambre, une icône invite à la prière.*
A L'EXTREME DROITE: *Le tableau accroché sous la voûte de l'entrée, représente la mère de Dolly.*

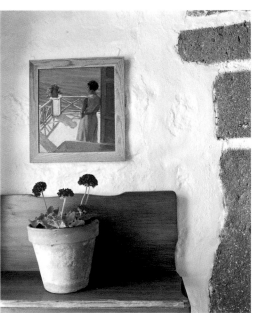

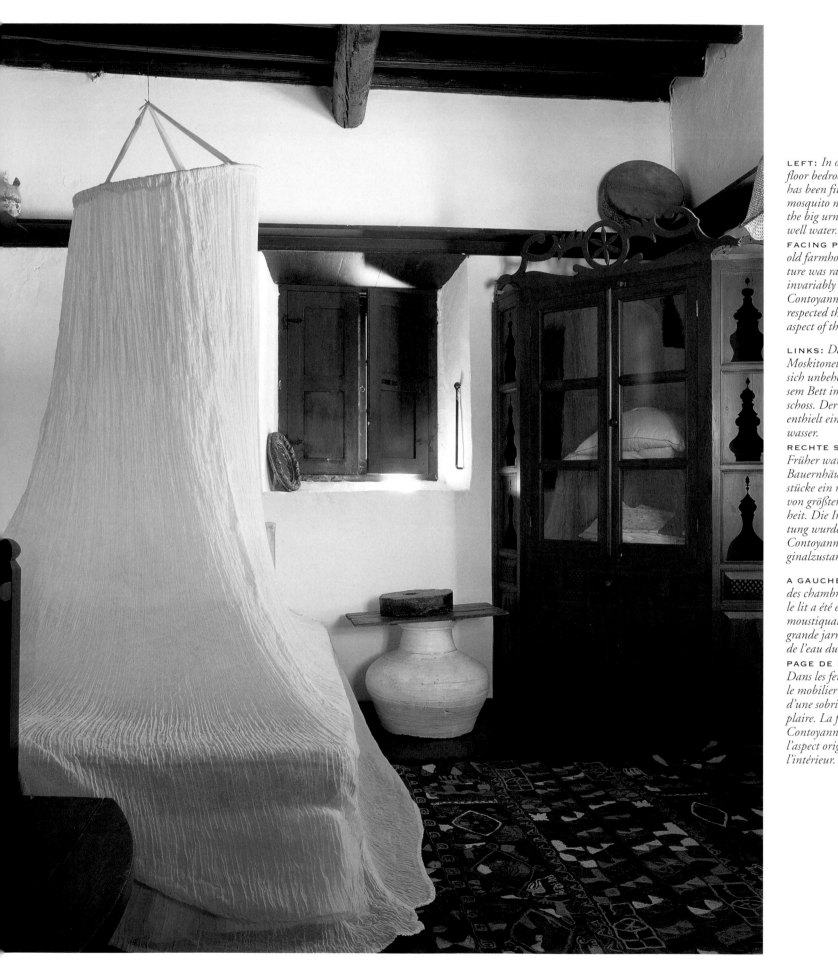

LEFT: *In one of the first floor bedrooms, the bed has been fitted with a mosquito net. Formerly the big urn contained well water.*

FACING PAGE: *In the old farmhouses, furniture was rare and invariably austere. The Contoyanni family has respected the original aspect of the interior.*

LINKS: *Dank des Moskitonetzes schläft es sich unbehelligt in diesem Bett im Obergeschoss. Der große Krug enthielt einst Brunnenwasser.*

RECHTE SEITE: *Früher waren in den Bauernhäusern Möbelstücke ein rares Gut und von größter Schlichtheit. Die Innenausstattung wurde von Familie Contoyanni im Originalzustand belassen.*

A GAUCHE: *Dans une des chambres à l'étage, le lit a été équipé d'une moustiquaire. Jadis la grande jarre contenait de l'eau du puits.*

PAGE DE DROITE: *Dans les fermes d'antan, le mobilier était rare et d'une sobriété exemplaire. La famille Contoyanni a respecté l'aspect original de l'intérieur.*

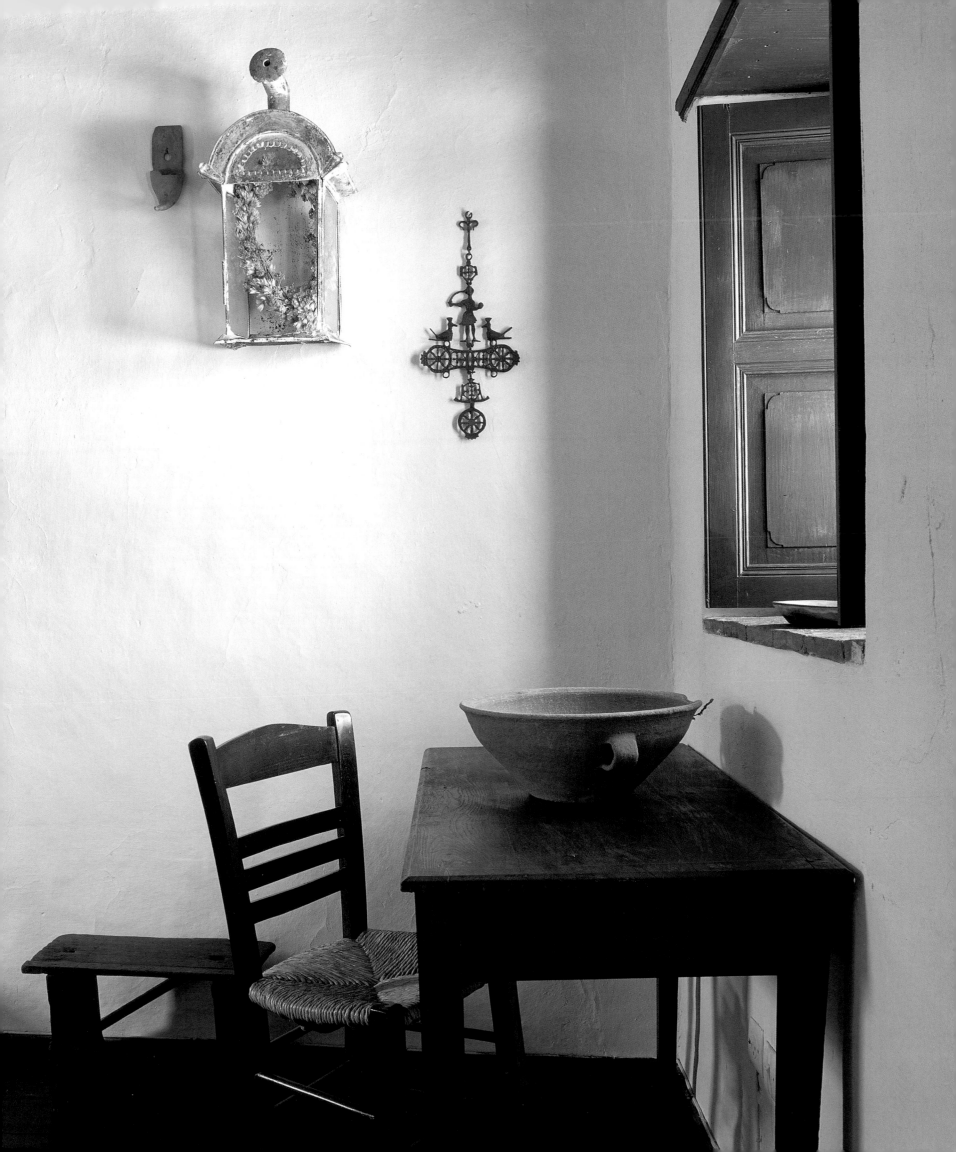

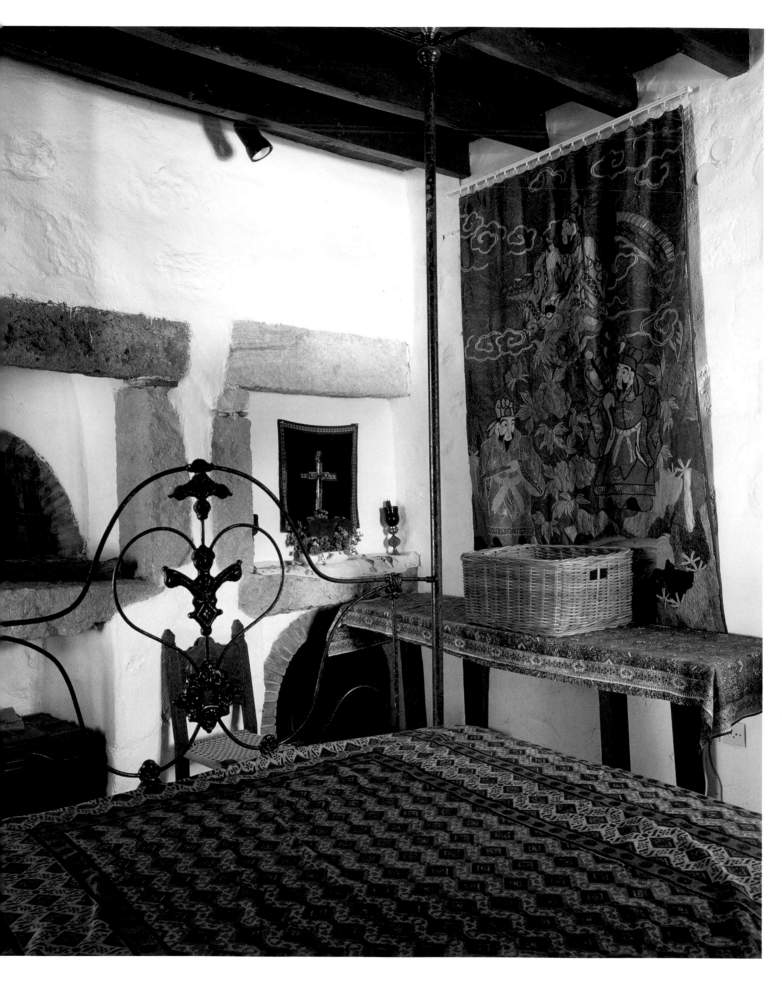

LEFT: *The old bakery room has become a guest bedroom, with a wrought iron four-poster. The embroidered silk curtain is inspired by the Orient.*
FACING PAGE: *The chapel has a pair of magnificent candlesticks, as well as icons by famous artists.*

LINKS: *Die frühere Brotbackstube wurde zum Gästehaus mit schmiedeeisernem Himmelbett umfunktioniert. Orientalisch angehaucht ist der bestickte Seidenvorhang.*
RECHTE SEITE: *Die Prachtstücke der Kapelle sind die beiden Kerzenhalter und die Ikonen, die von berühmten Künstlern stammen.*

A GAUCHE: *L'ancien four à pain est devenu une chambre d'amis avec un lit à baldaquin en fer forgé. Le rideau en soie brodée est d'inspiration orientale.*
PAGE DE DROITE: *La chapelle s'enorgueillit de la présence d'une paire de porte-cierges magnifiques et d'icônes réalisées par des artisans et des peintres célèbres.*

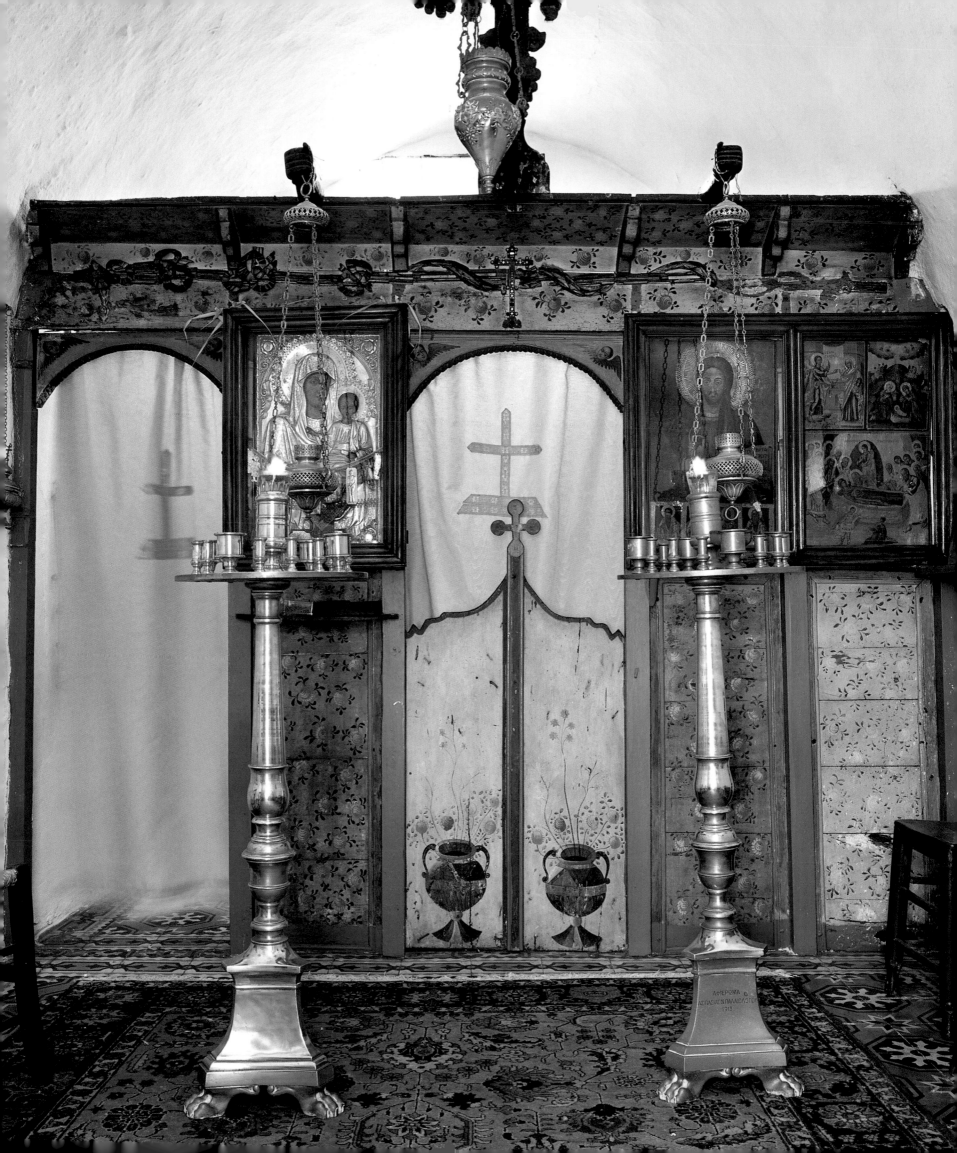

HIDDEN HOUSE

Dodecanese

"Live happy, live unnoticed," says the French proverb, and it exactly fits this extraordinary couple, who have chosen to spend their days at the foot of a magnificent monastery on an island in the Dodecanese. Aesthetes both, they have succeeded in transforming somebody else's former guest annexe into a setting out of "The Thousand and One Nights". It's a place of lavish yellows; the kitchen walls are decorated with brightly-coloured motifs which seem to light up the whole room; in the bedroom stands a Turkish-style bed covered in cushions gleaming gold, and the doors are all surrounded by frames of cobalt blue tiles. What Scheherazade had the idea of decorating the salon with furniture encrusted with mother-of-pearl, kilims and big traditional couches covered in old fabrics? And how do the new owners live among these *braseros*, these Indian chairs and these mirrors worthy of a maharajah's palace? You'll never know. The door closes behind us, while the long shadow of the monastery darkens the high wall that protects this secret place from prying eyes.

A detail of the decorated cupboards in the kitchen.

Detail der fein gearbeiteten Verzierung der Küchenschränke.

Un détail de la décoration des placards dans la cuisine.

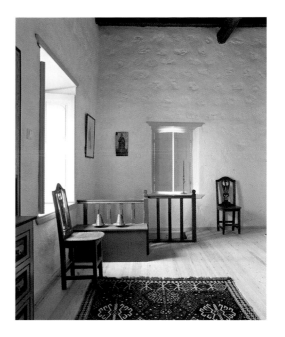

»Um glücklich zu sein, leben wir im Verborgenen«: Dieses
französische Sprichwort könnte von dem außergewöhnlichen
Paar stammen, das sich am Fuß eines prächtigen Klosters, auf
einer der Inseln im Dodekanes, niedergelassen hat. Die beiden
Ästheten haben es geschafft hinter dem undurchdringlichen
Schleier der Anonymität das ehemalige Gästehaus einer ande-
ren Persönlichkeit in ein Haus aus »Tausend und einer Nacht«
zu verwandeln. Regelmäßig gesetzte gelbe Akzente lockern das
Interieur auf, farbenfrohe Motive an den Wänden scheinen die
Küche zu erleuchten, das Schlafzimmer wird durch ein türki-
sches Bett mit golden schimmernden Seidenkissen verschönert
und in die Türen sind kobaltblaue Buntglasscheiben einge-
setzt. Man fragt sich erstaunt: Welche Scheherazade hatte den
Einfall, ihren Salon mit perlmuttbelegten Möbeln und großen
traditionellen Sofas einzurichten, auf denen alte Stoffe und
Kelims ausgebreitet sind? Und wie leben eigentlich die neuen
Eigentümer inmitten dieser »braseros«, den Wärmpfannen,
dieser indischen Sitzkissen und Spiegel, die des Palastes eines
Maharadschas würdig sind? Wir werden es wohl nie erfahren.
Die Tür hat sich wieder geschlossen und der Schatten des Klo-
sters fällt auf die hohe Mauer, die das Haus vor indiskreten
Blicken schützt.

«Pour vivre heureux, vivons cachés»: le dicton français va com-
me un gant à ce couple remarquable qui a choisi de s'installer
au pied d'un magnifique monastère sur une des îles du Dodé-
canèse. Mais le voile opaque de l'anonymat cache un duo d'es-
thètes qui a su transformer l'ancienne maison d'amis d'une
autre personnalité en une demeure sortie tout droit des «Mille
et Une Nuits». Egayée par l'emploi fréquent du jaune, par un
mur décoré de motifs aux couleurs vives qui semblent illumi-
ner la cuisine, par une chambre à coucher qu'embellit un lit à
la turque revêtu de coussins de soie aux reflets dorés et par des
portes ornées de carreaux bleu cobalt, la maison a de quoi
étonner les visiteurs. Quelle Shéhérazade a eu l'idée de garnir
son salon de meubles incrustés de nacre et de grands canapés
traditionnels habillés de tissus anciens et de kilims? Et com-
ment vivent les nouveaux propriétaires parmi ces braseros, ces
sièges indiens et ces miroirs dignes du palais d'un maharadjah?
Nul ne le saura jamais. La porte s'est refermée et l'ombre du
monastère tombe sur le grand mur qui protège la maison des
regards indiscrets.

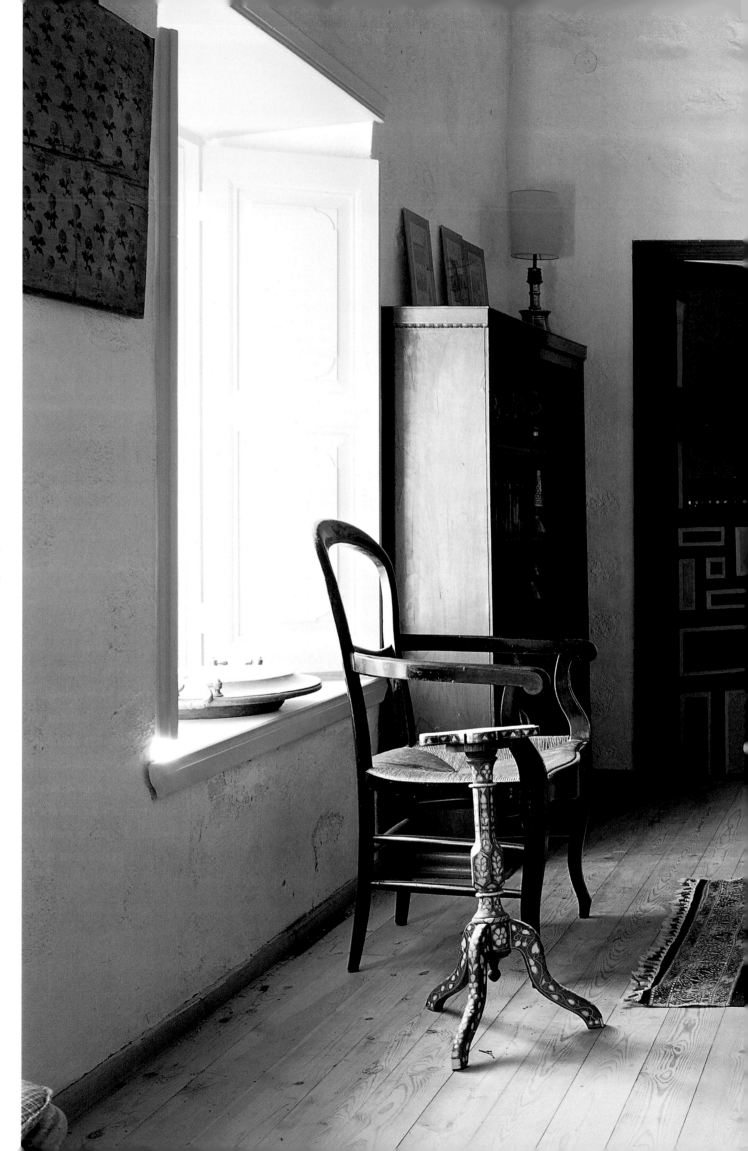

The main drawing room with its mother-of-pearl encrusted furniture, kilim and oriental tile panel. The blue tiles on the door add a further note of colour.

Der große Salon mit den perlmuttbesetzten Möbeln, dem Kelim und dem Tableau aus orientalischen Fayence-Fliesen versammelt alle Reize des Morgenlands. Das blaue Buntglas in den Türen setzt einen kräftigen Farbtupfer.

Le grand salon avec ses meubles incrustés de nacre, son kilim et son tableau composé de dalles en faïence orientales, évoque l'esprit et le charme de l'Orient. Les carreaux bleus des portes apportent une note de couleur vive.

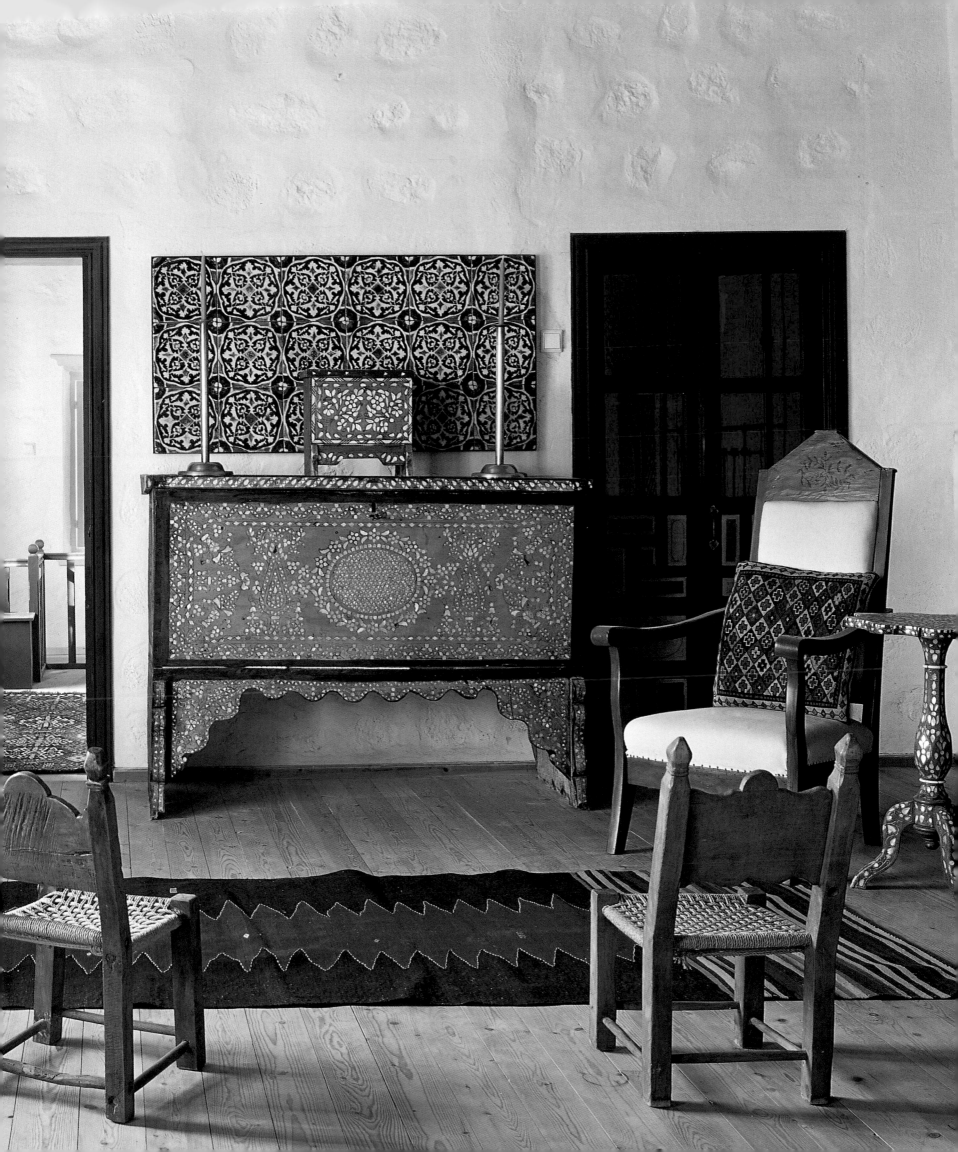

RIGHT AND FACING PAGE: *A wooden staircase leads from the ground floor bedroom to the main floor and the drawing room with its Turkish bed. The panels, alcoves and balustrades are all covered with stencilled floral patterns.*

RECHTS UND RECHTE SEITE: *Vom Schlafraum im Erdgeschoss führt eine Holztreppe in die Beletage und den großen Salon. Die Wände rings um das türkische Bett, die Alkoven und Balustraden sind mit stilisierten Blumenmustern geschmückt, die nach alter Manier mit der Schablone aufgetragen wurden.*

A DROITE ET PAGE DE DROITE: *De la chambre à coucher au rez-de-chaussée, un escalier en bois mène à l'étage noble et au grand salon. La pièce accueille un lit à la turque et les parois, les alcôves et les balustrades sont couvertes de décorations florales, stylisées, appliquées au pochoir.*

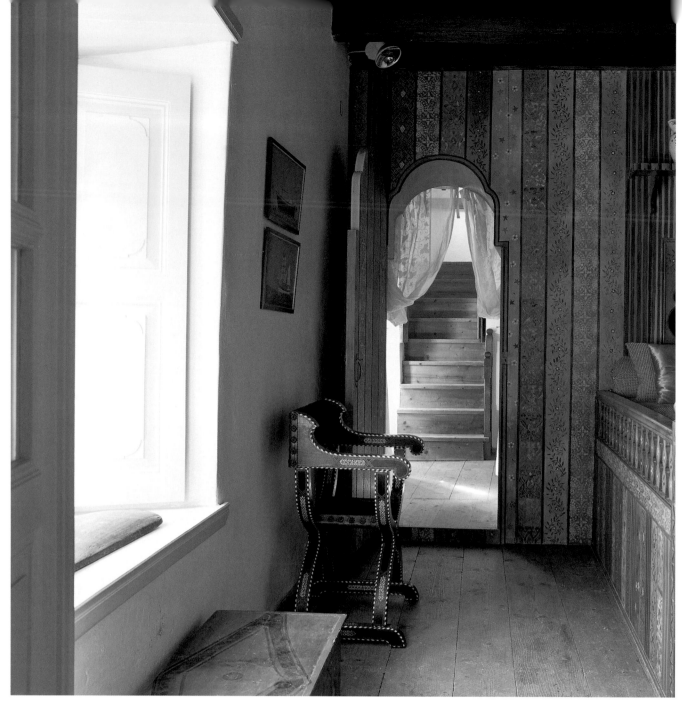

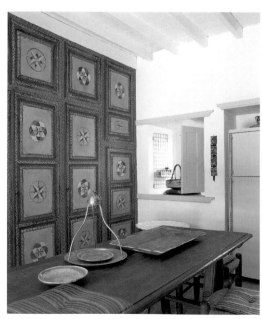

FAR LEFT: *In the entrance, the bright yellow of the windows, shutters and door is in stark contrast to the sober décor.*
LEFT: *the kitchen, with its painted cupboards.*
FOLLOWING PAGES: *detail of the traditional stencilled motifs on the kitchen cupboards.*

GANZ LINKS: *Im Eingangsbereich hebt sich das kraftvolle Gelb der Fenster und Türen von der schlichten Einrichtung ab.*
LINKS: *die Küche mit ihren schönen Schränken.*

FOLGENDE DOPPELSEITE: *Detail der volkstümlichen Motive auf den Küchenschränken.*

A L'EXTREME GAUCHE: *Dans l'entrée, le jaune vif des fenêtres, des volets et de la porte contraste avec la sobriété de la décoration.*

A GAUCHE: *la cuisine, avec sa décoration des placards.*

DOUBLE PAGE SUIVANTE: *détail des motifs folkloriques au pochoir qui ornent les placards de la cuisine.*

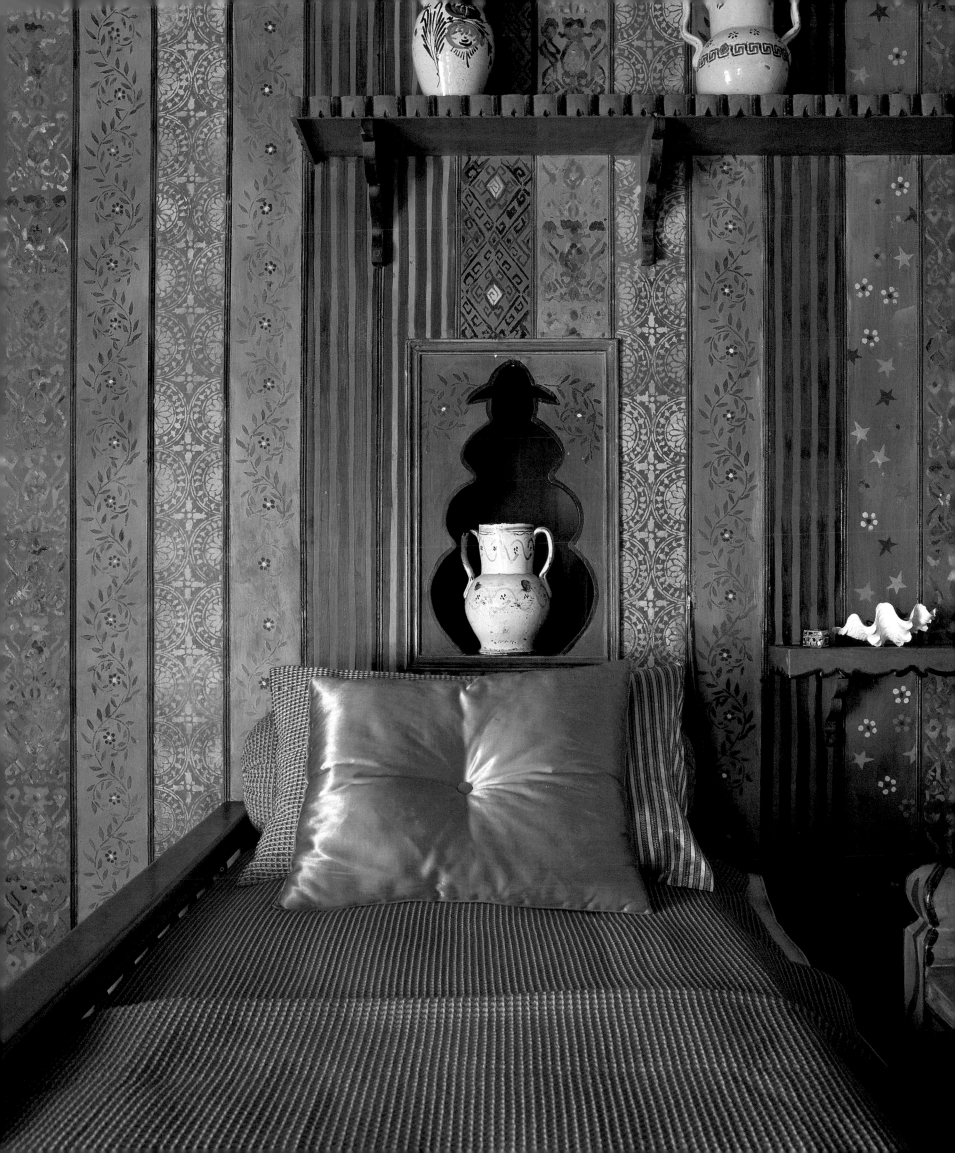

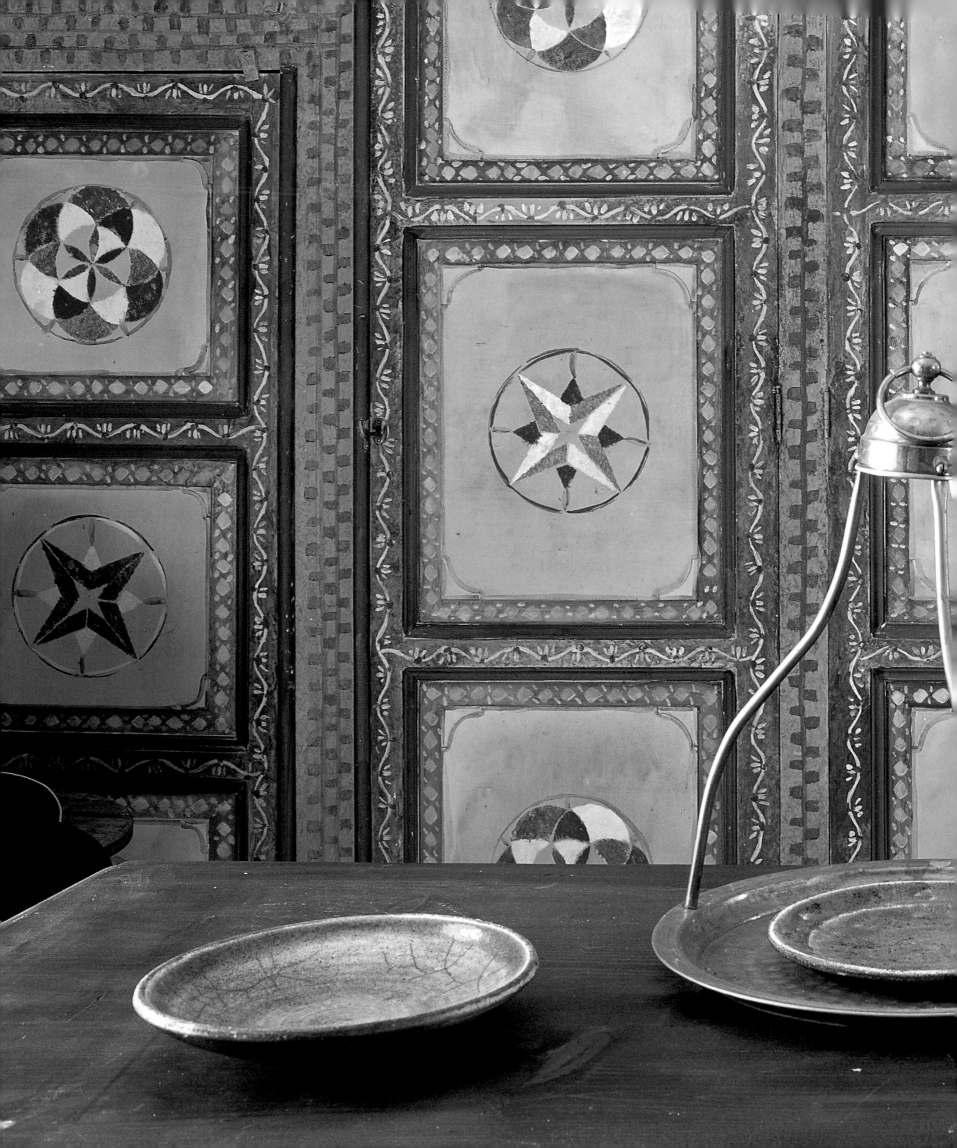

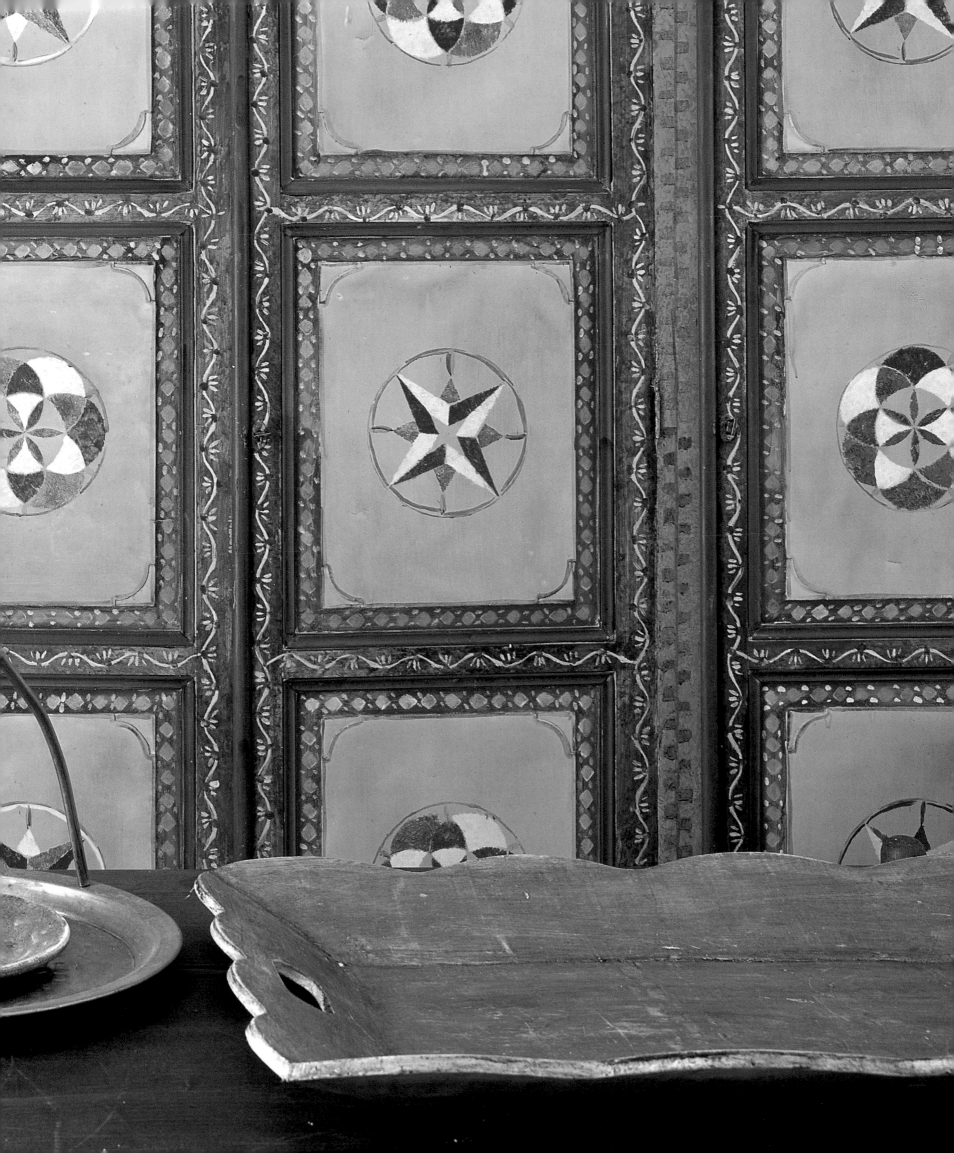

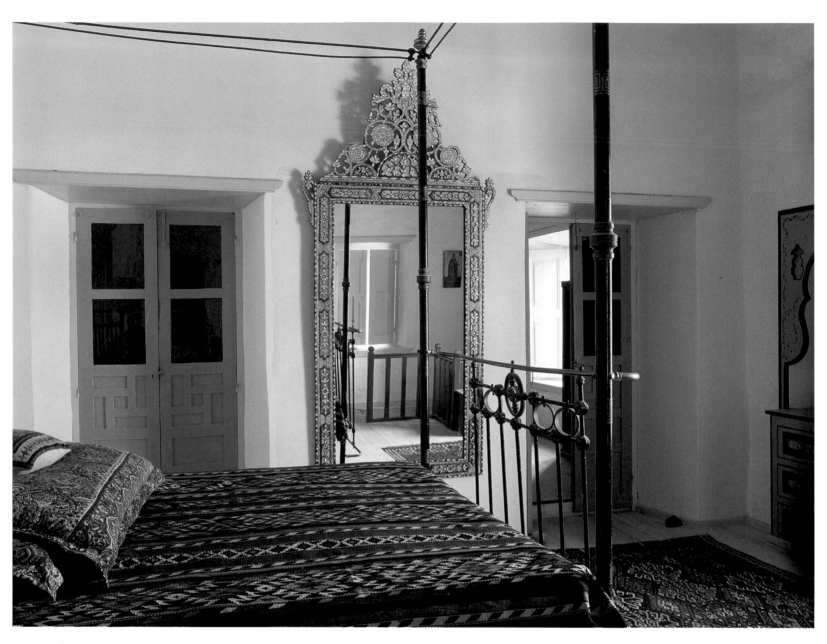

ABOVE: *the master bedroom, with its splendid Syrian looking glass, a 19th century four-poster bed and rare kilims.*
RIGHT: *By the door, a space to the side has been turned into a convenient bathroom.*
FACING PAGE: *The yellow shutters of the bathroom reflect bright sunshine on the seashells. The painting is by Felicia France.*

OBEN: *Das Zimmer der Hausherren beherbergt einen syrischen Spiegel mit einem Rahmen aus Perlmuttintarsien, sowie ein schmiedeeisernes Bett aus dem 19. Jahrhundert. Bemerkenswert sind auch der Bettüberwurf und die Kelims.*
RECHTS: *Ein kleiner Raum in Eingangsnähe wurde zum Badezimmer umgebaut.*
RECHTE SEITE: *Im Bad reflektieren die gelben Fensterläden die Sonne, die die Muscheln ins rechte Licht rückt. Das Gemälde ist ein Werk von Felicia France.*

CI-DESSUS: *La chambre des maîtres de maison abrite une magnifique glace syrienne incrustée de nacre, un lit à baldaquin en fer forgé 19ᵉ et un couvre-lit et des kilims remarquables.*
A DROITE: *Près de l'entrée, une petite pièce a été transformée en salle de bains.*
PAGE DE DROITE: *Dans la salle de bains, les volets jaunes reflètent un soleil éclatant qui s'attarde sur les coquillages. Le tableau est une œuvre de Felicia France.*

\mathcal{A} PARISIENNE'S RETREAT

Patmos

It's been upwards of thirty years since this very particular person, on the lookout as usual for beautiful and unusual things, discovered Patmos and its "chora", where somehow the maze of streets always leads to the mediaeval cloister of St. John. Today, she is more than happy that she seized the opportunity to buy the big house behind the blinding white wall. There's a grey door with a knocker in the shape of a woman's hand, and on the other side of it you're suddenly engulfed by the delicious white coolness that goes so perfectly with Mediterranean houses and is echoed in the curtains and the tiled stove. Against this immaculate background stand lavish sofas covered in velvet cushions with embroidered coats of arms, old carpets shimmering with colour. There is also a host of unpretentious objects: a fan, a copper ashtray shaped like a crescent moon, a blue papier maché cat: all of which shows that the woman who spends several months of the year in this house has the delicate soul of an artist.

Detail of an Art Deco bedcover in one of the guest bedrooms

Detail eines Art-déco-Bettüberwurfs im Gästezimmer.

Détail d'un couvre-lit Art Déco dans une chambre d'amis.

From her sitting room
the owner can see her
terrace and the roofs of
the "chora".

Vom Wohnzimmer aus
genießt die Hausherrin
den Ausblick auf ihre
Terrasse und die Dächer
der »chora«.

Du séjour, la maîtresse
de maison peut contem-
pler sa terrasse et les toits
du «chora».

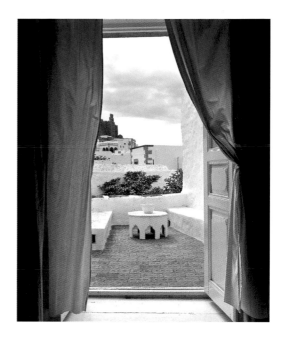

Stets auf der Suche nach dem Schönen und Seltenen, stieß die-se elegante Dame aus Paris bereits vor Jahrzehnten auf die Insel Patmos und ihre »chora«, jenes Labyrinth von Gassen mit weißen Häusern, die irgendwie immer zu dem mittelalterli-chen Johanneskloster führen. Heute ist sie froh über ihren Ent-schluss, das weitläufige, hinter einer blendend weißen Mauer verborgene Haus gekauft zu haben. Hinter der perlgrauen Tür mit einem Klopfer in Gestalt einer Frauenhand erwartet den Besucher eine angenehme Kühle und jenes Weiß, das für Mit-telmeerhäuser so bezeichnend ist und sich auch in den Vor-hängen und dem runden Fayence-Ofen wiederfindet. Einen schönen Kontrast vor diesem makellosen Hintergrund bilden nicht nur prächtige Kanapees, auf denen sich mit Wappen geschmückte Samtkissen stapeln, sondern auch alte Teppiche in schillernden Farben und allerlei Objekte von unaufdring-lichem Charme – ein Fächer, ein mondsichelförmiger Aschenbecher aus Kupfer, eine blaue Katze aus Pappmaché. All dies zeigt, dass die Dame, die sich ein paar Monate im Jahr hierhin zurückzieht, eine feinfühlige Künstlerseele hat.

Il y a quelques décennies déjà que cette Parisienne élégante et raffinée, toujours à la recherche du beau et du rare, a découvert Patmos et son «chora», ce dédale de petites rues aux maisons blanches qui semblent conduire invariablement au cloître médiéval de Saint-Jean. Aujourd'hui, elle se félicite de ne pas avoir hésité à acquérir cette vaste demeure dissimulée derrière un long mur d'un blanc aveuglant où s'ouvre une porte gris perle ornée d'un heurtoir en forme de main de femme. A l'in-térieur, le visiteur se sent enveloppé par une fraîcheur délicieu-se et par cette blancheur qui semble aller de pair avec les mai-sons méditerranéennes et se répète aussi dans les rideaux et dans le poêle en faïence aux formes arrondies. Sur ce fond immaculé se détachent de somptueux canapés où s'empilent des coussins en velours ornés d'armoiries, des tapis anciens aux couleurs chatoyantes et des objets d'un charme sans prétention – un éventail, un cendrier de cuivre en croissant de lune, un chat en papier mâché bleu – qui nous prouvent que celle qui vient se réfugier ici quelques mois par an possède une âme délicate d'artiste.

A stone staircase leading
up to the house from the
inner courtyard.

Vom großen Innenhof
führt eine Steintreppe
zum Haus.

De la grande cour
intérieure, un escalier
en pierre mène à la
maison.

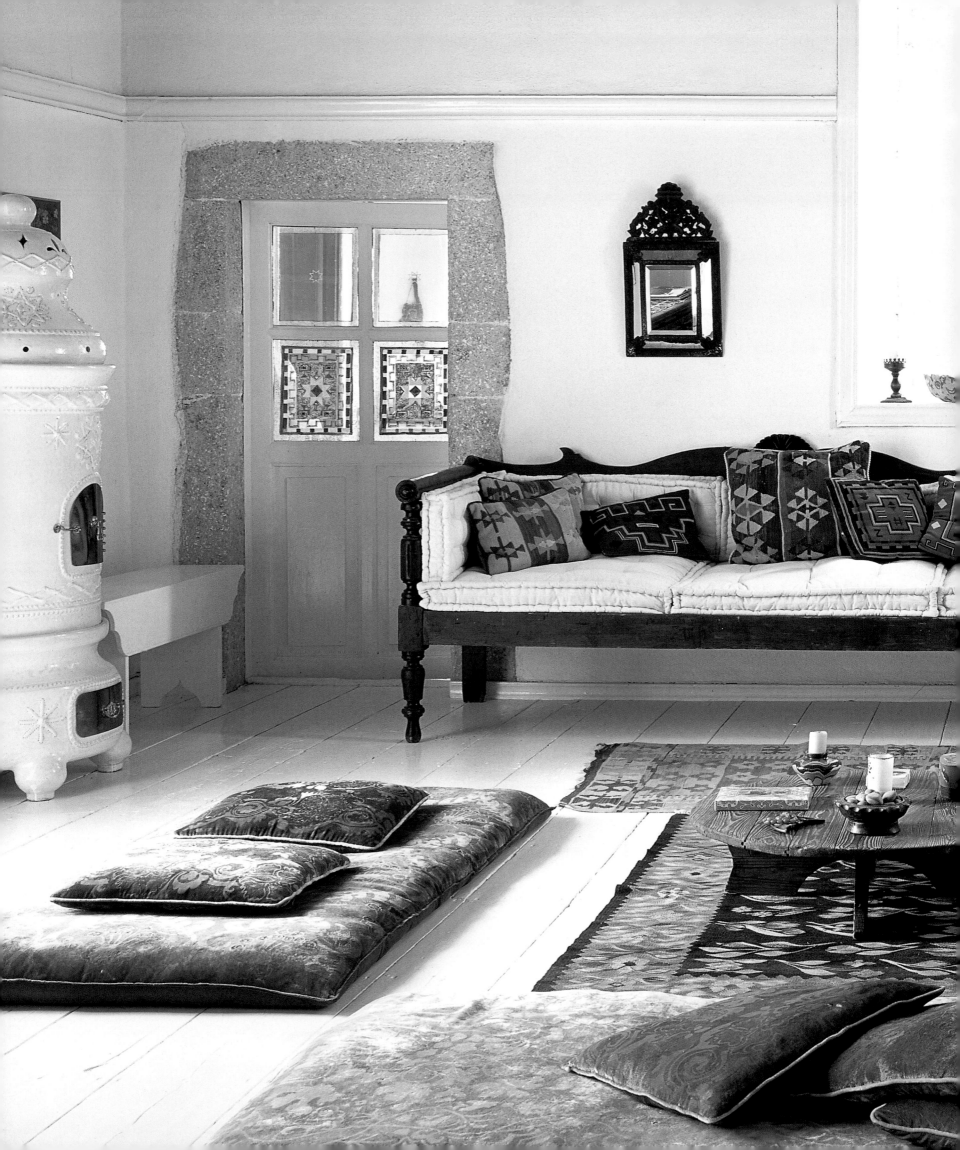

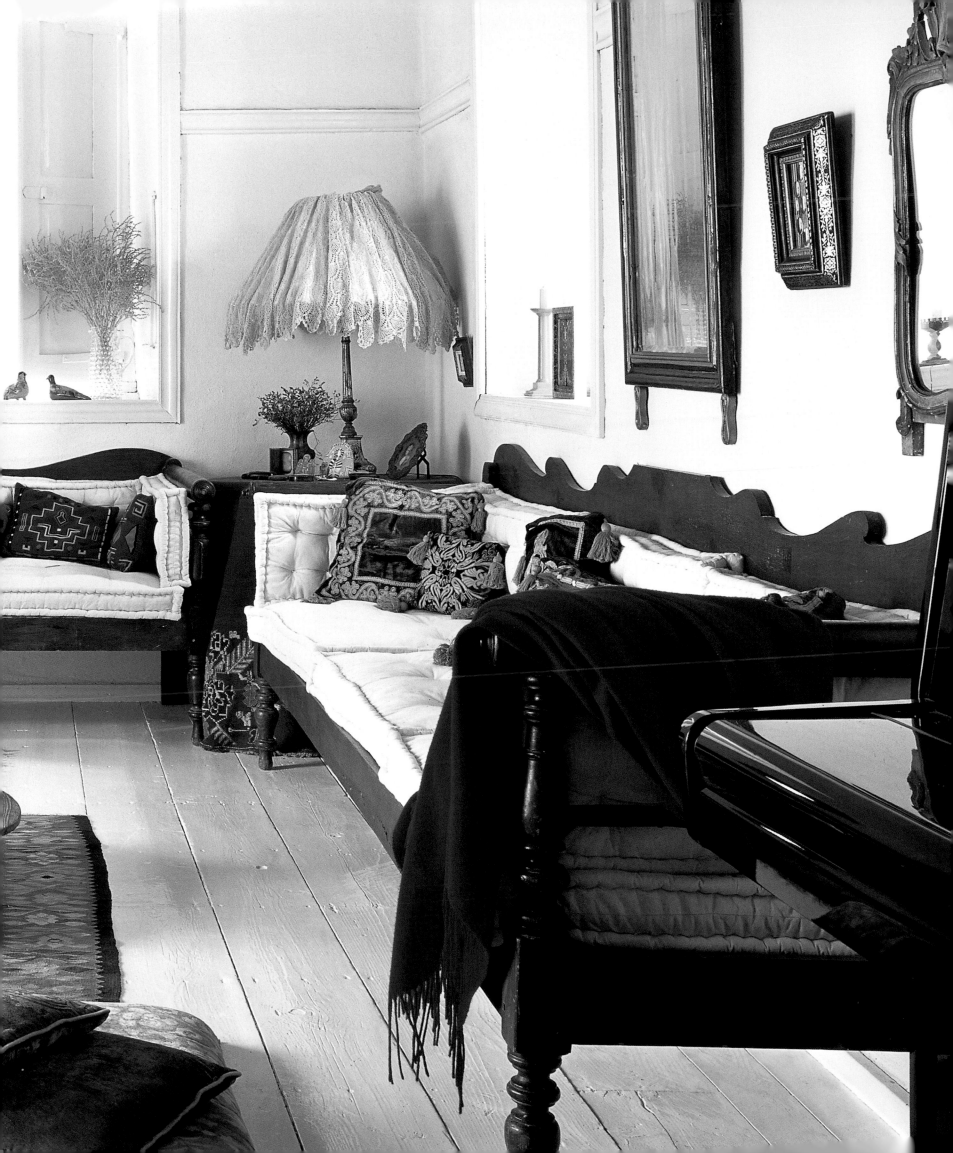

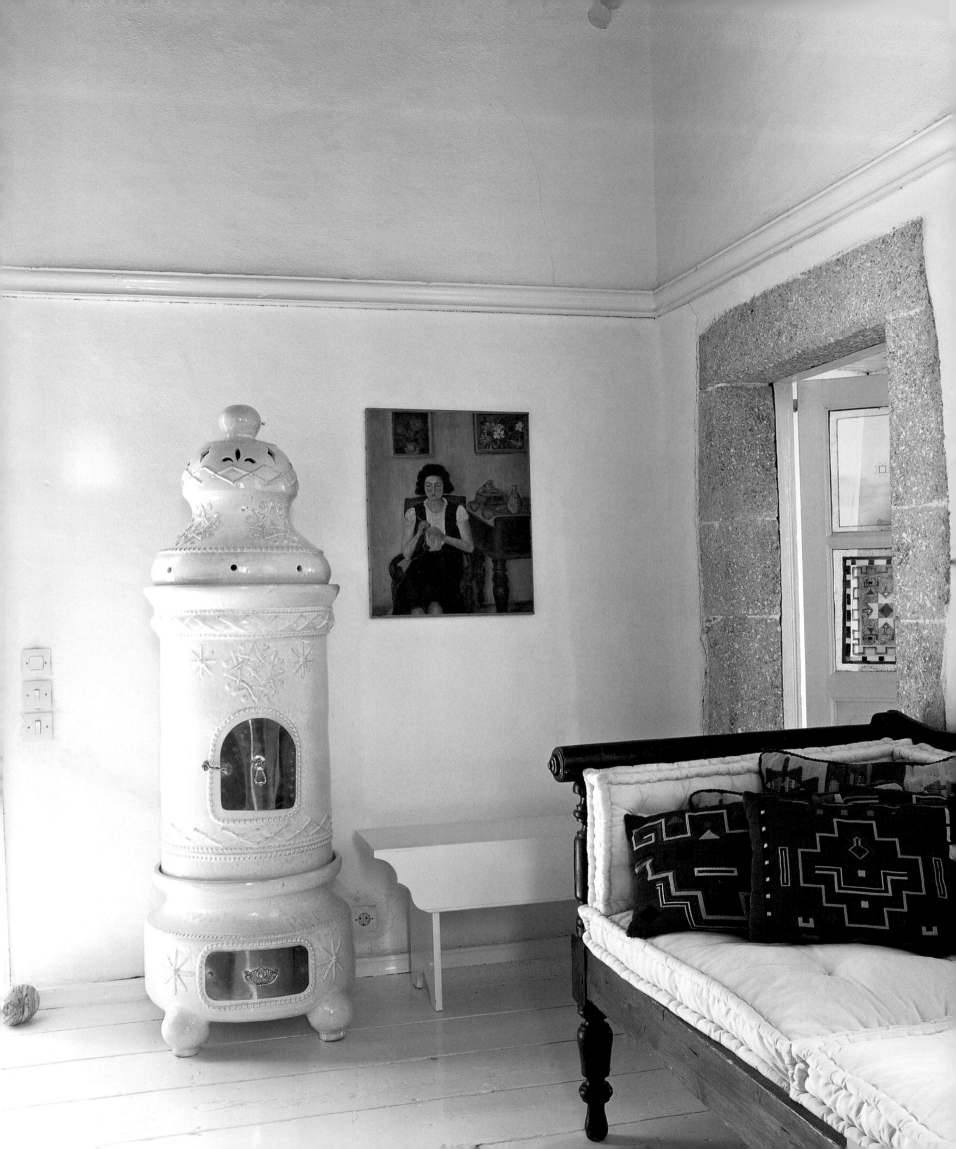

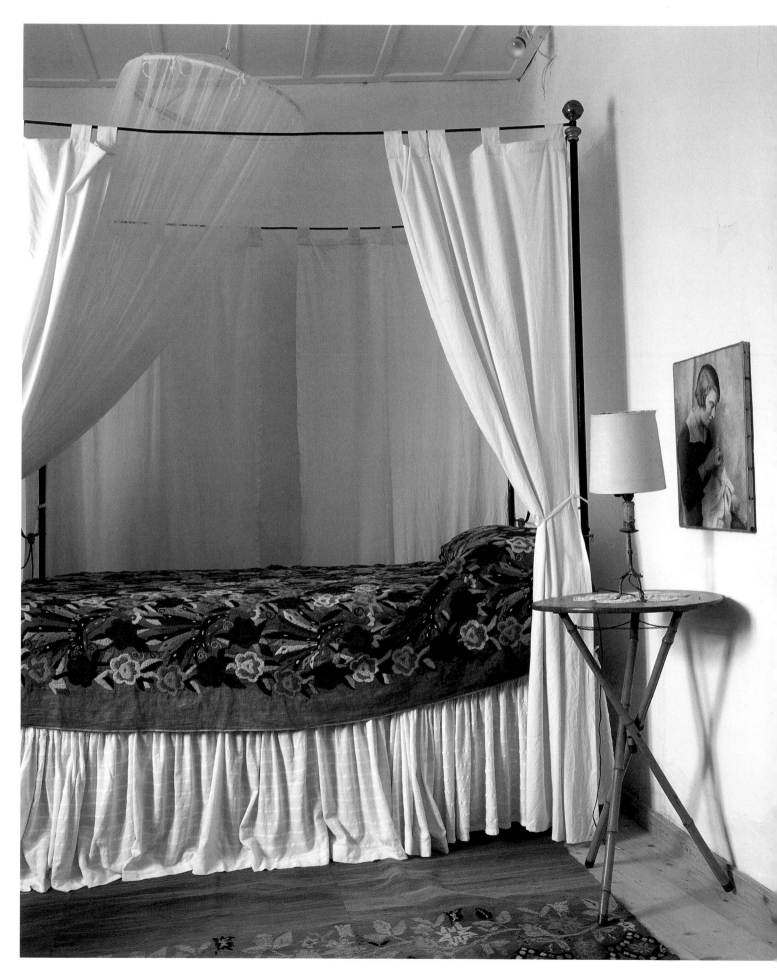

PREVIOUS PAGES:
*The refined decoration
of the sitting room com-
bines classical and typ-
ically Greek elements
like "kilims and
couches" with a thor-
oughly French concern
for elegance and luxury.*
FACING PAGE: *the
superb enamel stove in
the sitting room.*
RIGHT: *The four-poster
in the guest bedroom is
hung with curtains and
a mosquito net. The
embroidered counter-
pane dates from the
1930s.*

VORHERGEHENDE
DOPPELSEITE: *In der
geschmackvollen Ein-
richtung des Wohnzim-
mers wurden tradi-
tionelle und typisch
griechische Elemente
wie Bänke und Kelims
mit dem ganz und gar
französichen Hang zu
Luxus und Eleganz
verbunden.*
LINKE SEITE: *der
wunderschön gearbeite-
te Fayence-Ofen im
Wohnzimmer.*
RECHTS: *Am Himmel-
bett im Gästezimmer
sorgen Vorhang und
Moskitonetz für
ungestörten Schlaf. Der
bestickte Bettüberwurf
stammt aus den 1930er
Jahren.*

DOUBLE PAGE PRÉ-
CEDENTE: *La décora-
tion raffinée du séjour
marie des éléments clas-
siques et typiquement
grecs – tels que les ban-
quettes et les kilims – et
un souci de l'élégance et
du luxe très français.*
PAGE DE GAUCHE:
*l'étonnant poêle en
faïence.*
A DROITE: *Dans une
chambre d'amis, le lit à
baldaquin est doté de
rideaux et d'une mous-
tiquaire. Le couvre-lit
brodé date des années
1930.*

LEFT: *on the landing that leads to the bathroom and main bedroom, a papier maché cat and a sideboard made by a local craftsman.*

FACING PAGE: *the blue mosaic in the shower.*

LINKS: *Auf dem Treppenabsatz, der zum Badezimmer und in das Schlafzimmer führt, steht eine lustige Pappmaché-Katze auf einem Sideboard, das von einem ortsansässigen Handwerker angefertigt wurde.*

RECHTE SEITE: *die Dusche mit ihrem blauen Mosaik.*

A GAUCHE: *Sur le palier qui mène à la salle de bains et à la chambre principale, un amusant chat en papier mâché égaie le buffet construit par un artisan local.*

PAGE DE DROITE: *la cabine de douche et sa mosaïque bleue.*

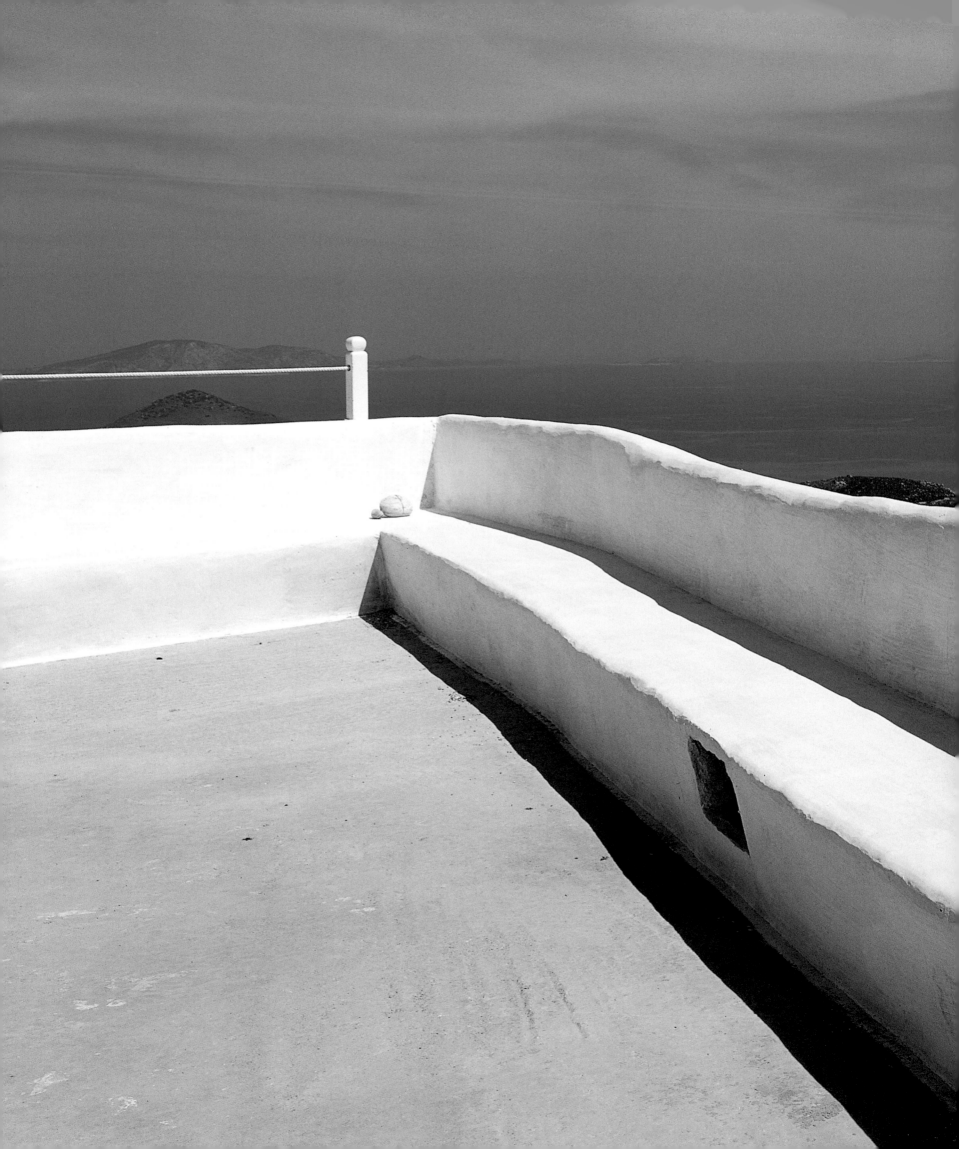

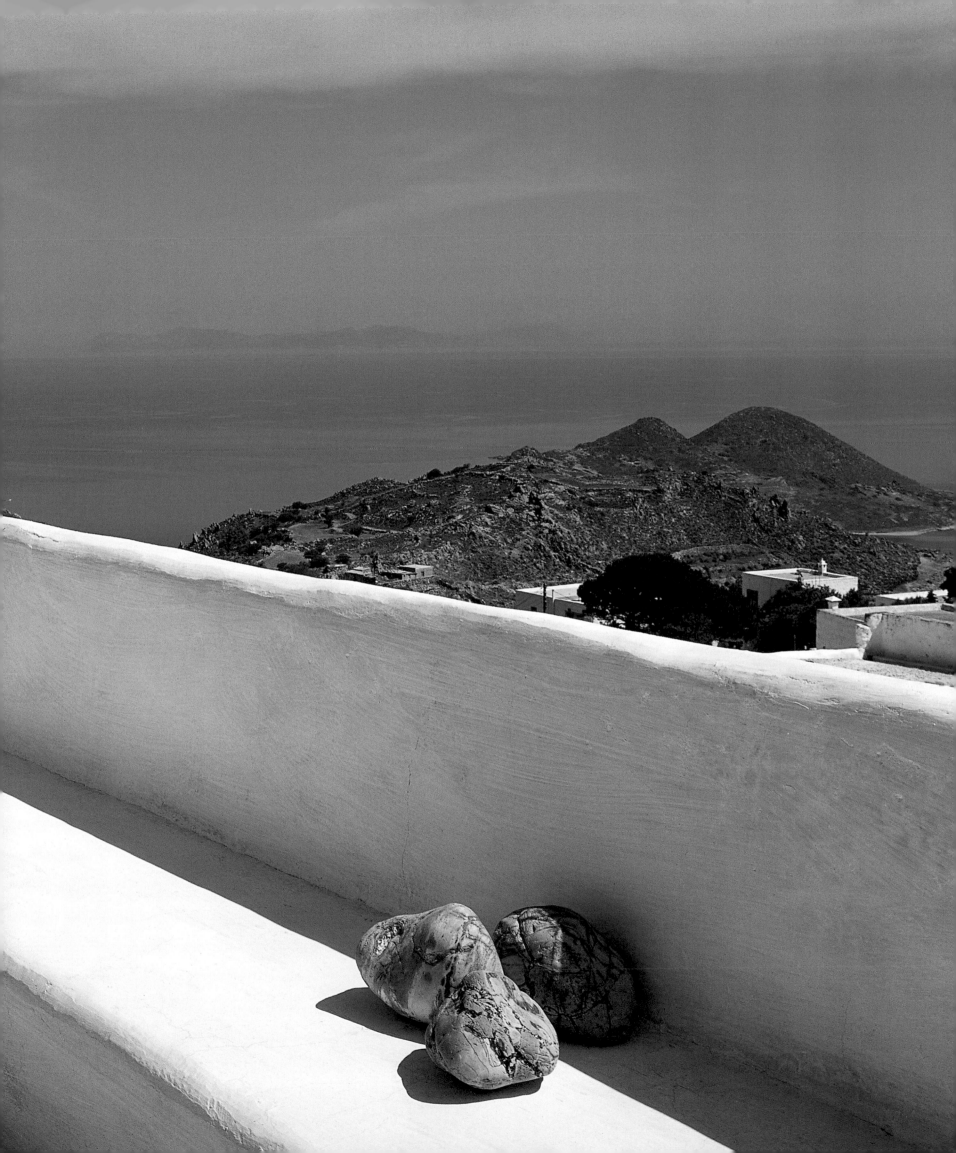

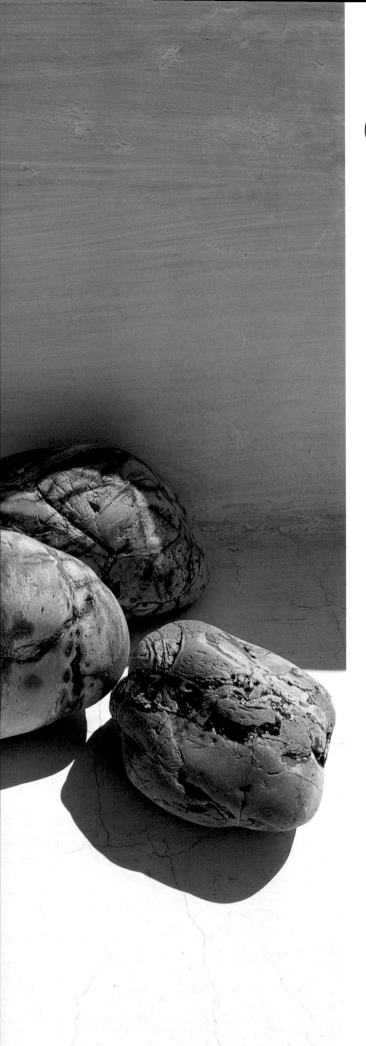

\mathscr{A} FAMILY HOME

Dodecanese

The oldest part of this house dates from the 17th century, and one wonders if at that time it was already surrounded by the high thick wall which protects it today. Inside, there's a shady courtyard with niches and benches, a delightful place to relax after a day in the burning sunshine. The family that owns this building, which has been jealously protected for more than four centuries, considers itself the guardian of something unique of its kind, and for that reason it will not change any part of it. As a result this house, with its labyrinth of cool, old-fashioned rooms, has a life that is entirely its own, and it is watched over by its inhabitants like a creature of flesh and blood. The sofas, pictures, china, and lamps have never been disturbed, any more than the 19th century brass four-poster in the bedroom, where icons, counterpane and an antique fan evoke the memory of a beloved relative. Most nostalgic of all, perhaps, is the formal salon with its towering ceiling and its overwhelming sense of a hundred years ago.

PREVIOUS PAGES AND LEFT: *three stones as sculpture on the blinding white terrace.* **ABOVE:** *narrow streets leading up to the "chora".*

VORHERGEHENDE DOPPELSEITE UND LINKS: *Die drei Steine auf der weißen Terrasse wirken wie eine zeit-genössische Skulptur.* **OBEN:** *Enge Gassen führen zur »chora« hin-auf.*

DOUBLE PAGE PRECEDENTE ET A GAUCHE: *Sur la terras-se blanche, trois pierres composent une sculpture contemporaine.* **CI-DESSUS:** *Des ruelles étroites montent vers le «chora».*

Der älteste Teil des Anwesens stammt aus dem 17. Jahrhunderts und man fragt sich, ob es damals schon von der hohen, dicken Mauer eingefasst war, die vor neugierigen Blicken schützt. Innen bietet ein wohltuend schattiger Hof mit Nischen und Bänken die Möglichkeit, sich von einem Tag in der brennenden Sonne zu erholen. Die Familie, die dieses Haus seit über vier Jahrhunderten vor der Außenwelt versteckt hält, sieht sich als Hüterin eines einzigartigen, unantastbaren Gutes. Die Kühle und die Stimmung vergangener Zeiten, die in dem Labyrinth von Zimmern vorherrscht, verleihen dem Gebäude eine Seele. Deshalb wird es gehütet, als handele es sich um ein Wesen aus Fleisch und Blut. Die Sofas, Gemälde, Porzellanwaren und Lampen wurden nie von der Stelle gerückt. Im Schlafzimmer dominiert ein kupfernes Himmelbett aus dem 19. Jahrhundert und die Ikonen, der Bettüberwurf und ein alter Fächer halten die Erinnerung an eine geliebte Anverwandte wach. Nostalgische Gefühle weckt auch der repräsentative Salon mit seiner beeindruckenden Deckenhöhe und seiner Jahrhundertwende-Ausstattung.

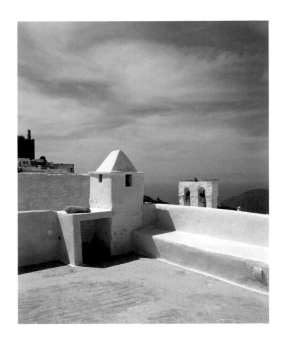

The view from the terrace: a nearby chapel and the monastery overlooking the bay.

Von der Terrasse blickt man auf eine benachbarte Kapelle und auf das Kloster, das hoch oben auf dem Felsen die Bucht beherrscht.

De la terrasse, on peut également voir une chapelle avoisinante et le monastère qui domine la baie du haut de son rocher.

La plus ancienne partie de la demeure date du 17ᵉ siècle, et on se demande si, à cette époque-là, elle s'entourait déjà de ce haut mur robuste qui la protège des regards indiscrets et si elle possédait alors cette cour ombragée dotée de niches et de bancs, où il fait bon se reposer après une journée de chaleur accablante. La famille qui possède cet endroit jalousement caché depuis plus de quatre siècles, se dit gardienne d'un bien unique en son genre auquel elle refuse obstinément de toucher. Pour elle, cette maison – un labyrinthe composé d'un grand nombre de pièces où règnent la fraîcheur et l'esprit d'antan –, possède une âme. Et elle la protège, comme s'il s'agissait d'un être de chair et de sang. En témoignent ces canapés, ces tableaux, ces porcelaines et ces lampes qui n'ont jamais changé de place. En témoigne cette chambre à coucher où domine un lit à baldaquin en cuivre 19ᵉ, où les icônes, le couvre-lit et un éventail ancien évoquent le souvenir d'une parente bien-aimée. Et en témoigne ce salon formel, avec sa hauteur sous plafond impressionnante, dont l'ambiance fin de siècle est imprégnée de nostalgie.

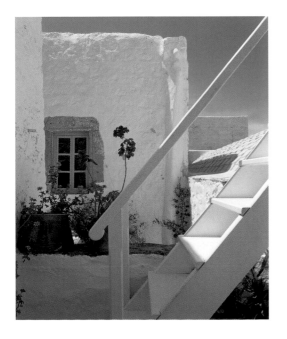

An outside staircase in wood leads to the broad roof terrace.

Über die Außentreppe aus Holz gelangt man auf die große Dachterrasse.

Un escalier extérieur en bois mène à la grande terrasse au sommet de la maison.

LEFT: *simple utensils in the kitchen.*
FACING PAGE: *In the ground floor dining room, the décor is confined to rustic furniture and a naive portrait of a woman.*

LINKS: *Die schlichten Küchenutensilien weisen auf ein einfaches Alltagsleben hin.*
RECHTE SEITE: *Die Einrichtung des Esszimmers im Erdgeschoss beschränkt sich auf rustikales Mobiliar und ein naives Frauenportrait.*

A GAUCHE: *La simplicité des ustensiles de cuisine révèle la sobriété de la vie quotidienne.*
PAGE DE DROITE: *Dans la salle à manger du rez-de-chaussée, la décoration se limite à un mobilier rustique et un portrait naïf de femme.*

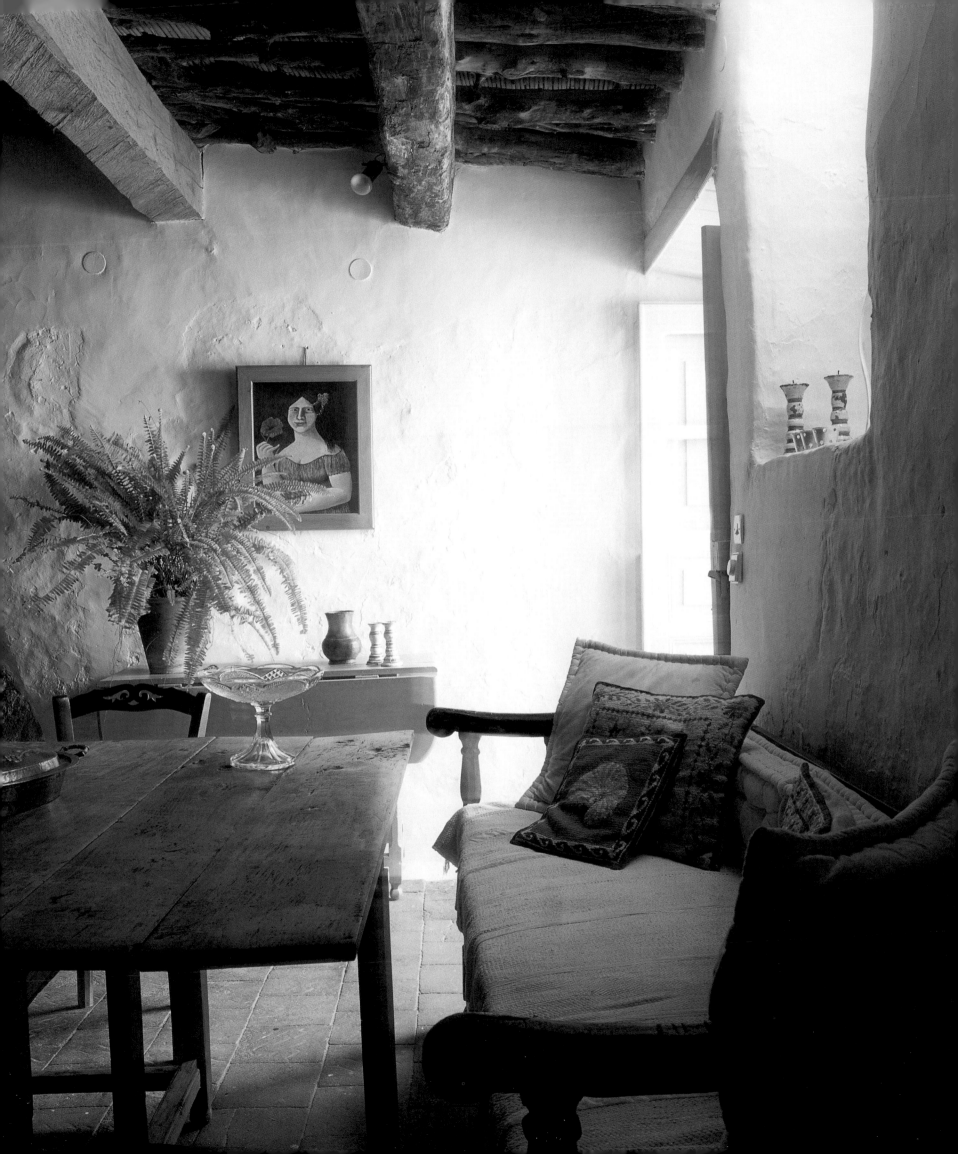

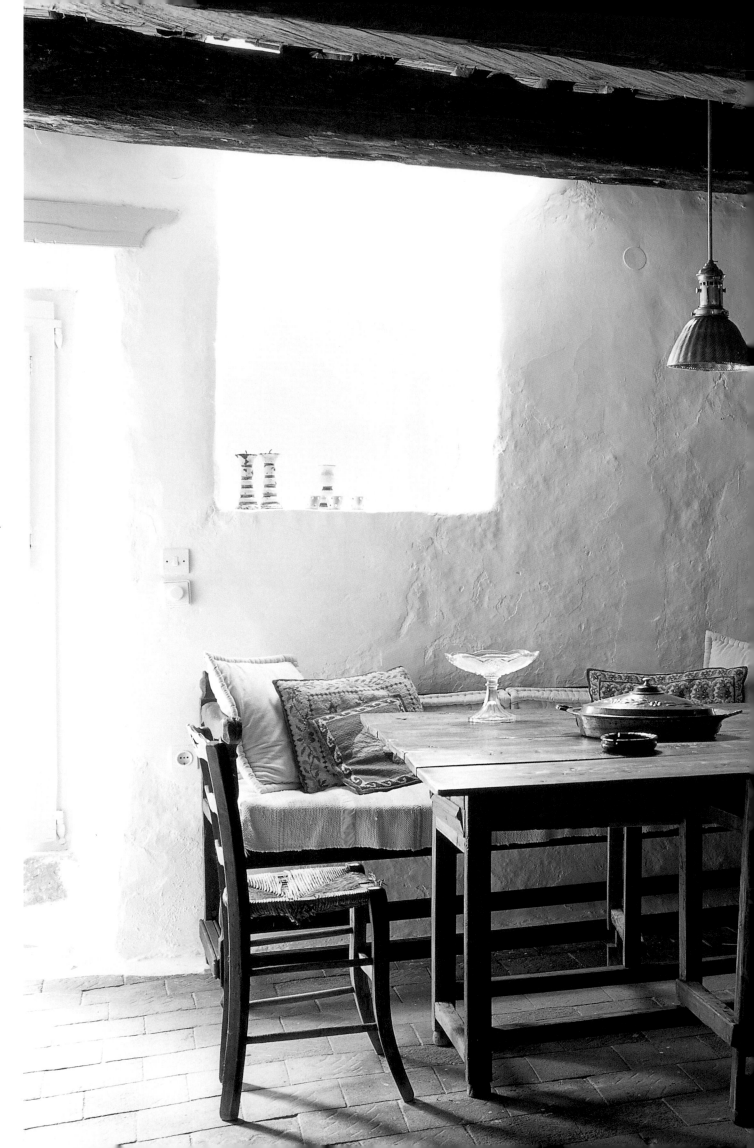

In the dining room, the large neogothic dresser forms an unusual contrast with the sturdy country furniture. The window looks out on a sunlit inner courtyard.

Der große neogotische Geschirrschrank im Esszimmer bildet einen ungewöhnlichen Kontrast zum robusten Landhausmobiliar am Fenster, das sich zum stets lichtdurchfluteten Innenhof öffnet.

Dans la salle à manger, le grand vaisselier néogotique forme un contraste insolite avec le robuste mobilier campagnard, près de la fenêtre qui donne sur la cour intérieure toujours inondée de lumière.

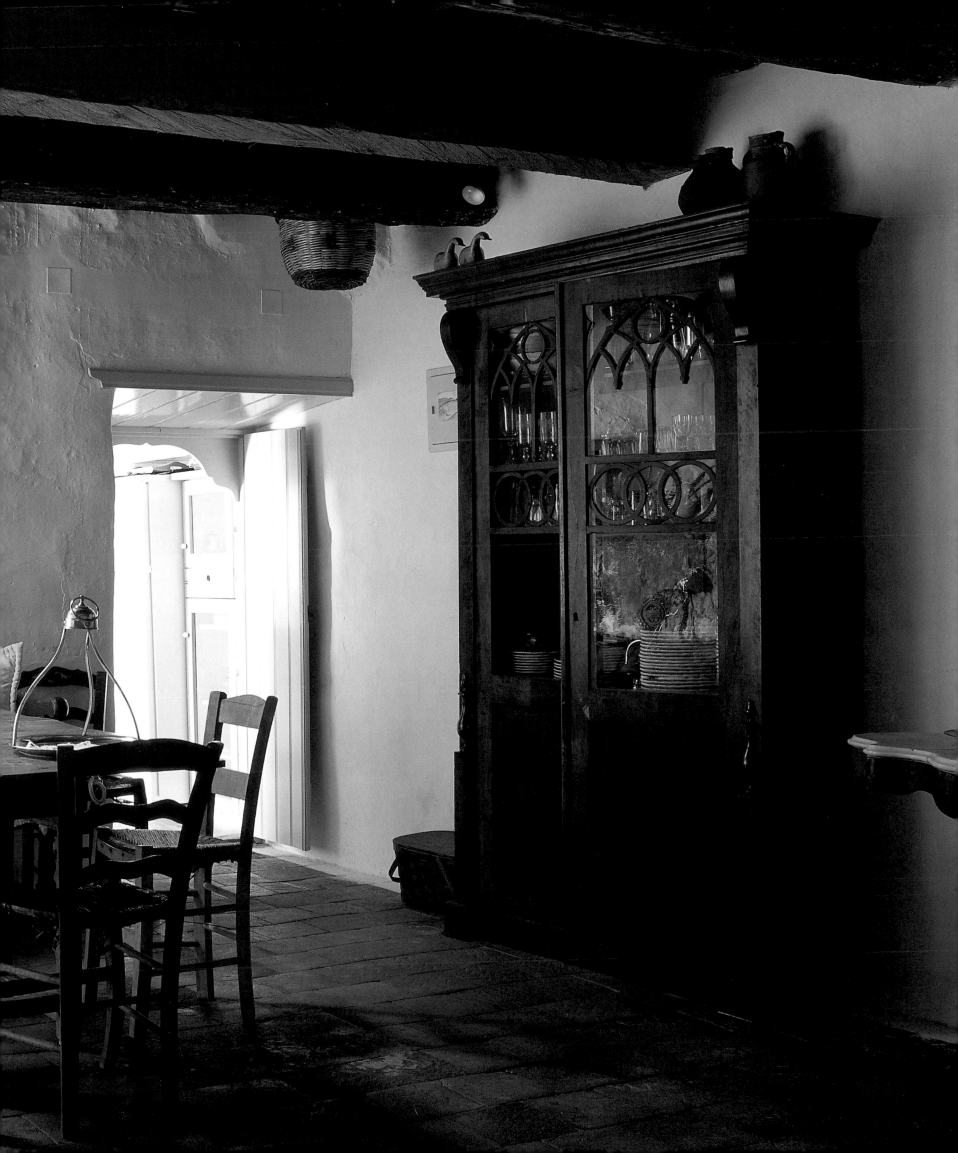

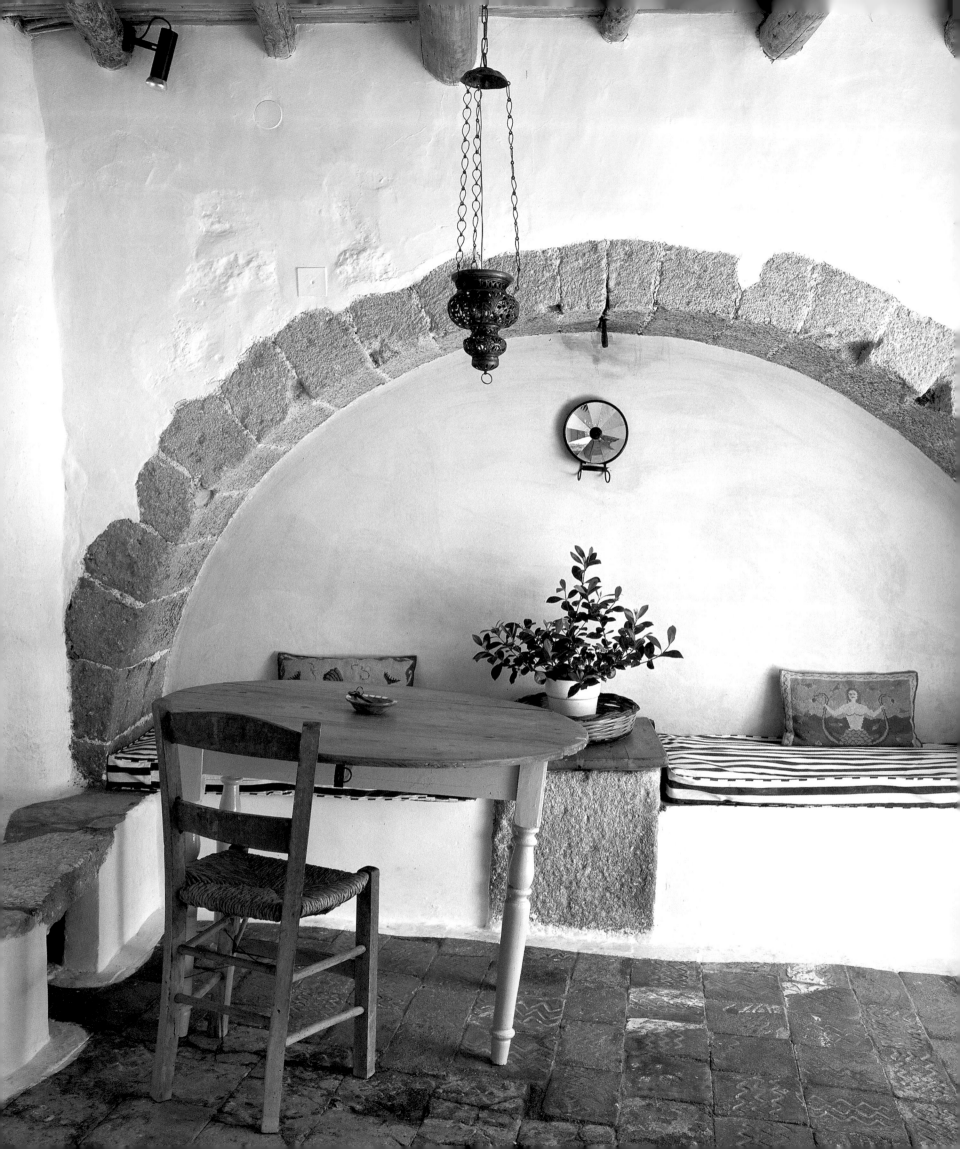

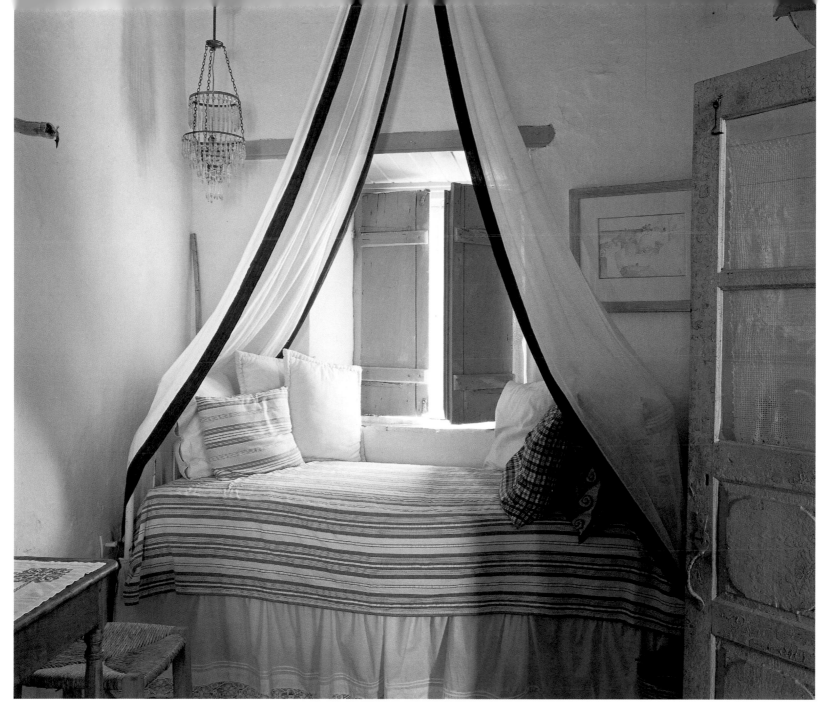

FACING PAGE: *in the patio next to the entrance, a niche with a banquette.*
ABOVE: *a small crystal chandelier hanging over a cotton-draped bed.*
RIGHT: *the guest bathroom.*

LINKE SEITE: *In der Nische des kleinen Innenhofs nahe dem Eingang ist eine Bank untergebracht.*
OBEN: *Der Baldachin aus Baumwollvoile und ein kleiner Kristall-Lüster bilden ein elegantes Ensemble.*
RECHTS: *Für ihre Gäste haben die Eigentümer ein ausgesprochen hübsches Bad eingerichtet.*

PAGE DE GAUCHE: *Dans la courette près de l'entrée, une niche accueille aujourd'hui une banquette.*
CI-DESSUS: *Le baldaquin en voile de coton et un petit lustre en cristal forment un ensemble élégant.*
A DROITE: *Les propriétaires ont créé un cabinet de toilette fort charmant pour les invités.*

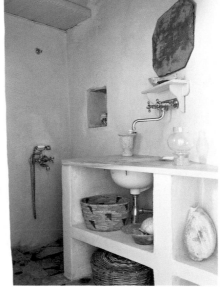

\mathcal{A} SECRET HOUSE

Patmos

They had bought themselves a pretty white house in the shadow of the monastery of St. John, on Patmos, one of the Sporades islands. But it filled up so quickly with furniture, objects and paintings, that before long they began to look hungrily at the places adjoining theirs, with a view to enlarging the space available to them. By dint of taking over a maze of rooms and terraces connected by sundry staircases and courtyards, the family – who shall remain nameless – found themselves at the centre of a labyrinth capable of accommodating any number of friends. As for the decoration, the owner and her husband opted for a look entirely dominated by the need for total comfort, with ample sofas, low tables, and lamps and lanterns from the Far East. They also kept to natural materials which chimed exactly with their simple lifestyle. For here the real luxury is to wake up in a flowered four-poster bed, to have lunch on the covered patio, and to spend one's days dreaming under the eternal blue sky.

A wrought iron fish on the wall of one of the terraces.

Ein schmiedeeiserner Fisch auf dem Mauersims einer der Terrassen.

Un poisson en fer forgé a trouvé sa place sur le rebord du mur d'une des terrasses.

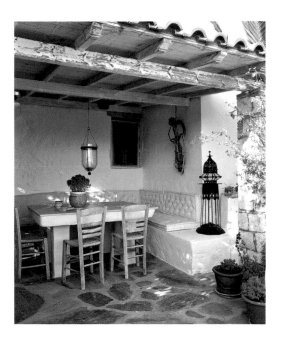

Sie hatten ein hübsches weißes Haus im Schatten des Johan-
nesklosters auf der Sporadeninsel Patmos gekauft. Doch da
sich der zweite Wohnsitz rasch mit Möbeln, Objekten und
Gemälden füllte, warfen sie schon bald ein Auge auf die umlie-
genden kleinen Häuser. Indem sie diese schließlich mit dem
eigenen verbanden, entstand ein stattliches Ferienhaus. Etliche
Zimmer und mehrere durch Treppen und kleine Höfe verbun-
dene Terrassen wurden angegliedert und so bewohnt die
Familie, die anonym bleiben möchte, nun ein Labyrinth, das
zahlreiche Freunde, die ein paar Wochen in der Sonne ver-
bringen möchten, aufnehmen kann. Die Hausherrin und ihr
Mann wählten eine Einrichtung, die sich vor allem durch
absolute Bequemlichkeit auszeichnet. Helle, großzügig bemes-
sene Sofas, niedrige Tische, Laternen und Leuchter aus dem
Fernen Osten und natürliche Materialien unterstreichen eine
ungekünstelte Lebensweise. Denn wahrer Luxus bedeutet hier,
in einem geblümten Himmelbett aufzuwachen, das Frühstück
im überdachten Hof einzunehmen und den ganzen Tag unter
dem blauen Himmel zu verträumen.

Ils avaient acheté une jolie maison blanche à l'ombre du
monastère de Saint-Jean à Patmos, une des îles Sporades. Mais
leur résidence secondaire se remplissant très vite de meubles,
d'objets et de tableaux, ils jetèrent un œil gourmand sur les
petites demeures qui les entouraient et les rattachèrent à la
leur maison pour obtenir ce bel ensemble aux proportions
agréables. Après avoir annexé un grand nombre de pièces et
plusieurs terrasses reliées par des escaliers et des courettes,
notre famille anonyme occupe un labyrinthe propice à
accueillir de nombreux amis désireux de passer quelques
semaines au soleil. Côté décoration, la maîtresse de maison et
son époux ont choisi une ambiance dominée par le souci du
confort absolu, optant pour des canapés clairs aux proportions
généreuses, des tables basses, des lanternes et des luminaires
venus d'Extrême-Orient et pour des matériaux naturels qui
soulignent un mode de vie sans sophistication. Ici, le vrai luxe,
c'est de se réveiller dans un lit à baldaquin fleuri, de prendre le
déjeuner sur le patio couvert et de passer ses journées à rêver
sous un ciel bleu à souhait …

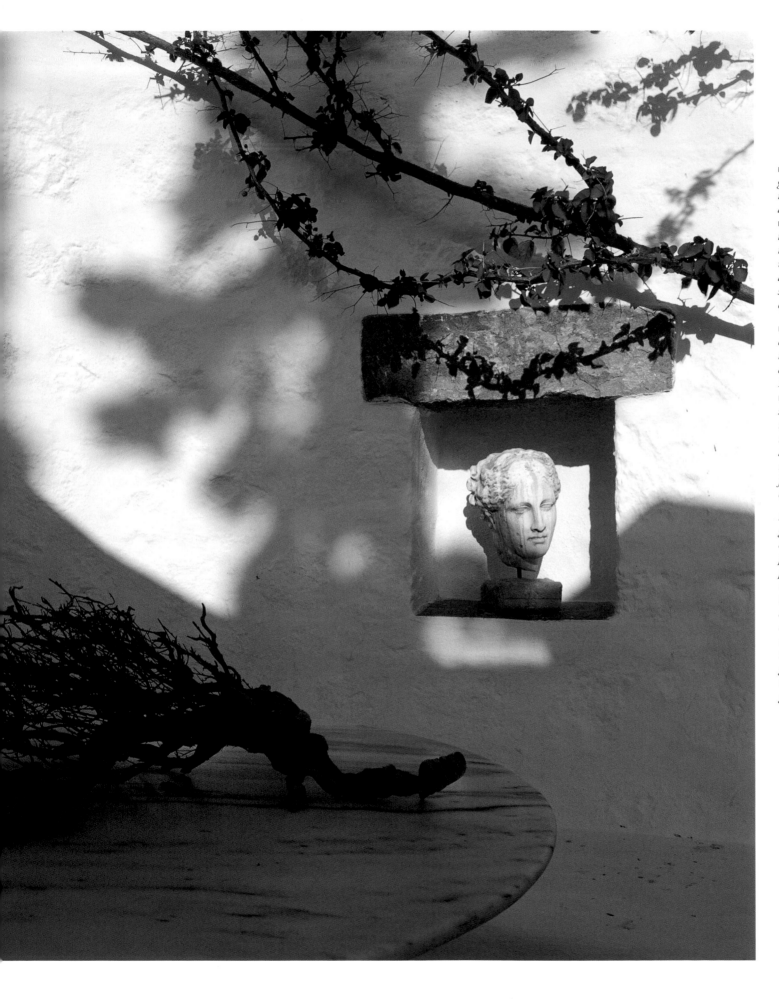

LEFT: *a plastercast of a goddess's head, hidden in the half darkness of a shallow niche.*
FACING PAGE: *the terrace outside one of the guest bedrooms, with terracotta tiles and a "krokalia" motif of stones in the tradition of ancient Greece.*

LINKS: *Die Replik eines griechischen Göttinnenhauptes belebt die flache Nische im Halbschatten.*
RECHTE SEITE: *Das zentrale Motiv der Terrasse des Gästezimmers mit Terrakottaboden ist als »krokalia«, Kieselmosaik, gearbeitet und führt eine uralte griechische Tradition fort.*

A GAUCHE: *Le moulage d'une tête de déesse dissimulé dans la pénombre d'une niche peu profonde.*
PAGE DE DROITE: *La terrasse de la chambre d'amis est dotée d'un sol en terre cuite dont le motif central en «krokalia» – une mosaïque de galets – perpétue une très ancienne tradition grecque.*

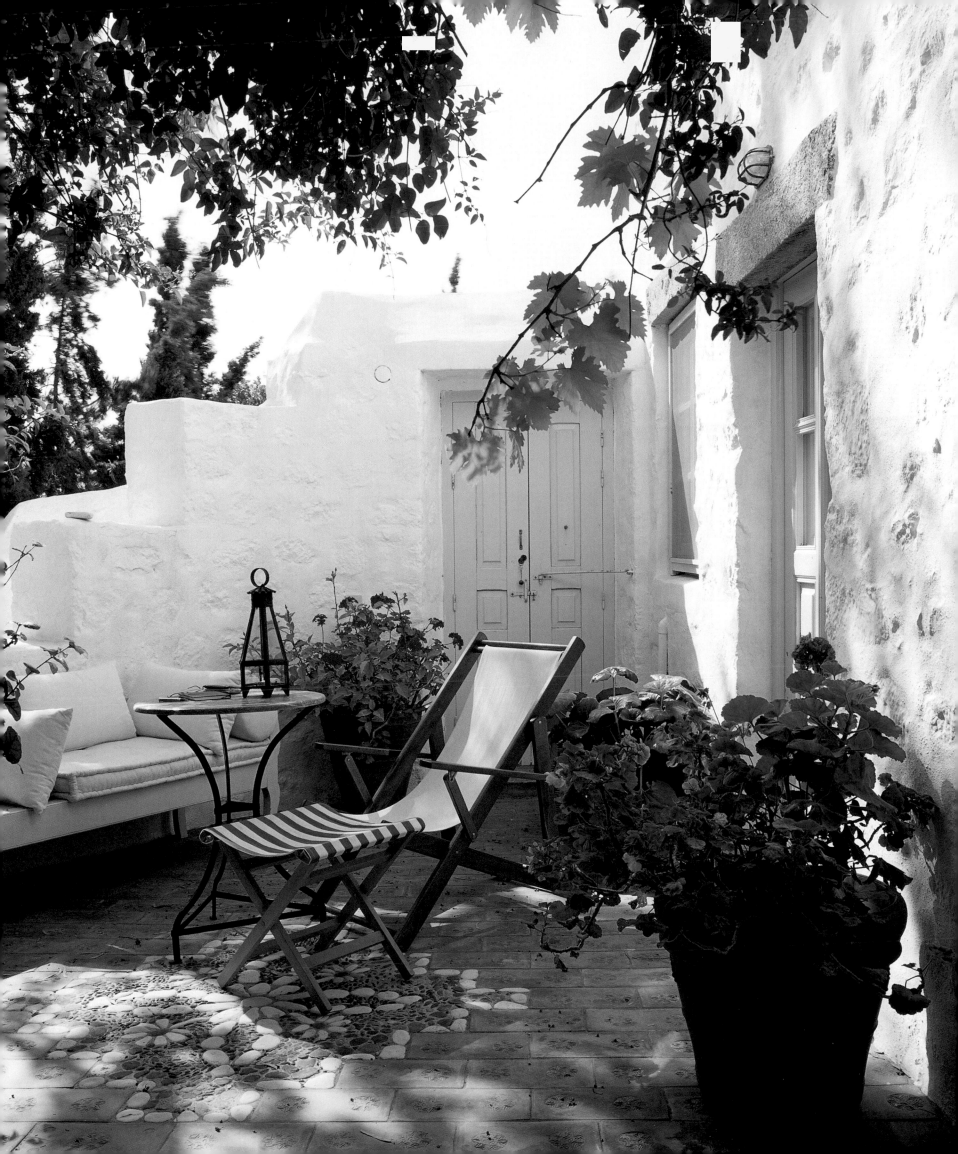

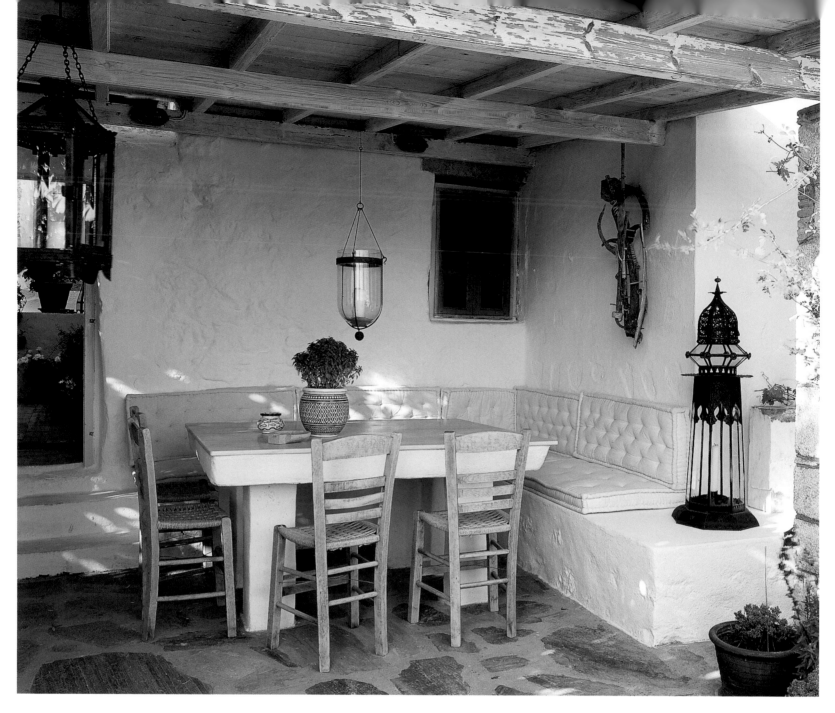

ABOVE: *On one of the patios, the family has set up a large stone table, with chairs and an L-shaped bench around it.*
RIGHT: *The guest bedroom gives on to a charming small courtyard, just the place for reading, snoozing or doing strictly nothing at all.*

FACING PAGE: *The house is filled with original decorative touches, such as this broad four-leaved screen which imitates classic paneling. The armchairs and the lampshades go well with the whitewashed walls.*

OBEN: *In einem der Höfe steht ein großer Steintisch mit einer L-förmigen Bank und Stühlen mit Binsengeflecht.*
RECHTS: *Im Hof des Gästezimmers kann man sich zum Lesen, zur Siesta oder zum »dolce far niente« zurückziehen.*

RECHTE SEITE: *Im Haus wimmelt es von originellen Dekorationsideen wie diesem großen Paravent, der eine klassische Täfelung nachahmt. Die Sessel und Lampenschirme sind auf die weißen Wände abgestimmt.*

CI-DESSUS: *Dans une des cours, la famille a installé une grande table en pierre entourée de chaises paillées et d'une banquette en L.*
A DROITE: *La chambre d'amis donne sur une courette charmante où l'on peut se retirer pour lire, faire une sieste ou s'adonner au «dolce far niente».*

PAGE DE DROITE: *La maison regorge de trouvailles décoratives telles que ce grand paravent à quatre feuilles imitant un lambris chassique. Les fauteuils et les abat-jour sont harmonisés au blanc des murs.*

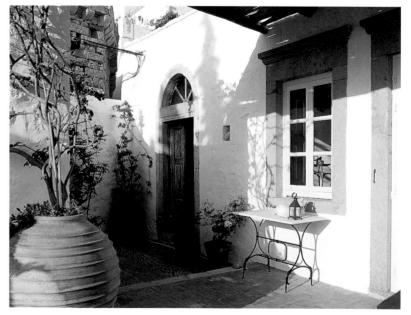

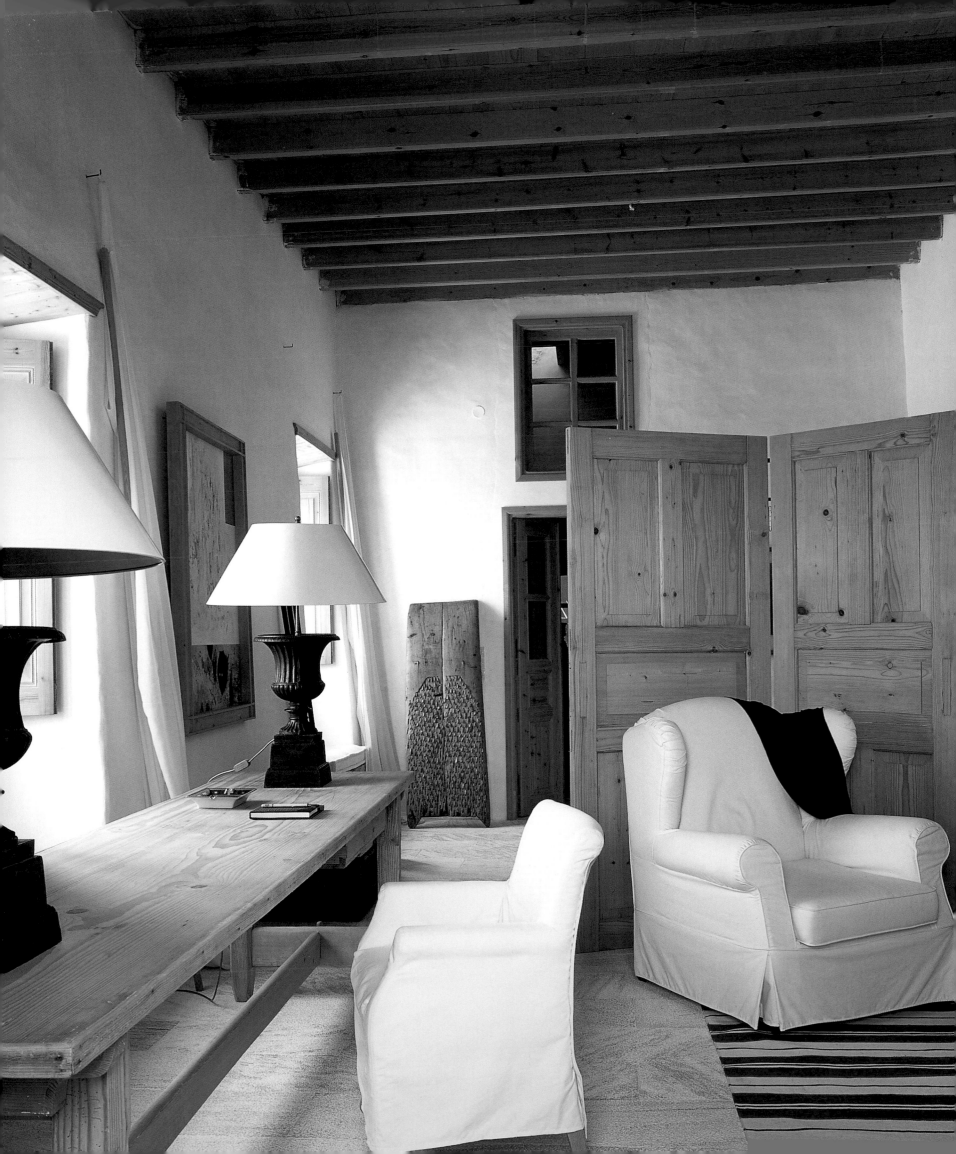

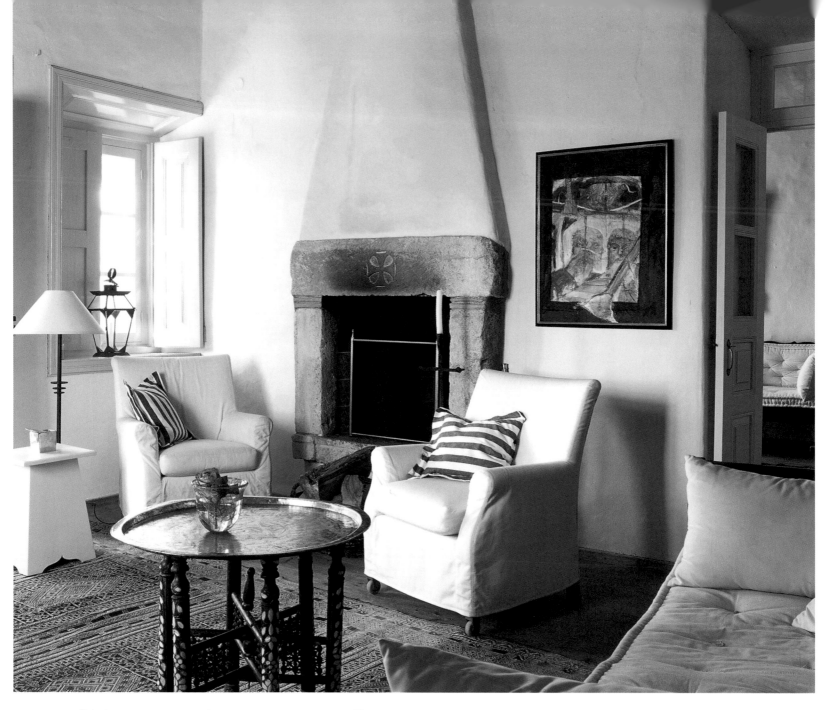

ABOVE: *a small, intim- ate living room, com- fortably furnished, with a stone fireplace bearing the cross of Malta. The table with its hammered copper tray is from Morocco.*

RIGHT: *a minimalist bathroom, enlivened by blue and white striped towels.*

FACING PAGE: *a four- poster bed in one of the guest bedrooms, where blue and white also pre- dominate.*

OBEN: *ein bequem eingerichter, intimer kleiner Salon, ausgestat- tet mit einem Kamin aus gemeißeltem Stein, den ein Malteserkreuz ziert, und einem marokkanischen Tisch mit gehämmertem Kupfertablett.*

RECHTS: *Das minima- listische Badezimmer wird von blauweiß gestreiften Handtüchern aufgelockert.*

RECHTE SEITE: *Bei diesem Himmelbett im Gästezimmer geben wiederum Blau und Weiß den Ton an.*

CI-DESSUS: *Un petit salon intime, meublé confortablement, abrite une cheminée en pierre sculptée ornée d'une croix de Malte et une table marocaine avec un plateau en cuivre martelé.*

A DROITE: *Une salle de bains minimaliste est animée par la présence des serviettes à rayures bleues et blanches.*

PAGE DE DROITE: *Un lit à baldaquin tient la place d'honneur dans une chambre d'amis dominée, elle aussi, par le bleu et le blanc.*

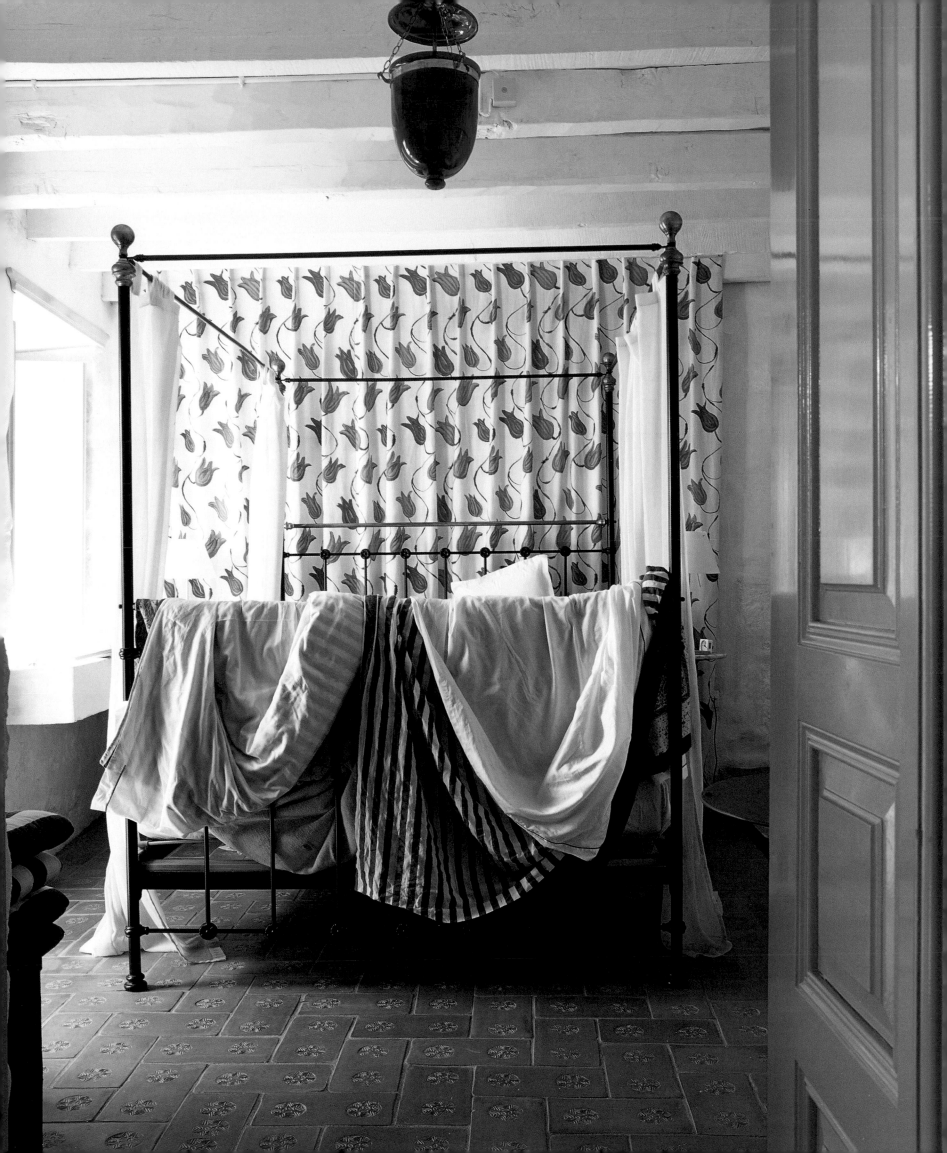

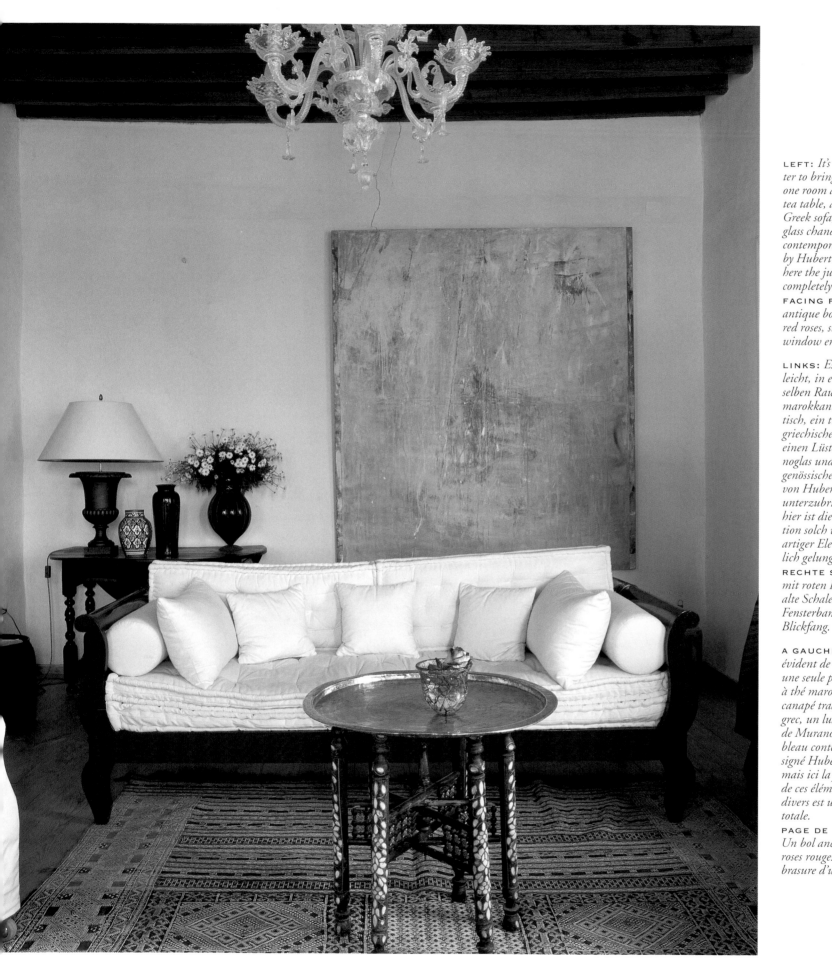

LEFT: *It's no easy matter to bring together in one room a Moroccan tea table, a traditional Greek sofa, a Murano glass chandelier and a contemporary painting by Hubert Scheibel, but here the juxtaposition is completely successful.*
FACING PAGE: *an antique bowl filled with red roses, standing in a window embrasure.*

LINKS: *Es ist nicht leicht, in ein und demselben Raum einen marokkanischen Teetisch, ein traditionelles griechisches Kanapee, einen Lüster aus Muranoglas und ein zeitgenössisches Gemälde von Hubert Scheibel unterzubringen. Doch hier ist die Kombination solch verschiedenartiger Elemente wirklich gelungen.*
RECHTE SEITE: *Eine mit roten Rosen gefüllte alte Schale auf der Fensterbank dient als Blickfang.*

A GAUCHE: *Il n'est pas évident de réunir dans une seule pièce une table à thé marocaine, un canapé traditionnel grec, un lustre en verre de Murano et un tableau contemporain signé Hubert Scheibel, mais ici la juxtaposition de ces éléments très divers est une réussite totale.*
PAGE DE DROITE: *Un bol ancien rempli de roses rouges égaie l'embrasure d'une fenêtre.*

LEFT: *the graceful outline of a wrought iron bed, seen against the walls and white curtains of a guest bedroom.*

LINKS: *In einem der Gästezimmer hebt sich der feingliedrige Umriss eines schmiedeeisernen Himmelbetts von den weißen Wänden und Vorhängen ab.*

A GAUCHE: *La silhouette gracieuse d'un lit à baldaquin en fer forgé se détache sur les murs et les rideaux blancs d'une chambre d'amis.*

FACING PAGE: *In one of the bedrooms, a work by Hermann Nitsch hangs above a cushion-covered sofa. The striped carpet and the furniture upholstered with white slipcovers show that comfort is a real priority here.*

RIGHT: *Beyond the old carved wood balustrade, a few stone steps lead to the guest bedrooms. The lanterns were brought back from a trip to Morocco, and the painting is by Teddy Millington Drake.*

LINKE SEITE: *Über der Couch mit gesteppten Polstern in einem der Schlafzimmer hängt eine Arbeit von Hermann Nitsch. Der gestreifte Teppich und das mit abnehmbaren weißen Bezügen versehene Mobiliar lassen auf ein feines Gespür für Komfort schließen.*

RECHTS: *Jenseits der sehr alten Holzbalustrade führen ein paar Steinstufen zu den Gästezimmern. Die Laternen sind Mitbringsel von einer Marokko-Reise und das Bild stammt von Teddy Millington Drake.*

PAGE DE GAUCHE: *Dans une des chambres à coucher, une œuvre de Hermann Nitsch est accrochée au-dessus d'un canapé aux coussins matelassés. Le tapis rayé et le mobilier recouvert de housses blanches amovibles trahissent un grand souci du confort.*

A DROITE: *Au-delà de la très ancienne balustrade en bois sculpté, quelques marches en pierre mènent aux chambres d'amis. Les lanternes ont été rapportées d'un voyage au Maroc et le tableau est signé Teddy Millington Drake.*

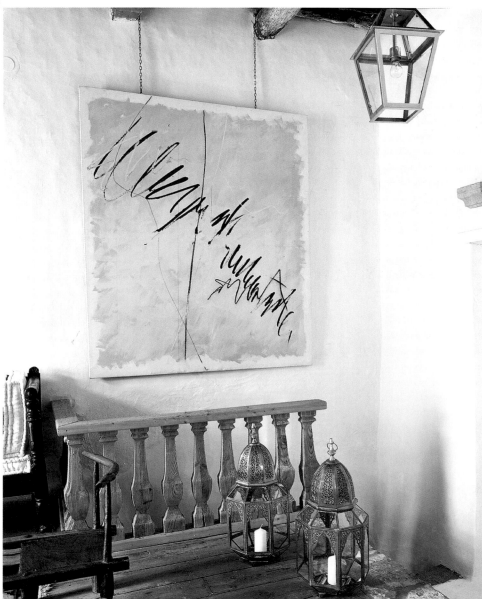

SPITI MARILENAS
Marilena Liakopoulos
Patmos

Marilena Liakopoulos bears a famous name and her Athens gallery is known all over the world: she is the daughter of the painter Byzantios, and she has a wonderful house in "The Jerusalem of Greece", namely the island of Patmos. Nevertheless, she has remained profoundly simple, unlike her house, or rather her palace. It's an imposing 18th century structure, with a broad-arched loggia and a pair of centuries-old stone lions on its balcony; the immediate impression is very much of a Florentine "palazzo". Inside, contrary to what you might suppose, Marilena has refrained from any form of baroque ostentation, and despite the presence of period features like the doors, ceilings, floors, and beautiful old four-poster beds, she has imported nothing but contemporary artwork and objects. The centrepiece, of course, is a huge cool kitchen with a long refectory table.

The door knocker with its grotesque mask, cherubim and coat of arms.

Der Türklopfer mit einer grotesken Maske, Wappen und pausbäckigen Cherubinen.

Le heurtoir de la porte avec son masque grotesque, son blason et ses chérubins grassouillets.

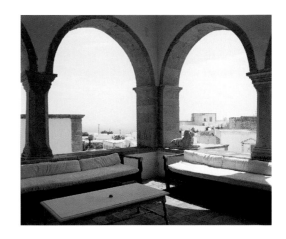

Sie trägt einen legendären Namen und ihre Galerie in Athen ist weltbekannt: Die Tochter des berühmten Malers Byzantios besitzt ein entzückendes Haus auf der Insel Patmos, dem »Jerusalem Griechenlands«. Dennoch ist Marilena Liakopoulos ein einfacher Mensch geblieben, im Gegensatz zu ihrem Haus – oder besser gesagt Palast – auf Patmos. Dieser imposante »palazzo« aus dem 18. Jahrhundert verfügt über eine beeindruckende Loggia mit weiten Bögen, in der seit Jahrhunderten zwei steinerne Löwen wachen. Man kann sich des Gedankens nicht erwehren, Patmos sei auf wundersamem Wege mitten in die Stadt der Medici verpflanzt worden. Bei der Inneneinrichtung hingegen hat Marilena auf alles Pompöse und Barocke verzichtet. Denn im Kontrast zu historischen Elementen wie Türen, Zimmerdecken, Fußböden und schönen alten Himmelbetten hat sie nur zeitgenössische Kunstwerke und -objekte in ihrem Haus aufgenommen. Das i-Tüpfelchen ist eine geräumige, angenehm kühle Küche, in der ein stattlicher Refektoriumstisch das Zentrum bildet.

Elle porte un nom légendaire et sa galerie d'Athènes a une renommée mondiale: la fille du célèbre peintre Byzantios possède une maison sublime dans le «Jérusalem de la Grèce» – l'île de Patmos. Néanmoins, Marilena Liakopoulos est restée la simplicité même, contrairement à sa maison, ou faut-il dire son palais, de Patmos. Ceux qui contemplent ce «palazzo» 18e imposant, couronné d'une loggia aux arches généreuses et doté d'une paire de lions en pierre couchés comme des chiens de garde depuis des siècles sur les rebords du balcon, ne pourront tout à fait renoncer à l'idée que Patmos a été transplanté par quelque miracle au cœur de la ville des Médicis. Contrairement à ce que l'on pourrait supposer, Marilena s'est abstenue – côté décoration – de donner dans l'ostentatoire et le baroque. Et en dépit des éléments d'époque comme les portes, les plafonds, les sols et les beaux lits à baldaquin anciens, elle n'a intégré à sa demeure que des œuvres d'art et des objets d'art contemporains. Le point d'orgue? Une vaste cuisine où trône une table de réfectoire imposante et dans laquelle règne une fraîcheur délicieuse!

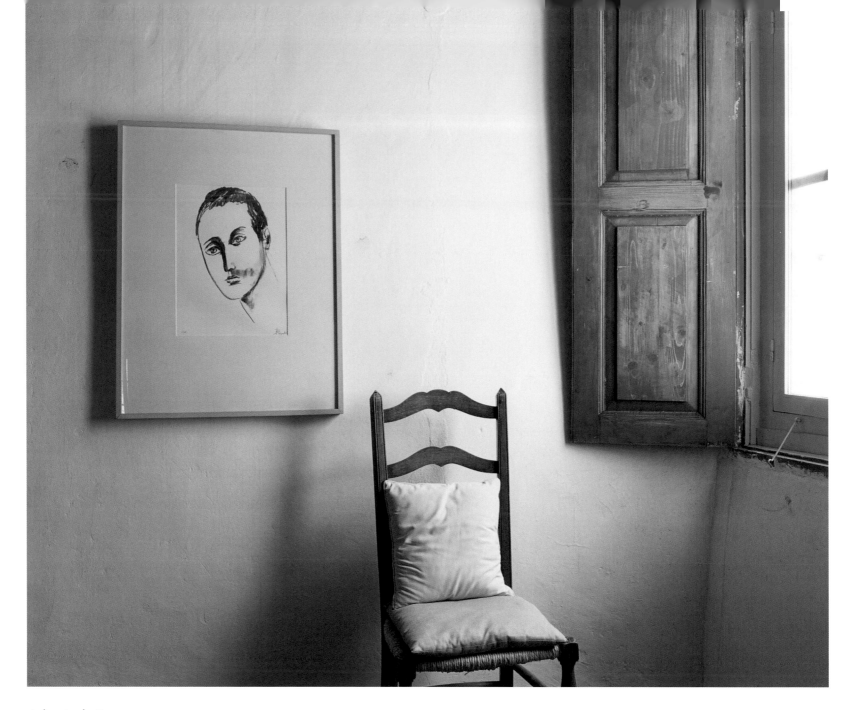

*A drawing by Constan-
tin Byzantios in Mar-
ilena's bedroom.*

*Die Zeichnung, die in
Marilenas Zimmer
neben dem strohbe-
zogenen Stuhl hängt,
stammt von Constantin
Byzantios.*

*Dans la chambre de
Marilena, le dessin
accroché près d'une
chaise paillée est de la
main de Constantin
Byzantios.*

*The round table in the
small salon with its cro-
cheted lace tablecloth.
The staircase leads to
one of the bedrooms.*

*Der runde Tisch im
kleinen Salon ver-
schwindet unter einer
Häkelspitzendecke. Die
Treppe führt zu einem
der Schlafräume.*

*La table ronde du petit
salon disparaît sous une
nappe décorée de dentel-
le au crochet. L'escalier
mène à une chambre à
coucher.*

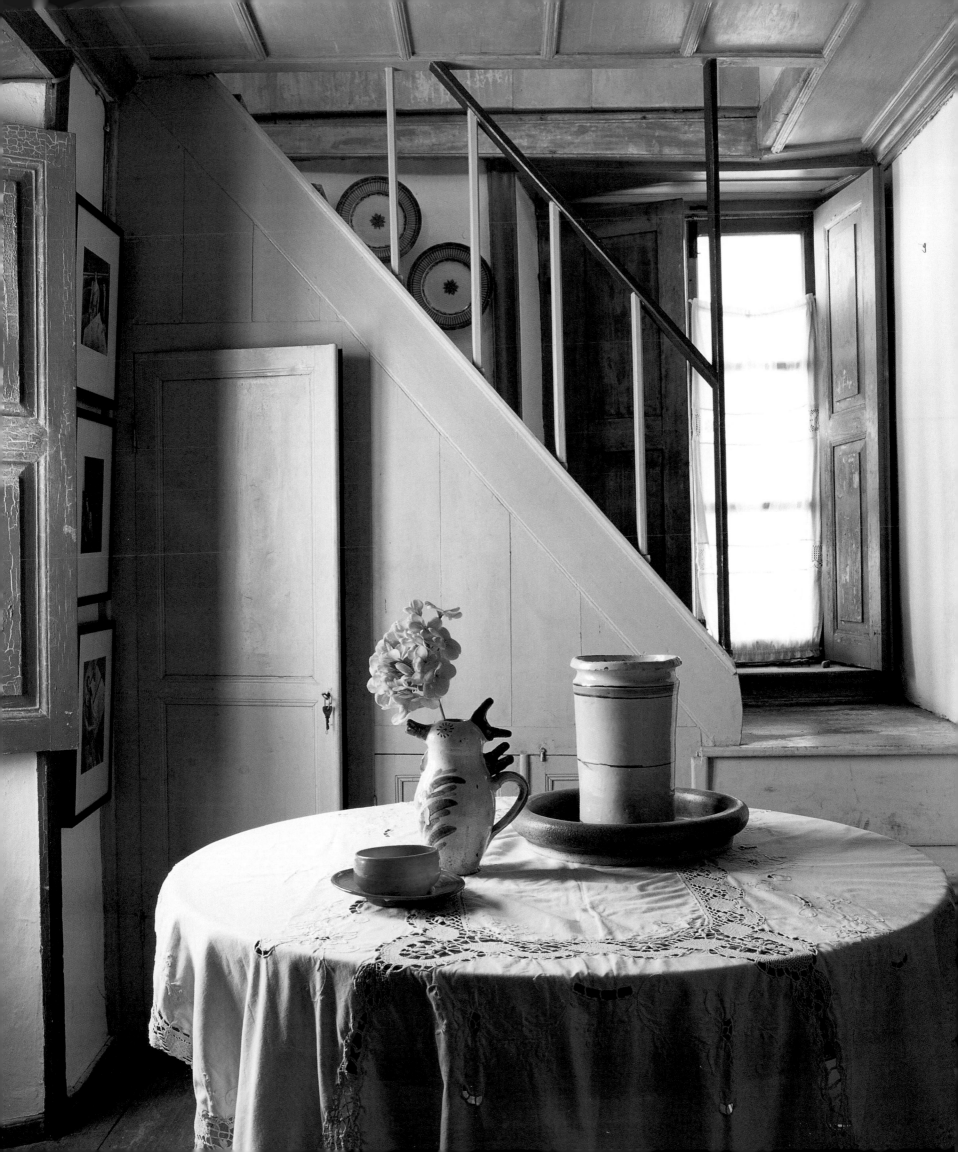

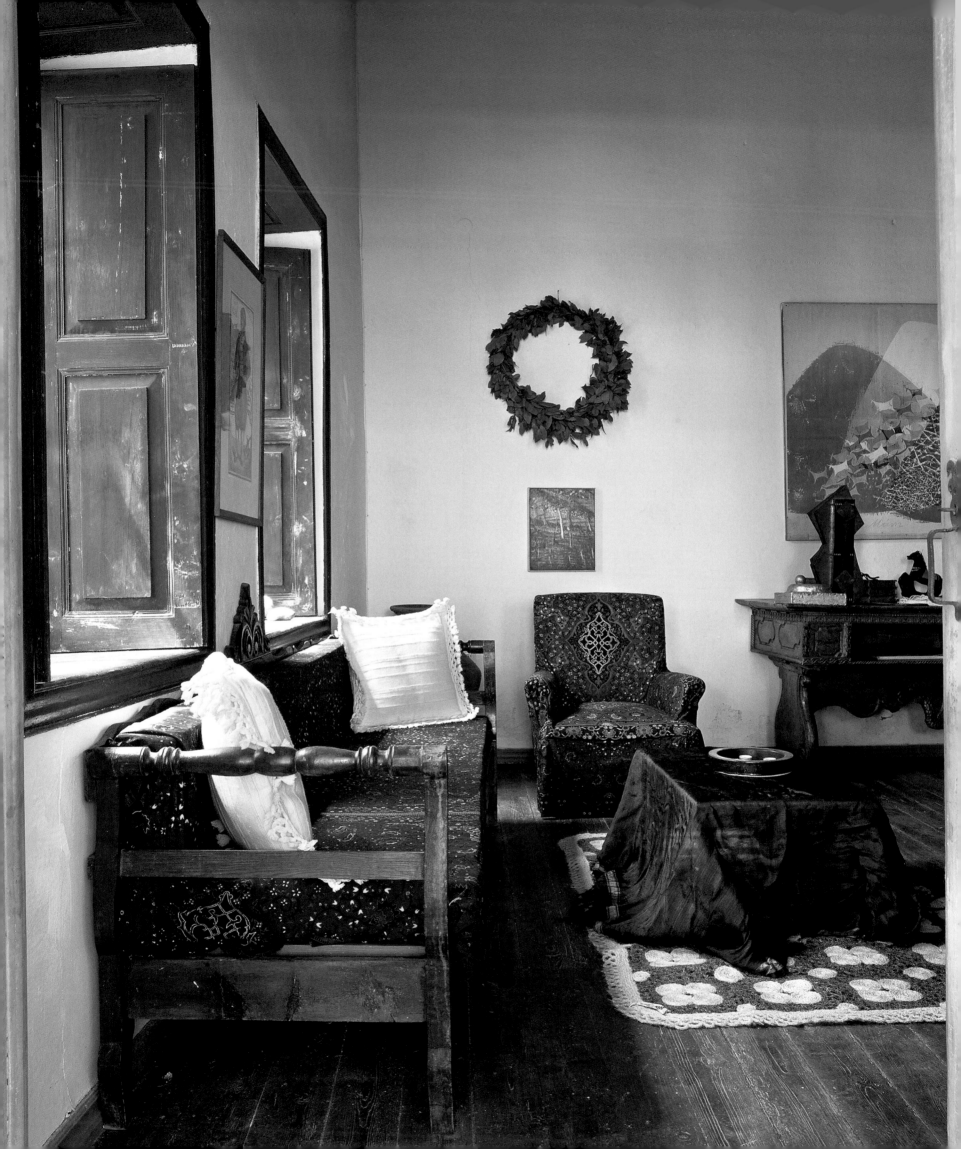

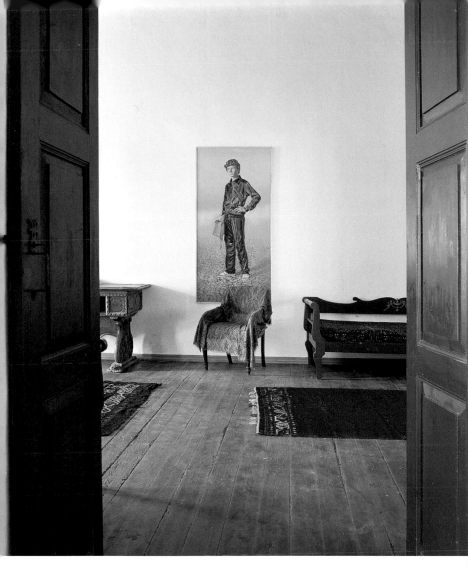

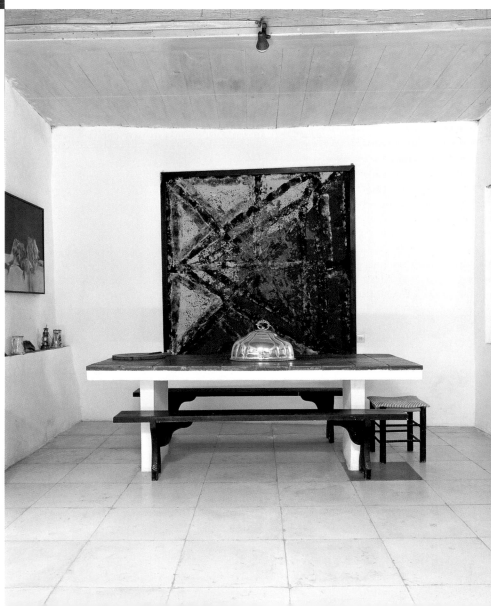

The austere spacious
kitchen. The picture on
the wall is by an artist
of the Milan school.

*Weitläufig wie ein Ball-
saal, besticht die Küche
durch ihre Schlichtheit.
Das Gemälde rechts ist
ein Werk aus der
Mailänder Schule.*

*Vaste comme une salle
de bal, la cuisine
impressionne par sa
sobriété. Le tableau à
droite est une œuvre de
l'Ecole milanaise.*

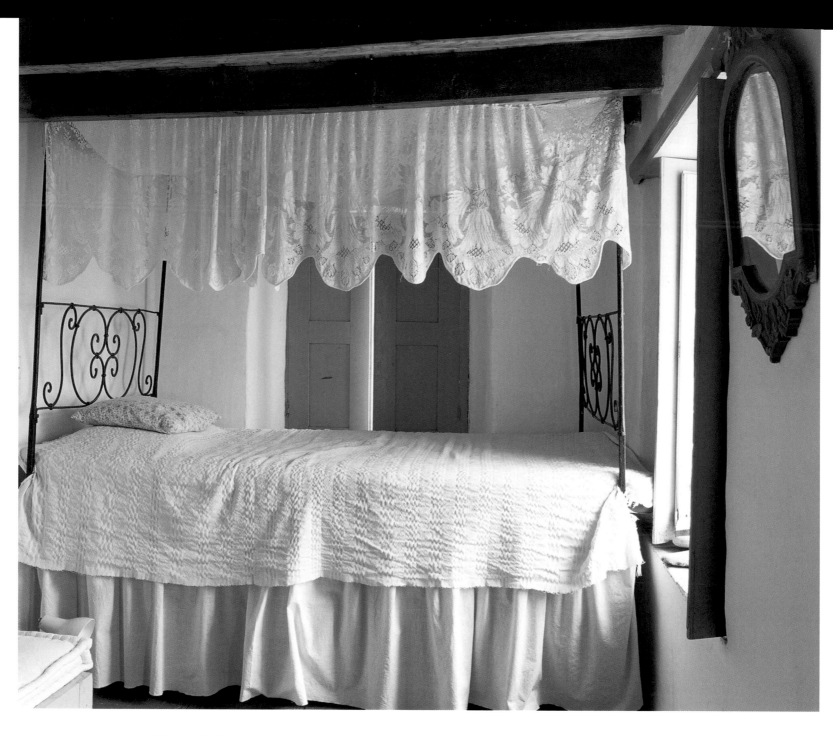

A 19th century wrought
iron bed takes up most
of the available space in
an entresol bedroom.
The lace hangings and
counterpane date from
the early 20th century.

In diesem Schlafzimmer
im Zwischengeschoss
nimmt ein schmiedeei-
sernes Bett aus dem 19.
Jahrhundert den ganzen
Raum ein. Spitzenbe-
hang und Bettüberwurf
stammen vom Anfang
des vergangenen Jahr-
hunderts.

Un lit en fer forgé 19ᵉ
prend tout l'espace dans
une chambre à coucher
située à l'entresol. Le
tour de lit en dentelle et
le couvre-lit datent du
début du siècle dernier.

FACING PAGE: *A steel
chopper, transformed
into an animal by
Natalia Mela, echoes
the sinuous outline of
the dressing table mir-
ror.*
FOLLOWING PAGES:
*the two bathrooms
– ultra-simple, com-
fortable and entirely
pictural.*

RECHTE SEITE: *Ein
von Natalia Mela zu
einem Tier umgestaltetes
Küchenbeil nimmt die
gewundenen Formen des
Frisierspiegels auf.*
FOLGENDE DOPPEL-
SEITE: *Die Badezim-
mer sind von beein-*

*druckender Schlichtheit
und verdanken ihren
Charme ganz dem
poetisch-malerischen
Ambiente.*

PAGE DE DROITE:
*Une hache en fonte
transformée en animal
par Natalia Mela fait
écho aux formes sinueu-
ses du miroir de la coif-
feuse.*
DOUBLE PAGE SUI-
VANTE: *Les salles de
bains sont d'une simpli-
cité impressionnante et
doivent tout leur char-
me à leur ambiance
poétique et picturale.*

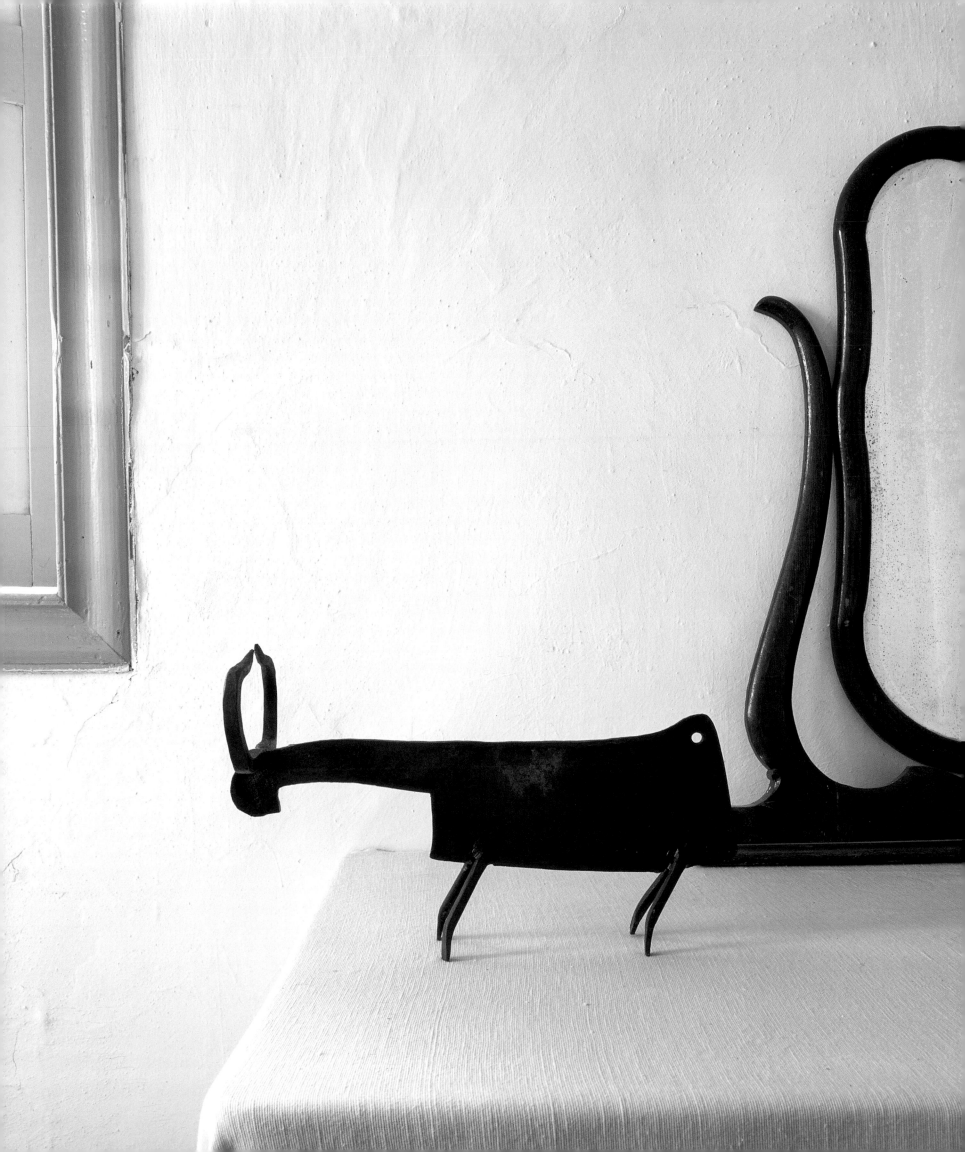

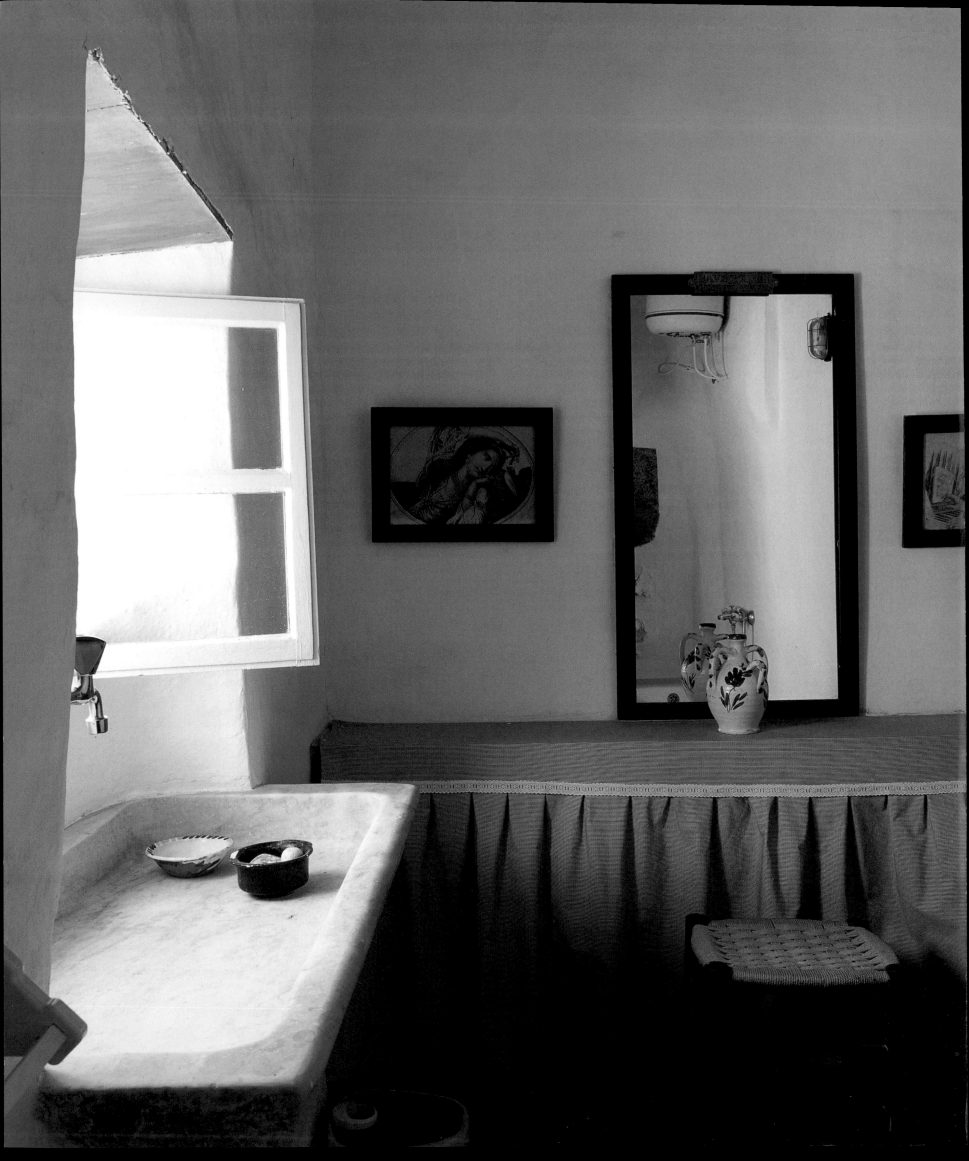

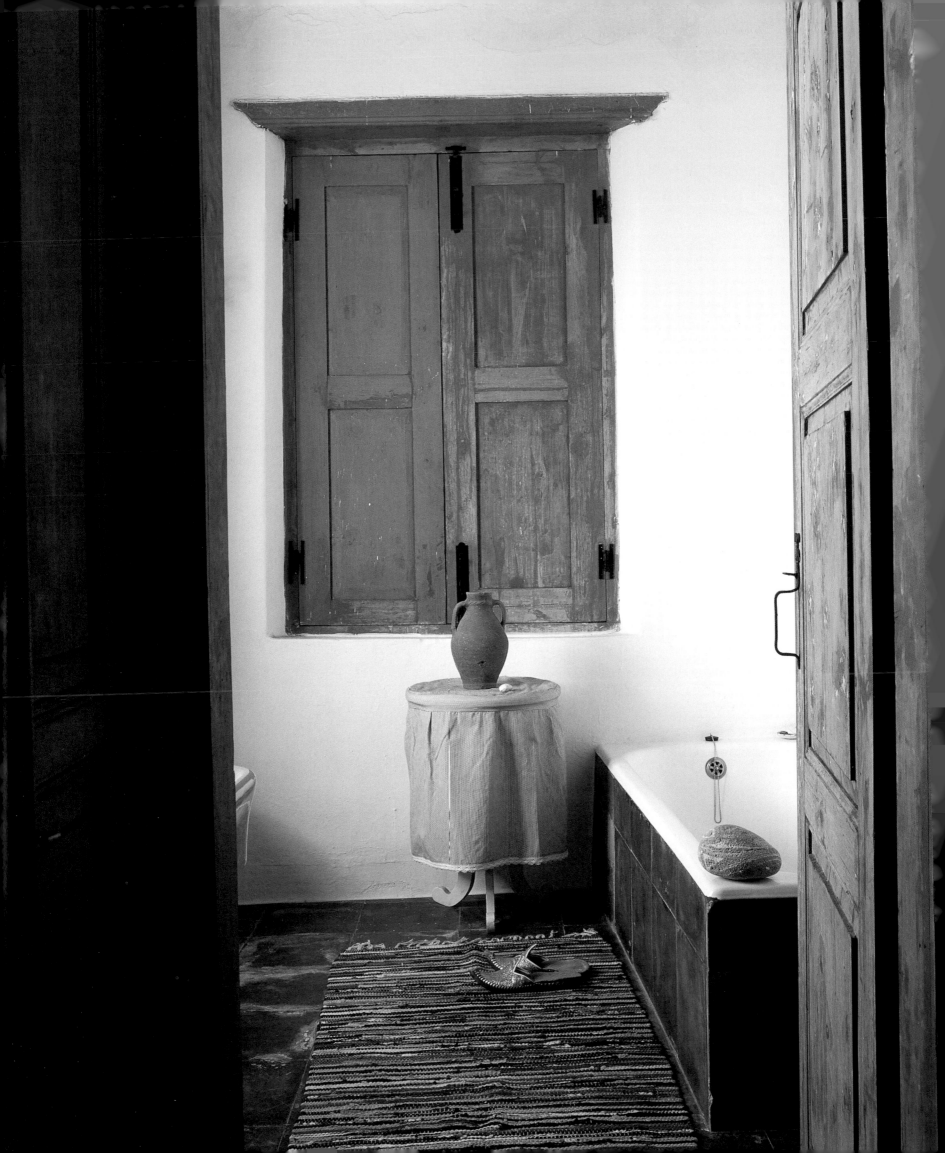

ACKNOWLEDGEMENTS

DANKSAGUNG

REMERCIEMENTS

This book could never have been written without the spontaneous help and hospitality of all those who opened their houses to us and welcomed us in; but our special thanks are due to Moska, our "guardian angel", as well as to Jean-Claude Chalmet, Maxie Leoussis, Tilly and Basile Touloumtzoglou, Timothy Hennessy, Yannis Kardamatis and Vassily Tseghis. Thanks to them, our long and difficult task was transformed into a marvellous sojourn in Greece.

Dieses Buch wäre nie zustande gekommen ohne die spontane Mitwirkung und Gastfreundschaft all derer, die uns ihre Wohnungstüren geöffnet haben. Dank auch an unseren »Schutzengel« Moska und an Jean-Claude Chalmet, Maxie Leoussis, Tilly und Basile Touloumtzoglou, Timothy Hennessy, Yannis Kardamatis und Vassily Tseghis. Mit ihrer Hilfe wurde aus unserem langwierigen und komplizierten Unterfangen ein wundervoller Aufenthalt.

Nous n'aurions jamais pu réaliser ce livre sans la collaboration spontanée et l'hospitalité de tous ceux qui nous ouvrirent la porte de leurs demeures. Merci aussi à notre «ange gardien» Moska et à Jean-Claude Chalmet, Maxie Leoussis, Tilly et Basile Touloumtzoglou, Timothy Hennessy, Yannis Kardamatis et Vassily Tseghis. Grâce à eux notre tâche longue et ardue s'est transformée en un séjour merveilleux.

Barbara & René Stoeltie

ENDPAPERS: *a niche crowded with seashells, on the terrace of the Paouris Palace, Hydra (see pages 32–39).*
VORSATZ: *Auf der Terrasse des Paouris-Palastes auf Hydra befindet sich eine Nische mit sonnengebleichten Muscheln (siehe Seite 32–39).*
PAGES DE GARDE: *Sur la terrace du Palais Paouris à Hydra, une niche regorge de coquilles blanchies par le soleil (voir pages 32–39).*

PAGE 4: *Lakoon (2nd century BC), detail, Musei Vaticani, Rome.*
SEITE 4: *Laokoon (2. Jh. v. Chr.), Detail, Musei Vaticani, Rom.*
PAGE 4: *Laocoon (2ᵉ siècle avant J.-C.), détail, Musei Vaticani, Rome.*

© 2002 TASCHEN GmbH
Hohenzollernring 53, D–50672 Köln
www.taschen.com

Design by Catinka Keul, Cologne
Layout by Angelika Taschen, Cologne
Texts edited by Susanne Klinkhamels, Cologne
Lithography by Horst Neuzner, Cologne
English translation by Anthony Roberts, Lupiac
German translation by Stefan Barmann, Cologne

Printed in Germany

ISBN 3–8228–5869–2 (edition with English/German cover)

ISBN 3–8228–5735–1 (edition with French cover)

TASCHEN'S COUNTRY HOUSES

Edited by Angelika Taschen
Barbara & René Stoeltie

PUBLISHED:

"'Decorator porn,' a friend calls it, those sensuous photograph books of beautiful houses. Long on details and atmosphere and packed with ideas, this is a bountiful look at beautiful but unpretentious homes in the place where 'everything is founded on the link between beauty and well-being.' It's easy to linger there."
The Virginian-Pilot, USA

IN PREPARATION:
Country Bathrooms
Country Bedrooms
Country Houses of Ireland
Country Houses of Morocco
Country Houses of New England
Country Houses of Portugal
Country Houses of Provence
Country Houses of Russia
Country Kitchens & Recipes